THE PENCIL

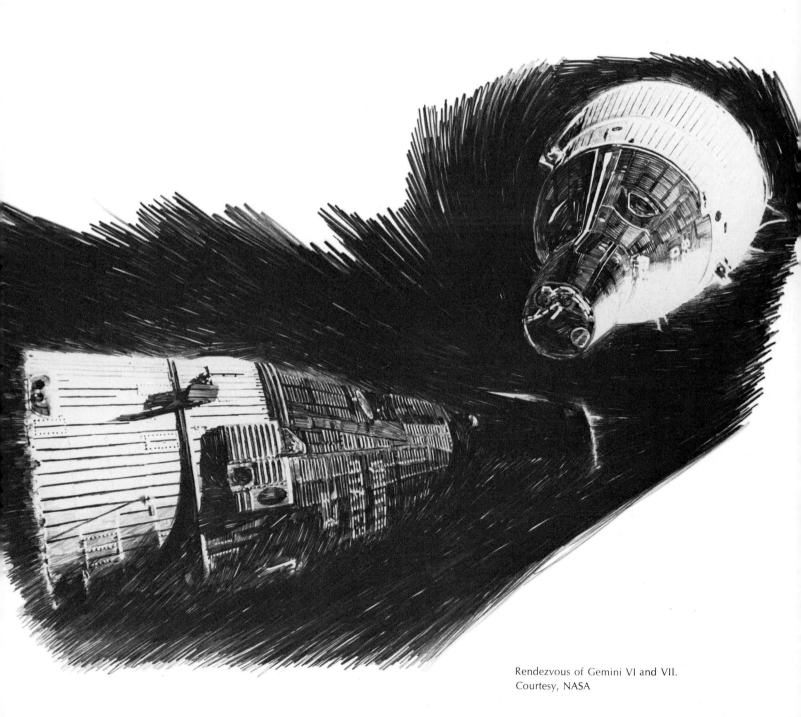

Rendezvous of Gemini VI and VII.
Courtesy, NASA

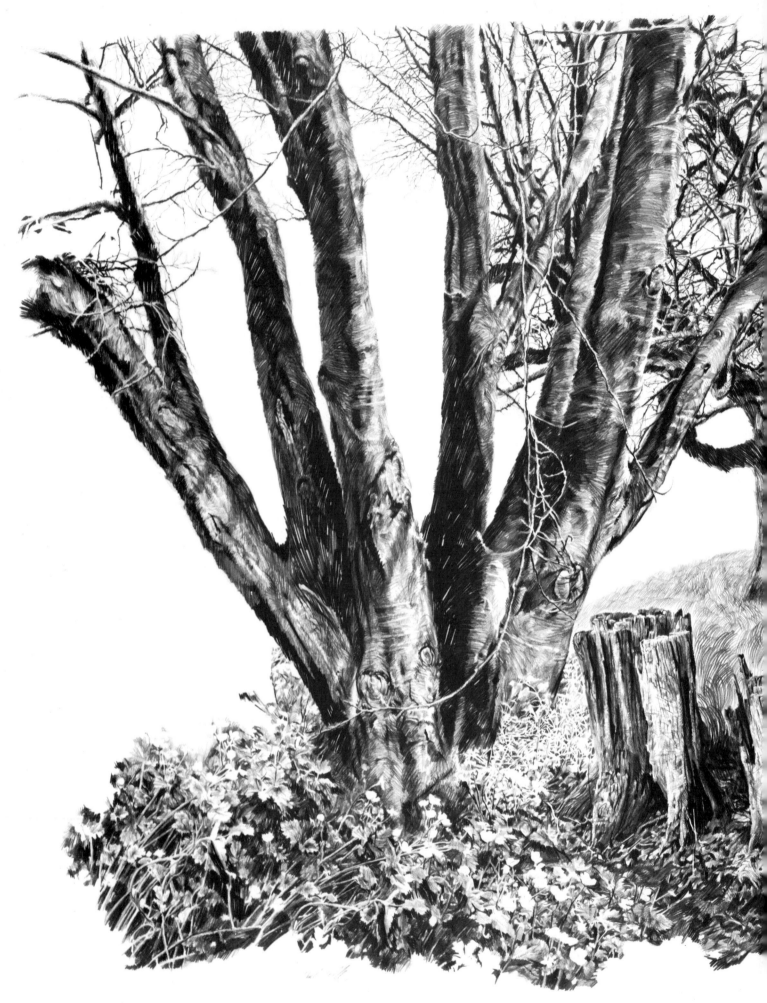

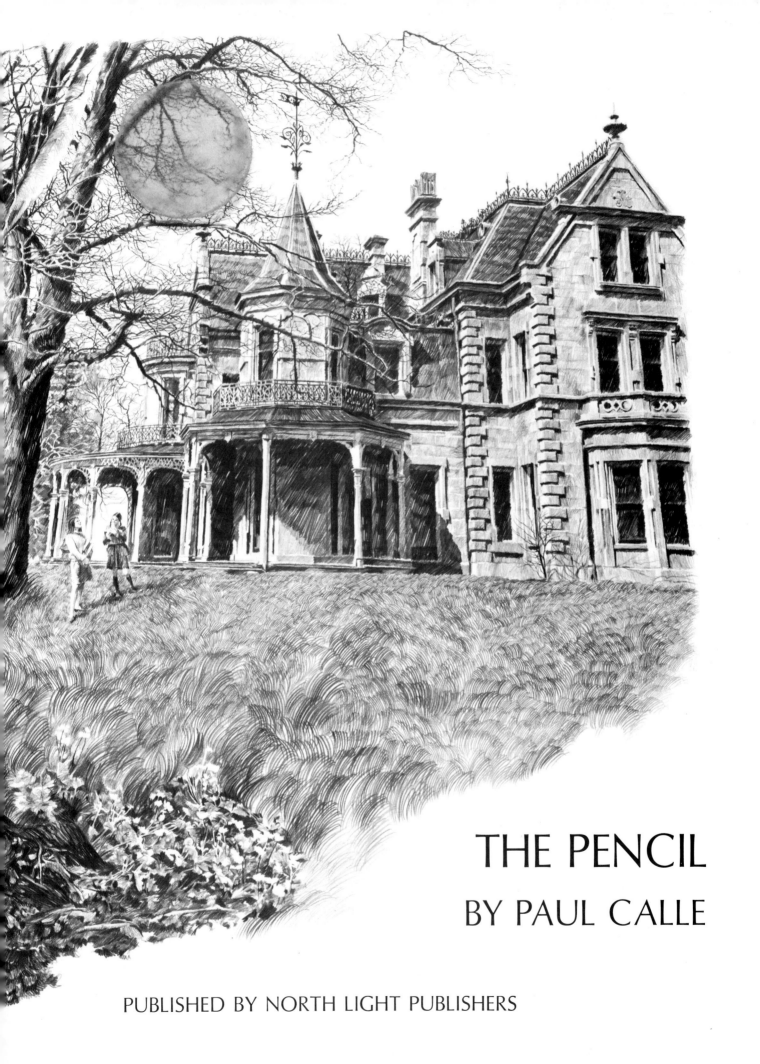

THE PENCIL

BY PAUL CALLE

PUBLISHED BY NORTH LIGHT PUBLISHERS

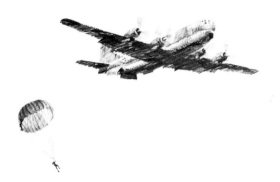

THIS BOOK IS DEDICATED
TO OLGA, WHO SHARES THE DREAMS AND THE
REALITIES...AND BELIEVES.

Published by NORTH LIGHT BOOKS, an imprint of
F&W Publications, Inc.
1507 Dana Ave., Cincinnati, Ohio 45207

Manufactured in U.S.A.

94 93 17 16 15

Library of Congress Catalog Card Number 74-83836
ISBN 0-89134-118-8

Edited by Walt Reed
Designed by Paul Calle

Alone, by PAUL CALLE
Courtesy, U. S. Air Force Art Collection

CONTENTS

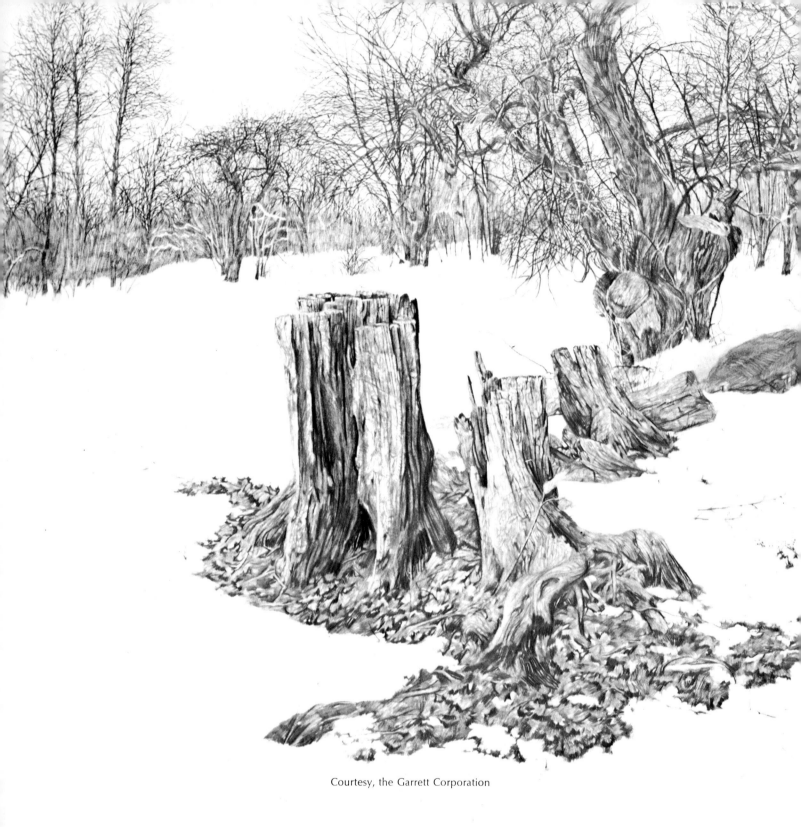

Courtesy, the Garrett Corporation

6

INTRODUCTION

For most working artists, the craft of drawing ranks high among the necessary professional qualifications. Almost invariably, the ability to draw is the first indication in art school of the student who will eventually "make it." For drawing is a tool that enables the artist to translate his ideas into form.

Yet the ability to draw is not given to anyone through inheritance. It must be learned, through constant practice. The artist's hand is the extension of his eye.

Traditionally, the artist has drawn with anything that would make a mark, from the charcoal remnants of a cave fire to the point of a diamond on glass. However, the graphite pencil has been one of the artist's favorite drawing tools since its invention several hundred years ago because it has the capability of representing a whole range of values from the darkest blacks to the lightest, most subtle grey tones.

I do not know of any contemporary artist who has attained greater mastery in the use of the pencil than the author of this book, Paul Calle. Most artists use the pencil only as a preliminary means to an end. Paul has explored it as a serious medium in itself. Because of this, he has sharpened his skills and exploited the possibilities of the pencil far beyond most of the rest of us.

As a member of the Stamp Advisory Committee, it has been a pleasure for me to assign work to Paul in his design of five U.S. postage stamps, some rendered entirely in pencil. Recently, several galleries have exhibited Paul's pencil drawings alongside the oils, acrylics and watercolors of other artists. The pencil technique has been given this importance because Paul has made it important.

It is to his great credit that in this book he has been willing to share the insights gained. They have been illuminating to me, as a professional, and can offer vital information for the student about how to see and how to draw, as well as how the pencil *can* be used as a versatile graphic tool.

Stevan Dohanos

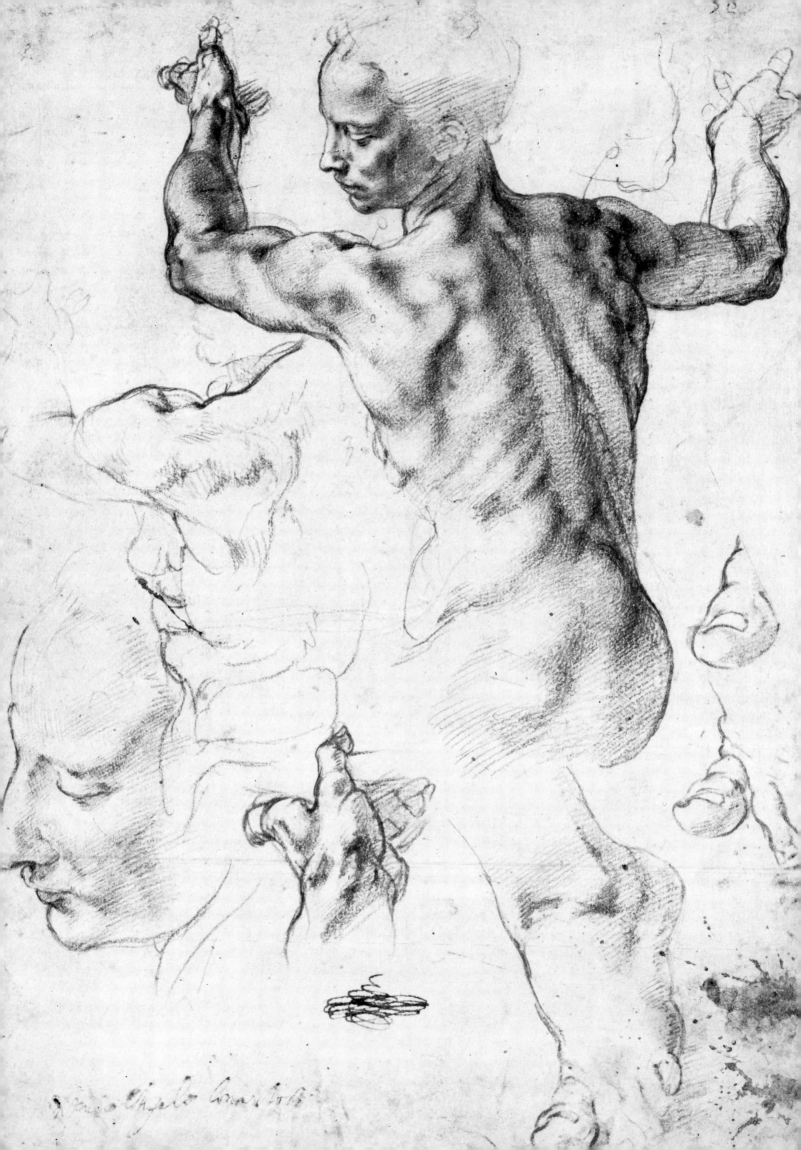

THE ART OF DRAWING

Imagine a scene in a cave during prehistoric times. A primitive man is seated before a fire. In the course of adding branches to the fire and stoking it with a fire-blackened stick, the man accidentally brushes it across the wall and discovers that the charred stick leaves a mark. Amazed, he finds that he can easily inscribe additional marks and symbols.

With the passage of time and the development of the brain and with the discipline of the hand, man learned that he could create images on the walls of his caves. He recorded pictures of various animals that roamed the land, men hunting, and events of everyday life with symbols and pictures long before the development of the written word. All were made in the beginning with that simple fire-blackened charcoal stick: the precursor of the pencil.

We have all watched with delight as a child scribbled on paper with a crayon or pencil — re-enacting the evolution of drawing in its own development. Although I have no memory of that first moment when I started my own "drawings," my parents told me it was quite early in my development, and I am conscious of drawing from the age of seven. I loved it and needed no urging. My parents and older brothers encouraged me and cheerfully provided the necessary materials; and, like the actor who grows up with stardust in his eyes, I grew up with graphite on my fingers. At that time, truly fine color reproductions were scarce and extremely expensive. Art books were for the most part in black and white, many illustrated with lithography, woodcuts, wood engravings, etchings and drawings. And there were numerous books available on the etchings and drawings of the old masters. In my youth, I devoured these prints — I studied them, copied them, even dreamed of them. I also spent long hours at the Metropolitan Museum of Art, the Frick Museum and the marvelous Morgan Library with its collection of illustrated manuscripts, drawings and prints.

Of all the artists, I was most impressed by the overwhelming power of the figure studies of that giant of the Renaissance, Michaelangelo. It's truly an awesome experience to contemplate his figure studies for the paintings of the Sistine Chapel. I never tire viewing his *Study for Adam* or the *Studies for the Libyan Sibyl*. In Adam, (page 16), notice how the pencil strokes follow the chest and rib cage, giving them form and volume.

MICHELANGELO (1475-1564)
Studies for the Libyan Sibyl
Red chalk on paper, 11⅜ x 8⅜"
The Metropolitan Museum of Art, Purchase, 1924,
 Joseph Pulitzer Bequest.

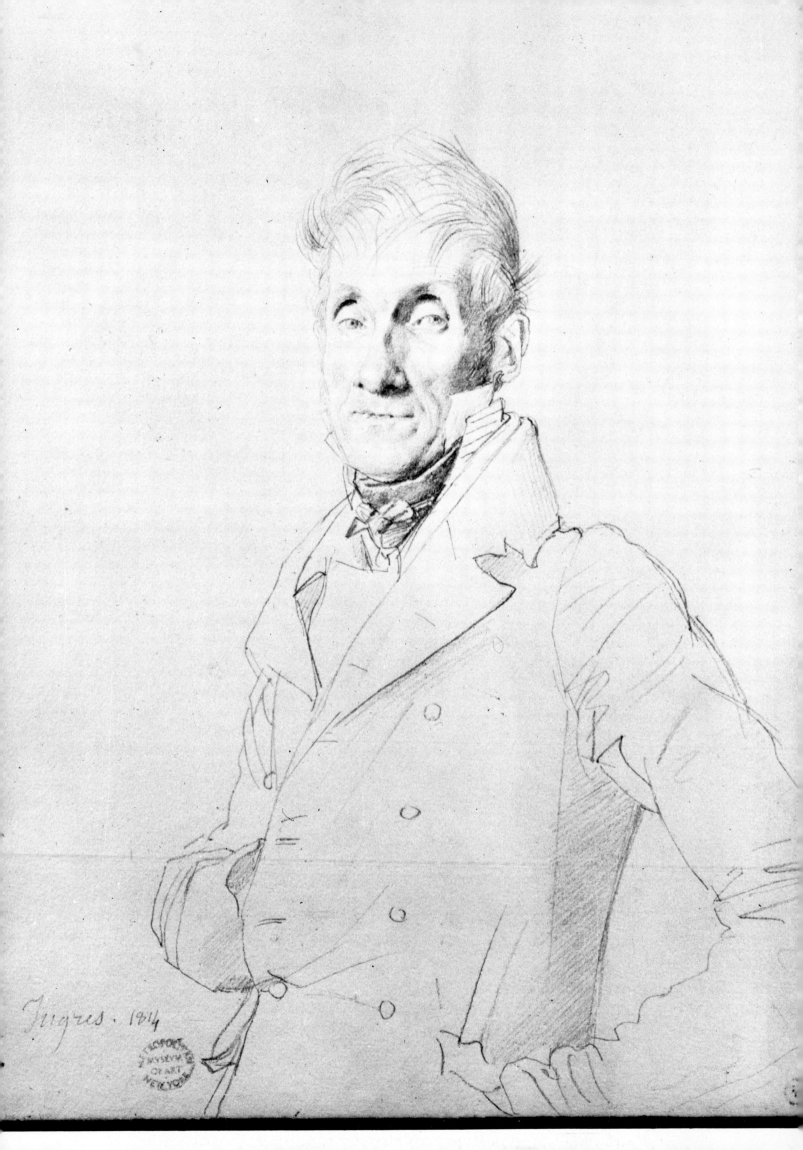

Ingres. 1814

Another Italian master was Guercino (Giovanni Francesco Barbieri). His pen and ink studies, when enlarged, are beautifully abstract in quality within their realism. Pen and ink, when handled in the manner of an artist such as Guercino, is a fluid technique enabling one to easily change the direction of the line and to move in and around one's subject. Guercino's employment of this directional pattern is masterful. One of the finest examples is his study for "*La Madonna, Sant' Anna e il Bambino* (below), which hangs in the British Museum. Let your eye follow the flow of the line from the figure on the right, moving behind the infant's head, picking up the directional flow in the bodice of the figure on the left. The change of direction of the skirt is readily apparent coming out from under the bodice, adding volume and solidity to the figure. The flow of the line on the back and sleeve of the woman holding the baby and the way the directional pattern is picked up on the baby are easily observed.

Now this abstract quality within the realistic drawing is an

In direct contrast to the surging power of Michaelangelo, observe the sensitivity and purity of the drawings of Ingres. In the beautiful, sensitively interpreted portrait of an unknown man, observe the softly defined head, the frugal and simple, yet assured, line that delineates the jacket — not a superfluous line anywhere.

JEAN AUGUSTE DOMINIQUE INGRES (1780-1867)
Portrait of an Unknown Man
Pencil on paper 8⅝ x 6⅜"
The Metropolitan Museum of Art, Rogers Fund, 1919.

GIOVANNI FRANCESCO BARBIERI, il GUERCINO (1591-1666)
La Madonna, Sant'Anna e il Bambino
By Permission of the Trustees of the British Museum.

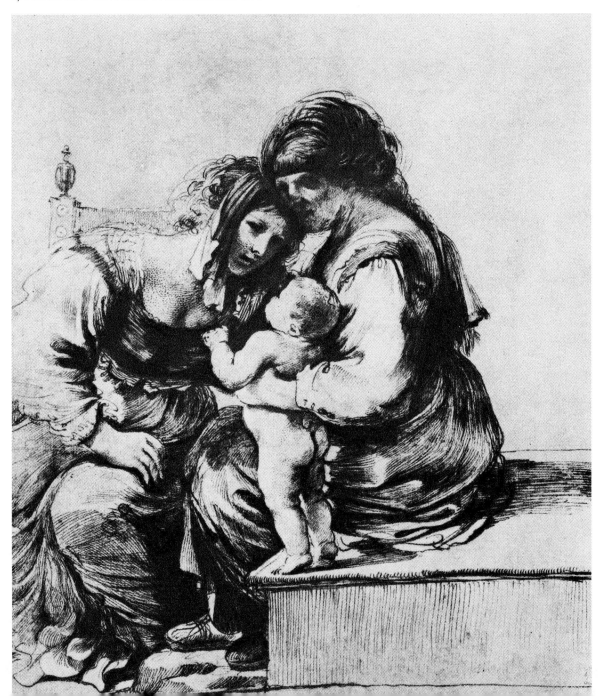

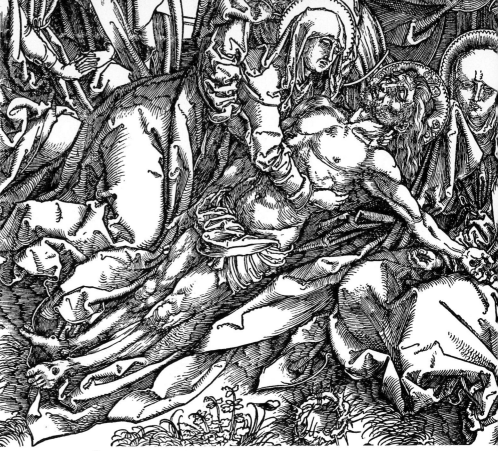

ALBRECHT DÜRER (1471-1528) *Lamentation for Christ, detail.*

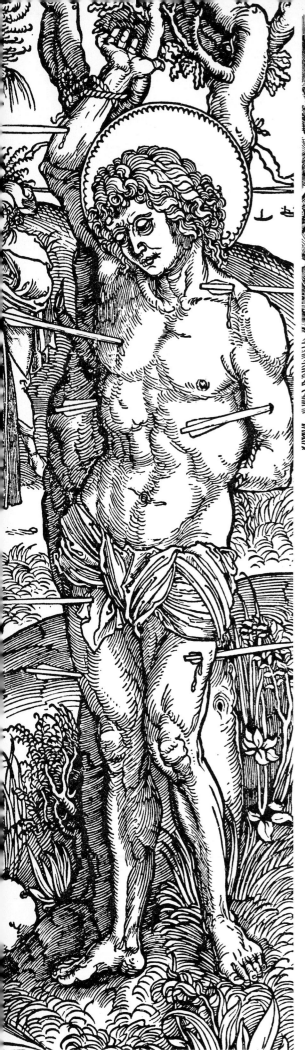

element that I have been utilizing in my work to a great degree in recent years. For while the impetus for drawing came from a desire to emulate the drawings of the old masters, you will find upon analyzing my work that the "technique" is more closely related to (and came about as a direct result of a rather extensive study of their pen and ink drawings) the etching process, and a study of wood engravings of the late 1800's and early 1900's. The basis of my pencil technique is that strokes follow the form of the object interpreted. In addition to the form, I attempt to give direction to the strokes to lead the viewer's eye within the composition.

Probably the most obvious examples of what I am alluding to are to be found in the work of the recognized master of the wood-cut technique, Albrecht Dürer. Due to the nature of the technique, the print obtained from the woodcut is clearly defined, and the pattern and direction of the line is easily understood.

A fine example is this print of the *Martyrdom of St. Sebastion* (left). It is obvious that Dürer, like Leonardo da Vinci, was a careful student of anatomy and knew the underlying structure of bone and muscle of the body. Notice the feeling of volume achieved in the figure of St. Sebastion — the pattern of the strokes on the thighs clearly delineates the vastus externus and internus muscles as well as the sartorius. You can almost feel the bone structure of the femur and tibia in the lower limb. Observe how the directions of the lines oppose each other in the two legs — opposing each other, yet giving volume to the mass, and direction to the stance of the figure. This feeling of direction that the pattern of strokes gives to the eye is more clearly understood in the upper torso. The obtained feeling of volume is quite apparent in the deltoid and external oblique and rectus abdominis areas and the pectoralis major. Now notice how the change in direction of the line in the chest area draws your eye toward the up-

ALBRECHT DÜRER (1471-1528)
Martyrdom of St. Sebastian, detail.

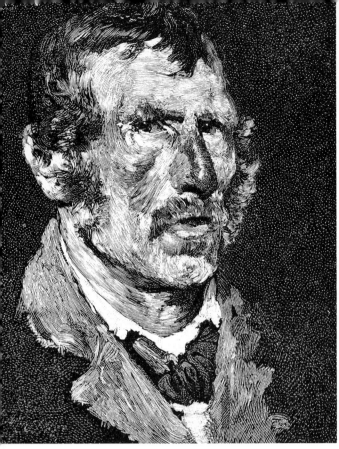 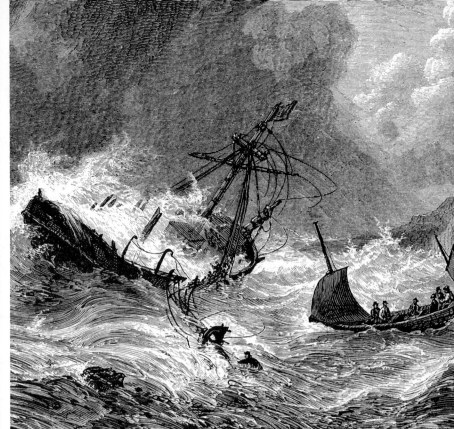

Study, by W. M. CHASE Wood engraving by JUENGLING W. W. MAY *Off Tantallon, detail.* Wood engraving by WHYMPER

raised arm bound to the tree limb. The direction of the strokes
all have meaning — to delineate, to create volume, to give
optical direction.

What was easily seen in the figure of St. Sebastion, is also
clearly evident in the rendition of the drapery in Dürer's
Lamentation for Christ. The pattern of the lines give volume to
the mass and direction to the folds of the drapery. And I must
say a beautiful abstract pattern is achieved within the realism.

Before the advent of photoengraving, a majority of tonal
illustrations in books and magazines were reproduced by means
of wood engravings, which translated the tones into black or white
areas. The areas which were to appear white were cut away;
those remaining received ink and printed black. The creation
of gray tones required very skillful planning and cutting away of
fine lines, creating patterns of black and white which the viewer's
eyes "read" as gray. At the same time, the lines had to express
the form of the subject itself. Wood engraving evolved to a highly
skilled art, and the engraver often signed his work as prominently
as the artist who created the original picture.

Probably wood engraving, more than any other technique,
had the most influence on the technical direction that my
drawings have eventually reached. An outstanding engraver of
the late 1800's named Juengling is the man whose work
influenced me the most. My knowledge of him is solely through
his masterful interpretations of the works of others. Some may
think of this as mere craftsmanship, but the way he could
interpret paintings, reducing the color to patterns or textures of
line is, to me, a form of creativity at its highest level.

Observe Juengling's engraving of a *Study* by William M. Chase.
Just look at the pattern of the strokes as it emanates from the
eye socket and swirls in and around the cheek bone — the
directional flow of the strokes leads you back to the eye. Once
again, the pattern changes, leading you downward, then across

13

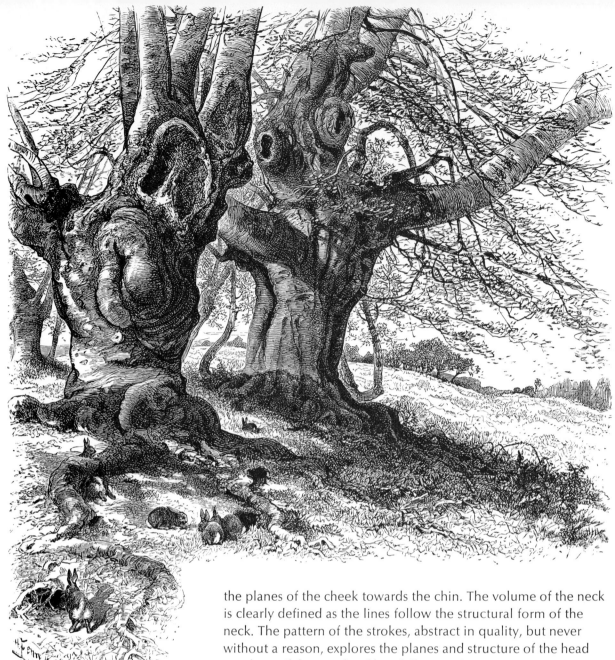

Burnham Beeches, by H. FENN

the planes of the cheek towards the chin. The volume of the neck is clearly defined as the lines follow the structural form of the neck. The pattern of the strokes, abstract in quality, but never without a reason, explores the planes and structure of the head — a beautiful example of line following form.

In the seascape, *Off Tantallon,* the directional pattern and form of the strokes are easily discerned and very apparent. They were engraved so as to add form and structure to the stormy sea. Your eyes literally roll with the waves.

It would be impossible for me to conclude this discussion of the engravings of the 1800's without an example of trees. For, as you go through this book, you'll see my love for drawing trees is obvious.

Once again, allow me to point out what by now you can easily see — that the pattern gives dimension — in this case to the massive trunks of *The Burnham Beech Trees.* The change in the direction accentuates the volume of the branches and defines the gnarled knots on the trunks.

The artists and engravers represented here never used "just lines" put there to delineate an area. Rather, they are drawn for a definite purpose, to give form and definition, convey volume, define planes, give movement and direction, articulate emotion. I feel that only one who has mastered a tradition has a right to attempt to add to it, or rebel against it, for it takes more than hands to draw — the eyes and hands are merely extensions of the mind, and the mind must contain a wealth of knowledge, convictions, experience and emotion.

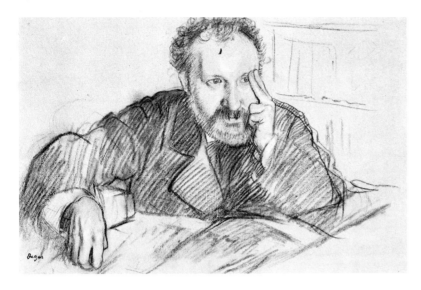

Degas was a master draftsman whose love affair with drawing permeated his entire life. He is equally at ease in his study of a dancer adjusting her slipper and his portrait of Duranty. In his study for the portrait, the bold strokes on the jacket serve as a beautiful counterpart to the sensitive strokes on the face and hands. Degas was a master, never to be equalled.

EDGAR DEGAS (1834-1917)
Portrait of Emile Duranty
Charcoal and white chalk 12⅛ x 18⅝"
The Metropolitan Museum of Art, Rogers Fund, 1918.

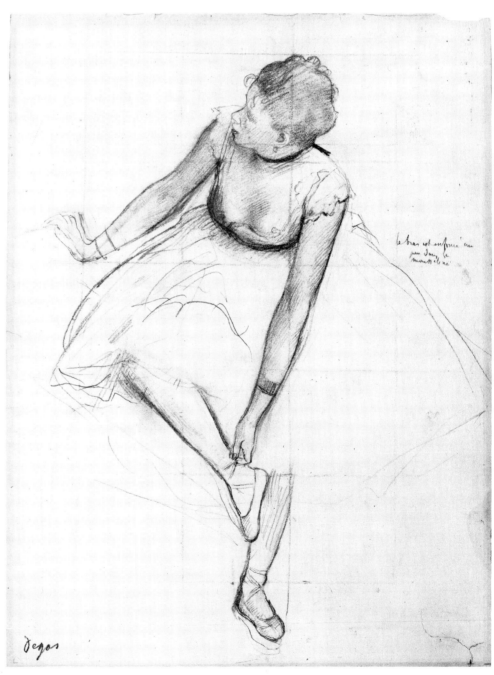

EDGAR DEGAS (1834-1917)
Dancer Adjusting her Slipper
Pencil and charcoal on faded pink paper, heightened with white chalk.
The Metropolitan Museum of Art, Bequest of Mrs. H. O. Havemeyer, 1929,
 The H. O. Havemeyer Collection.

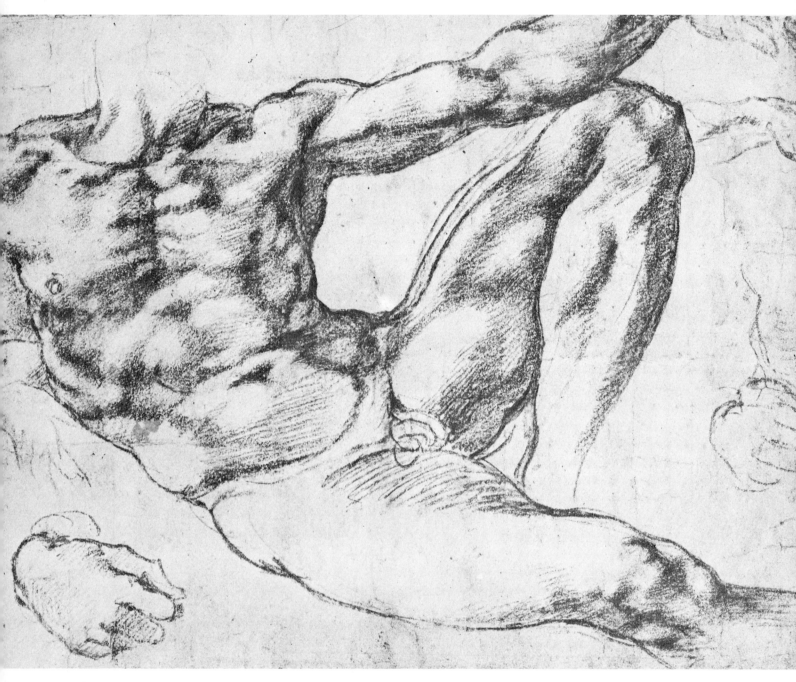

MICHELANGELO (1475-1564)
Study for Adam in the Sistine Chapel
By Permission of the Trustees of the British Museum.

HISTORY OF THE PENCIL

The pencil is such an accepted part of our lives that few people realize it is a relatively recent invention.

Most drawings of the old masters were made not with a pencil, but with a natural red chalk, or with ink applied with a reed or quill pen or brush.

The word pencil is derived from the Latin "pencillus," meaning "little tail," to describe a small brush which was used for lettering by the Romans. Although both the Greeks and Romans knew that the metal lead would make a mark, they employed it chiefly in the form of a small thin disk called a "plumbum" (Latin for lead) for ruling guide lines on papyrus to keep their lettering even.

Later the lead was formed into a rod and encased in a wood shaft to become the first lead pencil, but the metallic lead did not write well and was not the "lead" used in today's pencils.

The birth of the modern pencil can be traced to a storm in Elizabethan England when a tree blew down near Borrowdale in 1564, exposing a deposit of graphite or black carbon in a pure, solid form. It was discovered that the substance could be used to make a unique, black, writing implement. Because the science of chemistry was unknown, the new material was called, "plumbago," meaning "that which acts like lead."

At first, the graphite was used in small chunks wrapped in string to keep fingers clean; later the pieces were held in a metal holder called a port-crayon. These graphite marking stones were sold on the streets of London by hawkers who used to cry their wares. The doggerel rhyme of one of these venders still exists:

"Buy marking stones, marking stones buy
Much profit in their use doth lie;
I've marking stones of colors red,
Passing good, or else black lead."

Because the supply was so limited, mining was restricted to six weeks every seven years. The ore was shipped to London and sold at auction. Even with these restrictions, however, the graphite (which was also used for casting cannon balls) was soon worked out. Another graphite mine, less pure, had also been discovered in Bavaria and graphite was in fact plentiful in an impure state.

Courtesy, Berol Corporation

Small brush "pencillus" or "little tail" used by the Romans for lettering.

Disk made of lead. The ancient Greeks and Romans used this to rule
guide lines on papyrus to keep the lettering even.

Writing rod of thin lead encased in a wood shaft, used in the 14th century.

But the graphite was reduced to a powder in the refining process, and some means of binding the powder into a solid form had to be developed. The Germans used a mixture of graphite, sulfur, and antimony to produce a "white lead stick" in competing with the English pencil.

Under the impetus of Napoleon, who was cut off from both German and English graphite, a young inventor named Nicholas Jacques Conté developed an improved formula. He combined powdered graphite with powdered clay and fired the mixture in a kiln, like pottery. Not only did this produce a serviceable lead, but the degree of hardness or softness could be controlled by varying the proportions of the clay and graphite. This new method spread and became universally adopted.

By this time, chemists had identified plumbago to be a form of carbon, not lead, and the name "graphite" was created for it, from the Greek word, "graph", for writing. Gradual refinements in the grinding and mixing of clay and graphite have been continuously made since.

Modern pencil making is a sophisticated process beginning with a lengthy grinding of the refined graphite and clay into particles so small that they remain suspended in water like a colloid. When the particles have been uniformly mixed and homogenized in a water vehicle, the water is removed and the resulting dough is squeezed in a huge hydraulic press which applies pressure of over 60 tons per square inch. The mixture is forced through a diamond die at the bottom of the cylinder at the diameter of the finished lead. This string of lead is cut into segments and subjected to white heat which vitrifies the lead into a solid structure. After being given a wax coating the leads are ready to be joined to the wood casing.

This process is carried out in five successive stages. First, a wood slat, wide enough for several leads, is milled with grooves. Glue is applied to the grooves. Second, the leads are placed in the grooves. Third, a duplicate slat, grooved and glued in the same way, is placed on top, put under pressure and the "sandwich" is allowed to dry. Fourth, the glued block is shaped and divided by a machine into individual pencils. Fifth, these pencils are sanded, varnished or lacquered, stamped with the brand name and degree or hardness of lead and they are finished.

If all this gives you a new respect for pencils, fine!
You are now ready to put them to work.

Solid graphite ore, wrapped with string, was the first graphite pencil.

"Port-crayon," metal holder for graphite, used in the 18th century.

In early pencils the graphite was sawed into a square shape and encased in wood.

Courtesy, Eberhard Faber

STEPS IN MODERN PENCIL MANUFACTURE

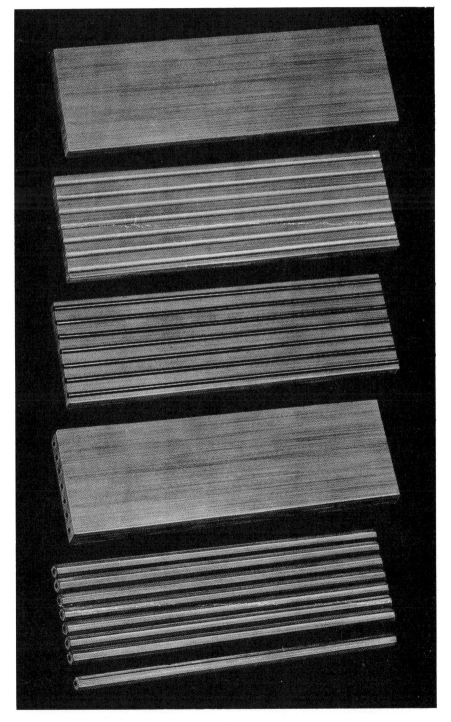

Single pencil slat, of straight grained cedar, one-half the thickness of a pencil.

Slat is grooved in parallel lines; glue is applied in grooves.

A lead is laid into each groove.

A second grooved and glued slat is placed on top, forming a sandwich, and held under pressure until the glue dries.

Shaping machines cut the sandwich into individual pencils. The pencils are then given a protective coating of paint and stamped with brand name and degree of lead.

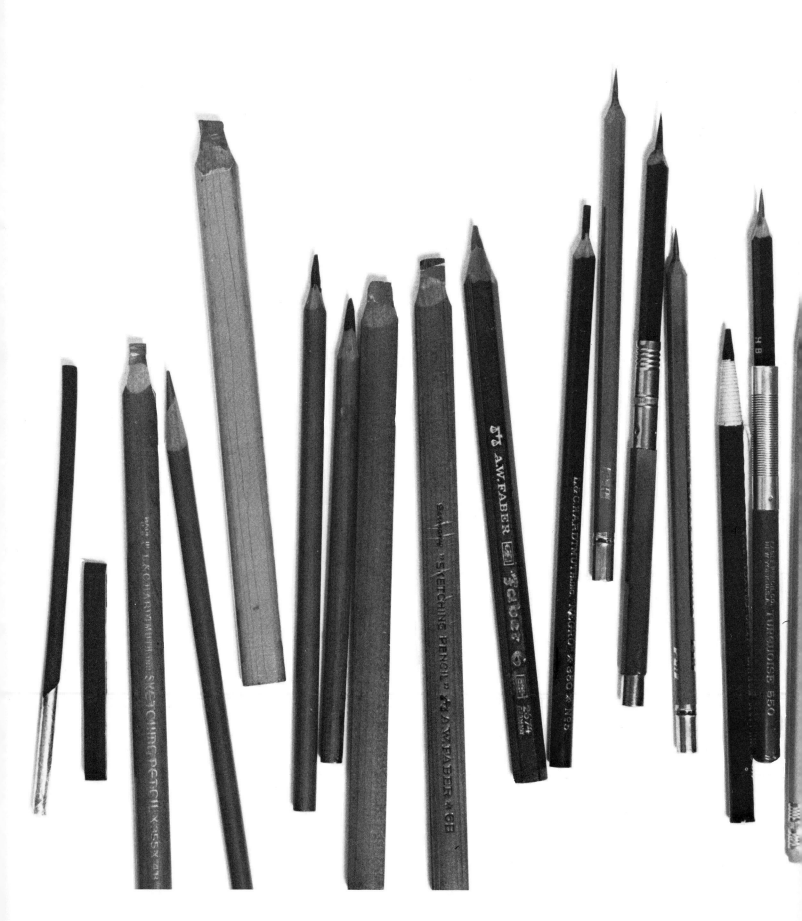

CHAPTER 1
MATERIALS

PENCILS

Pencils come in a wide variety of brand names and in the degrees of softness and hardness of the graphite. The leads range from an extremely hard 9H to a very soft 6B grade. I have also found that the graphite itself varies from manufacturer to manufacturer. An HB pencil made by one company is very different from the same designated HB pencil produced by another company. Only through much experimentation will you be able to find that with which you are most comfortable.

I prefer an HB pencil for most of my work, but occasionally use a 2H or 4H lead for the lighter areas. However, this is my personal preference and should not deter you from trying a whole range of pencils until you find those which are best suited to your own temperament. Naturally, the softer the pencil, the darker the tone.

In addition to the above-mentioned round-leaded forms, there is a varied assortment of other drawing pencils. There are the sketching and carpenter pencils with flat leads that many artists favor. These pencils, too, come in a variety of leads ranging from the very soft 6B to the harder H's. Graphite can also be obtained in round or flat sticks.

Then there are carbon pencils and charcoal pencils that many people prefer for their blacker blacks. Also, there are Conté pencils and Lithograph pencils. Although I personally no longer use them in my current work, I have used all kinds at one time or another.

Traditionally, several pencils have been recommended for doing studies . . . a 5B or 6B for the dark areas; HB for middle value areas and a 2H or 4H for the more finely detailed, lighter areas. I have found that I can get the same range of value and texture by employing just one or, at the most, two pencils. I can go from very dark to quite fine light detail with the HB. Only if I want to put things into the distance and still have great detail in them, will I then use a 2H or 4H pencil. Rather than changing pencils, I vary the pressure that I exert upon the point. Applying slight pressure will produce fine light lines whereas heavy pressure will produce thicker, blacker strokes in the areas you desire them. Combine this pressure change with all the variety of pencil leads, and you can see the tremendous range of values that pencil drawing offers you.

HB pencil on Bristol board plate finish surface (smooth).

Same stroke on Bristol board kid finish surface (slightly rough).

HB pencil stroke on linen texture paper.

HB pencil on a Cameo surface paper. Razor blade utilized to etch into surface.

HB pencil on scratchboard surface. Razor blade etched into surface.

One of many Coquille board texture surfaces.

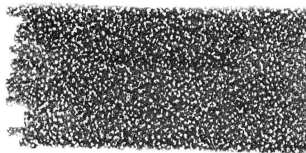

HB pencil on eggshell mat board.

PAPERS

Papers, like pencils, are made in an endless variety of sizes, weights and finishes. They come in sheet form, in pads, and mounted on cardboard backing as illustration board. The paper comes labeled for specific usage. Kid finish Bristol board is designed for pencil drawing, plate finish papers for pen and ink, watercolor paper for watercolors, hot pressed illustration board — smooth, and cold pressed illustration board — rough, are multi-media surfaces. You can get information from your local art supply dealer as to a specific manufacturer's brand name. You will also get advice from friends who may favor this paper and that finish. However, again, we come to the fact that what surface is most comfortable to one is not necessarily right for another. Only through personal experimentation will you arrive at the combination of paper, surface and pencils that is most desirable for you. I can only tell you what works for me.

At this stage of my artistic career, I have narrowed my paper down to three surfaces. On occasion, I use the kid finish Bristol board traditionally recommended for pencil drawings. However, the plate finish Bristol board recommended for pen and ink drawings is my favorite surface, and I use it most often for pencil drawings, both in my commercial and fine art commissions. And, on many occasions, I find that satin finish watercolor paper is an appropriate surface to work on. Again, you will find differences in papers made by the various manufacturers, and a product labeled kid finish Bristol board or plate finish Bristol board will vary considerably from company to company. While there are many other good papers on the market, I prefer the Strathmore or Grumbacher 4-ply kid finish or plate finish Bristol boards and D'Arches Satiné 180 lb. watercolor paper to all others.

I never make pencil drawings on illustration boards although many artists are very partial to these boards, which also come in a variety of surfaces. Some of the rough surfaced papers are effectively used by artists, as well as Coquille boards and eggshell mat boards. There are textured papers that are very effective when employed with imagination. Grumbacher produces a Cameo paper that takes a pencil stroke effectively with the added dimension in its surface, providing one with the ability to etch out or into areas with a knife or razor edge producing a very interesting effect.

One should always remember that the proper paper employed is as much a tool as the pencil. I encourage you to experiment and discover.

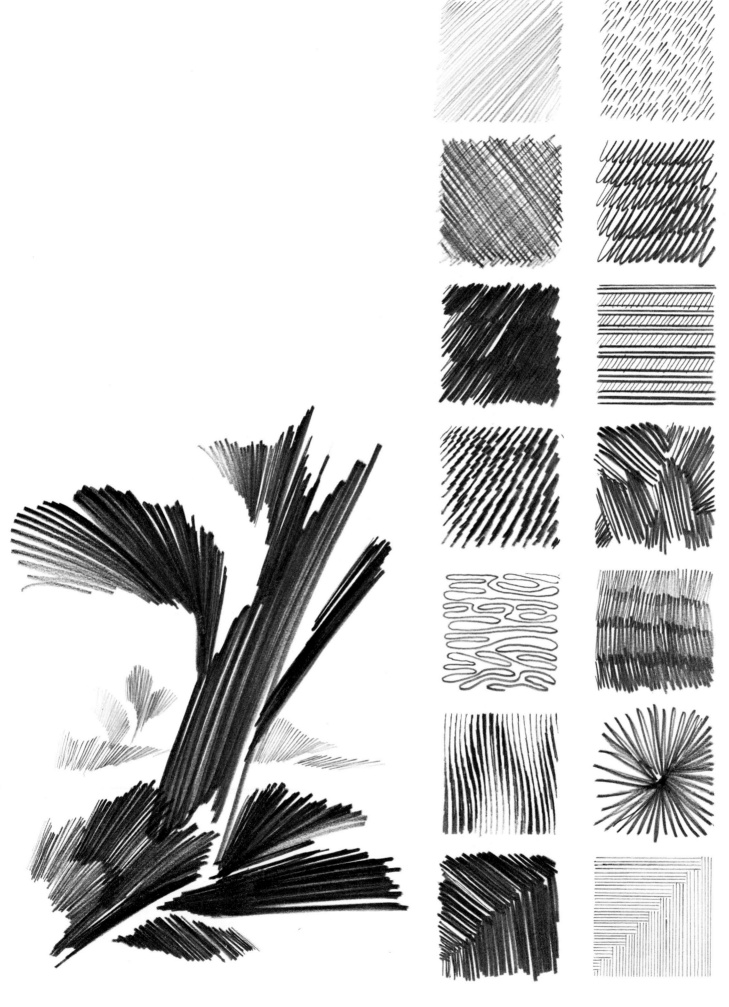

VALUES AND TEXTURES

Closely related to paper surfaces and the natural variety of strokes produced by them are the multitude of strokes which can be devised to indicate textures of various objects, such as grass, stone, leaves, water, etc. These are limited only by the creativity of the artist and their appropriateness to the subject being depicted.

To the left, I have demonstrated only a few of the limitless possibilities. I personally minimize them, but some artists make extensive use of such textural strokes. It is up to the reader to be governed by his own requirements.

While the painter, who has a palette with a complete spectrum of color, is aware of the importance of the value relationships in his work, the etcher or the graphic artist with his limited palette of black and white more acutely realizes and fully appreciates the importance of tonal relationships. The artist who chooses to express himself by a black and white pencil drawing, whether as a preliminary to a painting or as a finished piece of work in itself, is intimately concerned with the control of those value relationships in his composition. The successful exploitation and control of values can set and control the mood of the composition together with the rhythm and design patterns which I will describe later.

In addition to the variety of values and textures obtained by using different paper surfaces, various tonal effects are possible by utilizing different grades of pencils. The grade of pencil employed controls to a great degree the tonal range from the very black to light gray. You will never be able to achieve a dense black using a 9H pencil! A simple guide to remember is the H or hard lead pencils are best suited for the light tones and fine strokes, while the B series is best for the blackest values. 9H, the hardest graphite, produces the lightest grays while 6B, the softest, gives the deepest black. Further variations in tone and texture are achieved through the use of lines, dots, crosshatch and a variety of decorative patterns.

My basic pencil is an HB with a 2H used on occasion for background areas. I achieve my value differences by varying the pressure exerted upon the pencil and by controlling the thickness of the line. While this works for me, I urge you to experiment in order to find that which is most suited to your temperament.

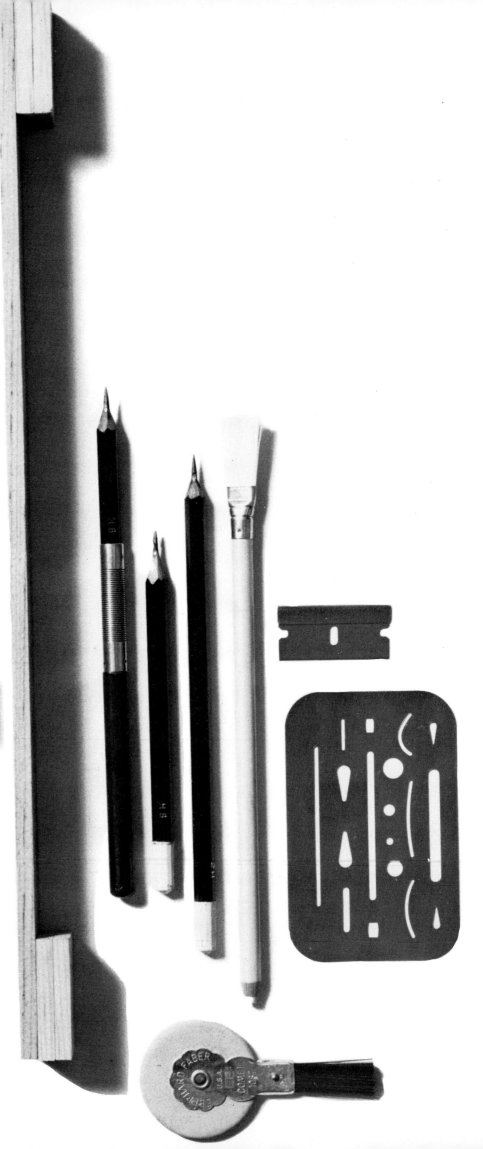

ERASERS AND ACCESSORIES

Erasers come in a variety of forms, textures and shapes. They run the gamut from the gritty sand erasers to the gum erasers. In the past, I used, and quickly abandoned, the gum eraser. There were too many eraser "crumbs" left on the drawing, and removing these crumbs would cause additional smears as I brushed them off the drawing. Through trial and error, I found that, for me, the kneaded eraser is an invaluable tool. It leaves no crumbs when erasing large areas and yet it can be kneaded into a variety of shapes and sizes. Kneading it into a very sharp point enables me to erase in small and difficult areas without destroying the surrounding drawing.

In very small and tightly confined areas, I find the employment of a masking shield to be an invaluable asset. It enables you to control the sweep of the erasure and protects and maintains the areas of the drawing you want to remain intact. The masking shield can be purchased at any well-equipped art supply or stationery store and should be part of your material supplies.

In areas where I have pressed particularly hard and deep into the paper, I find it very difficult to remove the blackness of the pencil stroke. The procedure for removing this unwanted area, or to change it, is to first rub off as much graphite as possible with the kneaded eraser. However, you will find it impossible to remove all the blackness of a heavy black stroke with the kneaded eraser alone. A gray area remains. With the aid of the masking shield, I then very carefully use a sand eraser, rubbing gently to avoid damaging the paper surface. When I remove the unwanted area, I then use a medium rubber eraser and finish off with my faithful companion, the kneaded eraser.

While working with pencil, great care must be taken not to smear the drawing. This can prove to be quite difficult because pencil drawings tend to smudge quite easily, especially when using the softer leads such as 2B, 4B and 6B. Keeping your paper clean is, of course, necessary and can be achieved by using a sheet of paper under your drawing hand and occasionally removing the pencil dust by blowing over the drawing.

I also employ a bridge enabling me to get at difficult areas. The bridge is constructed of a piece of wood 16 inches long, 1 inch wide by 1/4 inch thick mounted on 2 blocks 3/4 inch high attached on either end. This enables me to straddle a fairly wide area. By resting my drawing hand on top, I am able to get at the difficult areas without bringing my hand in contact with portions that are already penciled in.

FIXATIVES

Pencil drawings are very susceptible to accidental smearing and care should be taken to protect the finished rendering. This can be accomplished in several ways. The simplest procedure is to apply a coating of liquid fixative.

I place my drawing on my drawing table in an upright position. From a distance of approximately 16 inches from the surface of the pencil drawing, using a smooth side-to-side motion, I apply a thin coat of fixative from a spray can. Caution should be taken not to flood or over-spray an area since overspraying tends to bleed or slightly blur the pencil stroke. Because of the alcoholic content of the fixative, it dries extremely fast. I then apply a second smooth, thin spray-coating, and the finished drawing is protected against accidental smudging. Additionally, when delivering my drawing to clients or when storing them prior to shipment to my gallery, I take the added precaution of covering them with transparent acetate. This enables people to handle the work without fear of accidentally leaving oily fingerprints on the surface of the paper.

Fixatives in spray cans are produced by a number of companies and usually come in two finishes — either glossy or matte. Personally, I prefer the matte finish because when dry, the drawing retains its "pencil" character, whereas glossy is exactly that shiny. My preference is for the no-odor matte spray fixative.

Fixatives are also sold in bottles and are applied to the drawing by means of a mouth-operated atomizer. The fixative formula of alcohol and shellac is basically the same as in the pressurized cans and I can see no advantage in its use. The fact is that it is much easier to apply the desired even coat of protection with the pressurized cans.

While I do not agree, there are many artists who esthetically feel that fixative is harmful as a protective agent. They prefer to mat and frame their pictures immediately or protect them with a covering of transparent acetate or some other plastic sheeting. They obviously have never had an unfixed drawing delivered to an engraver or printer and then returned. It can be a disaster!

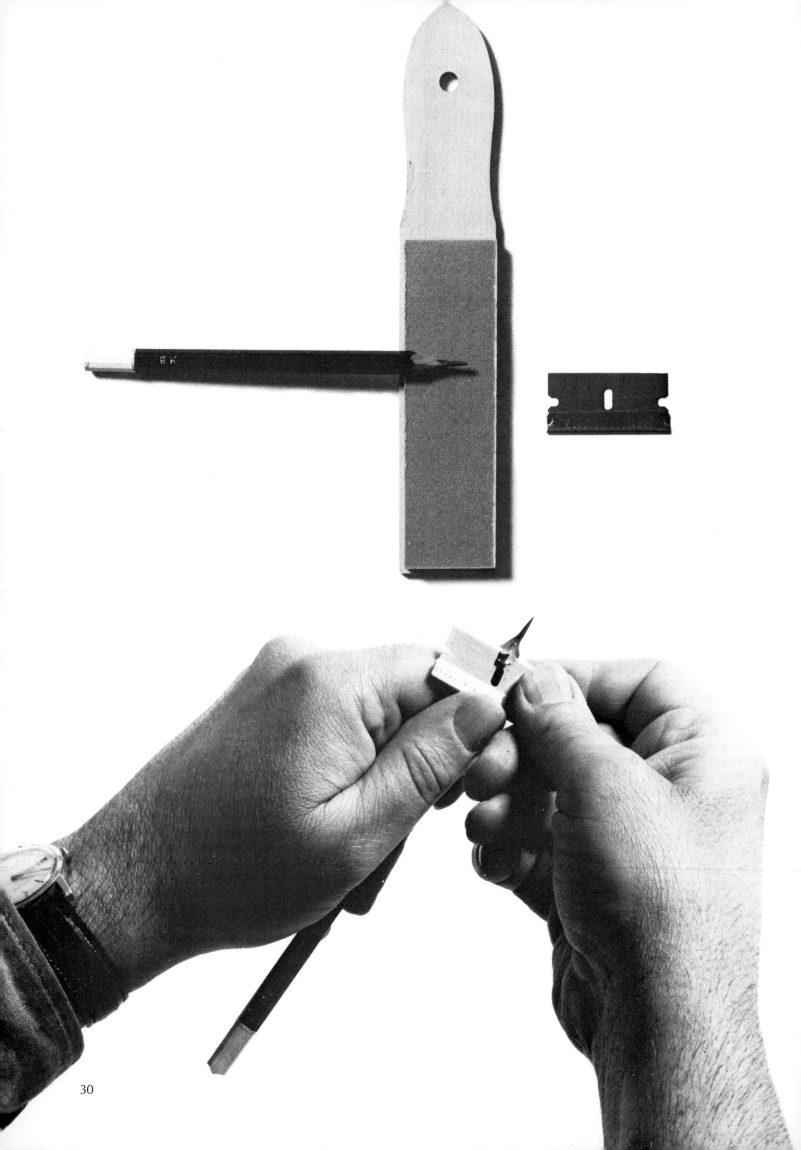

HOW TO SHARPEN A PENCIL

The sharpening of one's pencil is so personal that I hesitate to write about it!

In some books, I have read that the wood should be cut, removing 1 inch with a sharp knife exposing ¼ inch of graphite. The angle of the cut wood should be 12½ degrees. Avoid the long spear-like points because they break easily. Avoid the short points because they wear out rapidly all nonsense! I am sure that for every artist who breaks a long spear-like point, there is one who uses it to perfection. And there must exist an artist who makes good use of the short point while another finds it wears out quickly. I am unable to give you a foolproof formula. I can only describe what I find convenient and desirable based upon a period of trial and error. In the final analysis, sharpening pencils depends upon you.

It depends upon what angle YOU hold the pencil!

It depends upon what pressure YOU apply to the stroke!

It depends upon the hardness or softness of the graphite YOU choose!

Pencils can be sharpened with a mechanical sharpener operated either by hand or electrically. I have found them less than desirable because they are unable to provide me with a long or sharp enough point.

I have never found a knife with a blade thin enough or sharp enough to satisfactorily sharpen my pencils. I use a single-edge razor blade exclusively, removing about 3/4 of an inch of wood on a taper, leaving about 3/8 of an inch of graphite exposed. Although there are metal sand blocks available, I prefer sharpening the lead to its conical shape with a sandpaper block. The sandpaper blocks are available at any art supply store. When I have achieved the desired degree of sharpness, I remove all the excess graphite dust from the lead by wiping it off with a paper towel or soft cloth. While working, I always have several pencils sharpened, enabling me to continue uninterrupted for a period of time. This is important because it is frustrating to stop to sharpen a pencil just when the drawing is moving along.

While I use the conical shaped point exclusively in my work, there are many artists who employ a chisel point or broad stroke technique very effectively. A soft pencil is usually used, but once again, this should not rule out experimentation on your part. The sharpening procedure is the same as with a conical point except at the sanding stage. To achieve a conical, you roll the graphite around to acquire the point. To get the chisel, you hold the pencil at an angle, graphite against the sand block, then rub back and forth until a flat chisel or wedge-like point is achieved. Once again, use a soft cloth or paper towel to remove the excess graphite dust.

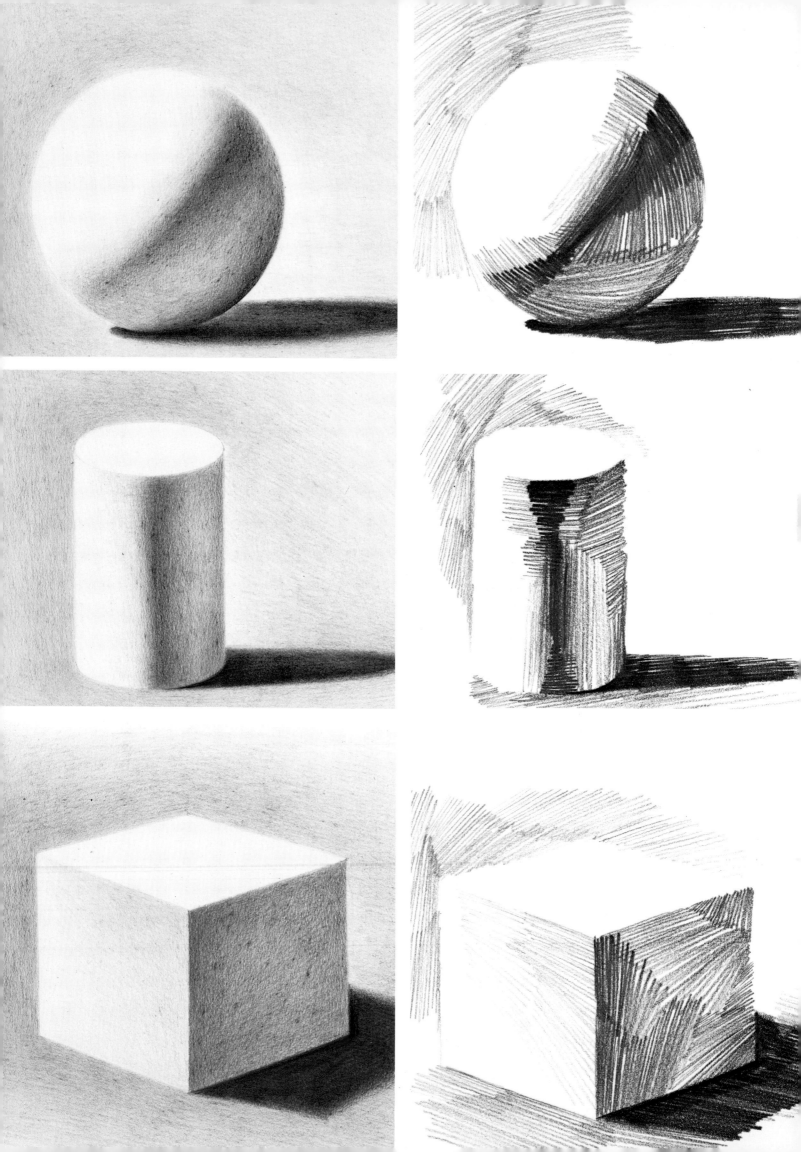

CHAPTER 2
FORM

By dictionary definition, "form is the structure and shape of anything." In order to best illustrate my pencil technique, let us investigate the rendering of a simple sphere. In the top figure, tones of the sphere are rendered in the traditional way with values ranging in intensity from light to dark. The graphite, with practice, can be smudged to produce a virtually photographic effect. The basis of my technique is an etching-like approach to drawing. Observe the same sphere. Notice that in my concentration on the tonal effect — the value scale from white to black — I use a series of lines. In the light value areas, the strokes are light and fine, in the middle value the strokes are firmer and heavier while the dark areas are bold, black and heavy. Notice also that the direction of the strokes tends to follow the form and shape of the sphere. It is not a photographic rendering of the sphere, rather it becomes an interpretation of the sphere employing a full value range made up of a variety of strokes of the pencil, a variety not only of values, but also in the thickness and length, giving form to the sphere.

Let us now add to our "pencil language" (and that is precisely what drawing is) another language form to express ourselves. Let us add to our sphere, a cylinder. Once again, observe how the utilization of the variety of pencil strokes not only gives volume to the form but gives it added substance. The rounded forms are chiseled and carved. The cylinder is virtually broken down and reduced into a series of planes that give it its form and dimension. The cylinder is not meticulously and photographically rendered; it is interpreted. And this is so important that it bears repeating, for it is the goal that I constantly aspire to. Even when I must work from a specific photograph, my objective is never to strive for a photographic rendering but to interpret, to add, to give it additional dimension.

We next enlarge our "vocabulary" with the addition of a cube. Again the careful, photographic rendition. And once again, an interpretation of the cube utilizing the variety in the tone and thickness of the strokes and emphasizing a strong directional quality to the lines.

With this investigation of these basic shapes — cube, cylinder, sphere — and understanding the concept of pencil drawing, I advocate we have the necessary ingredients to put the mastery of these basic shapes to practical rather than theoretical use. The spheres can become heads, character studies or portraits. Cylinders become hands, trees, and figures. Cubes and cylinders become ships, houses, landscapes.

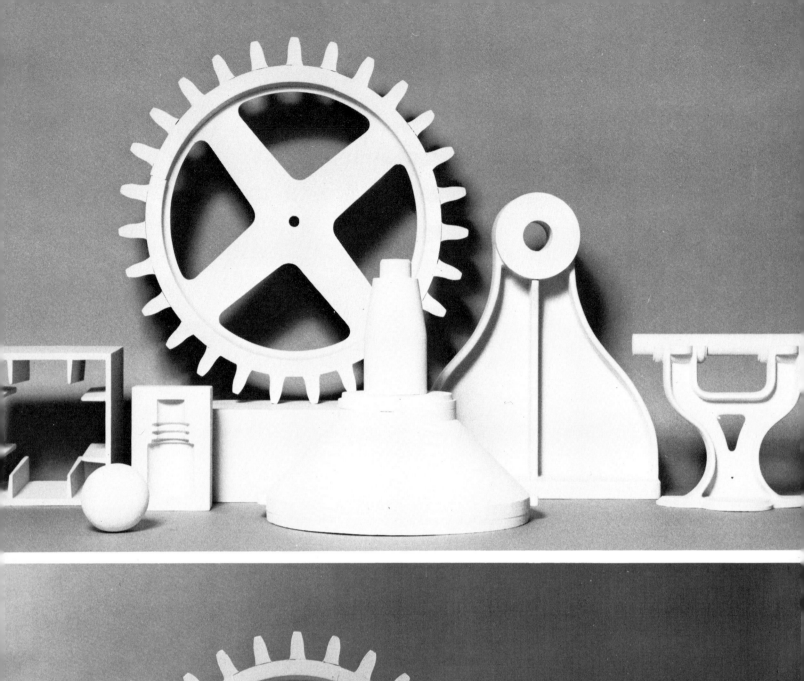

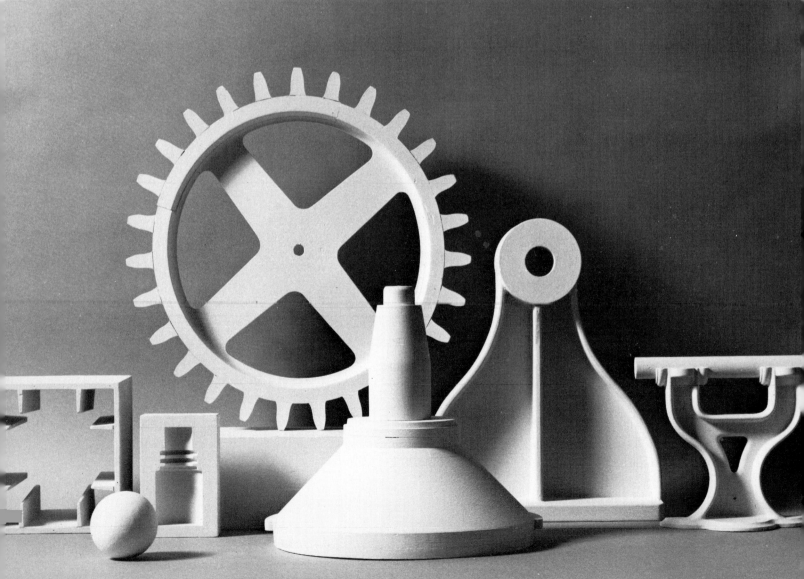

Here, I have taken an assorted group of mechanical forms
to use for a demonstration of the importance of lighting. Although
the positions of the objects are the same in both photos, the
direction of the light source has been changed.

As a general rule, lighting from right or left will bring out
the objects' forms better than a light source from the front or
directly behind the subjects which tends to flatten them
out. At times, top lighting or a strong light from below can
provide an effective variation.

In order to achieve clarity and depth, great care should be
exercised in lighting arrangements. The light source here is
relatively flat and, while the objects are illuminated, very little
impression of depth is achieved.

A strong light source coming from the left creates strong
patterns of light and shadow. Comparing the two photographs,
you can easily see the greater depth achieved in the latter.
It is very desirable to experiment with various light sources in the
planning stage of any picture.

The light source is coming from above and in front, creating relatively little shadow and a minimum amount of form.

The same intensity of light. However, this time it emanates from the left and slightly above, creating a strong structural form and depth.

The same light source, with the addition of a reflected light. This secondary source of reflected light can be quite effective in giving added volume to the object being portrayed. The additional light also gives some interesting edges to the structure, further delineating the form.

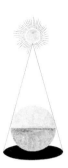

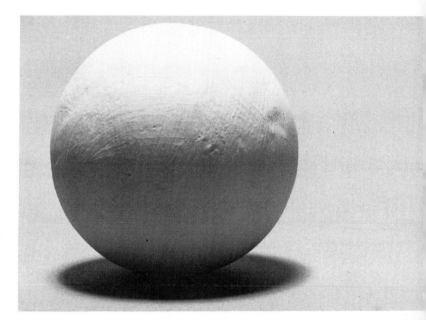

The higher the light source, the smaller the cast shadow. This is easily observed by viewing the landscape in the noonday sun. Additionally, the greater the intensity of the light source, the darker the shadows.

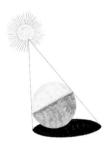

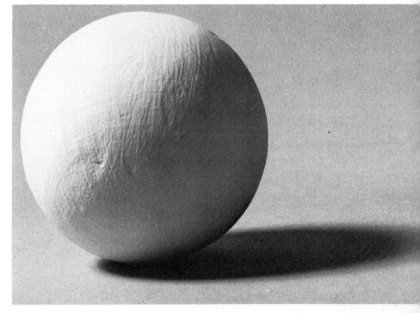

The shadow cast by a light source striking an object is always the darkest value. The shaded side is the middle value and, obviously, the lightest area is where the light strikes.

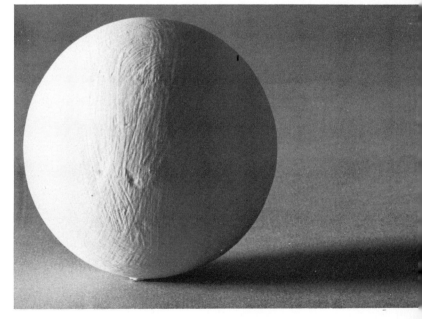

The lower the position of the light, the longer the shadow. Late in the day is a good time to view the long shadows. Because I find it the easiest way to control my value relationships, I invariably start my drawings with the darkest tones and work toward the light areas.

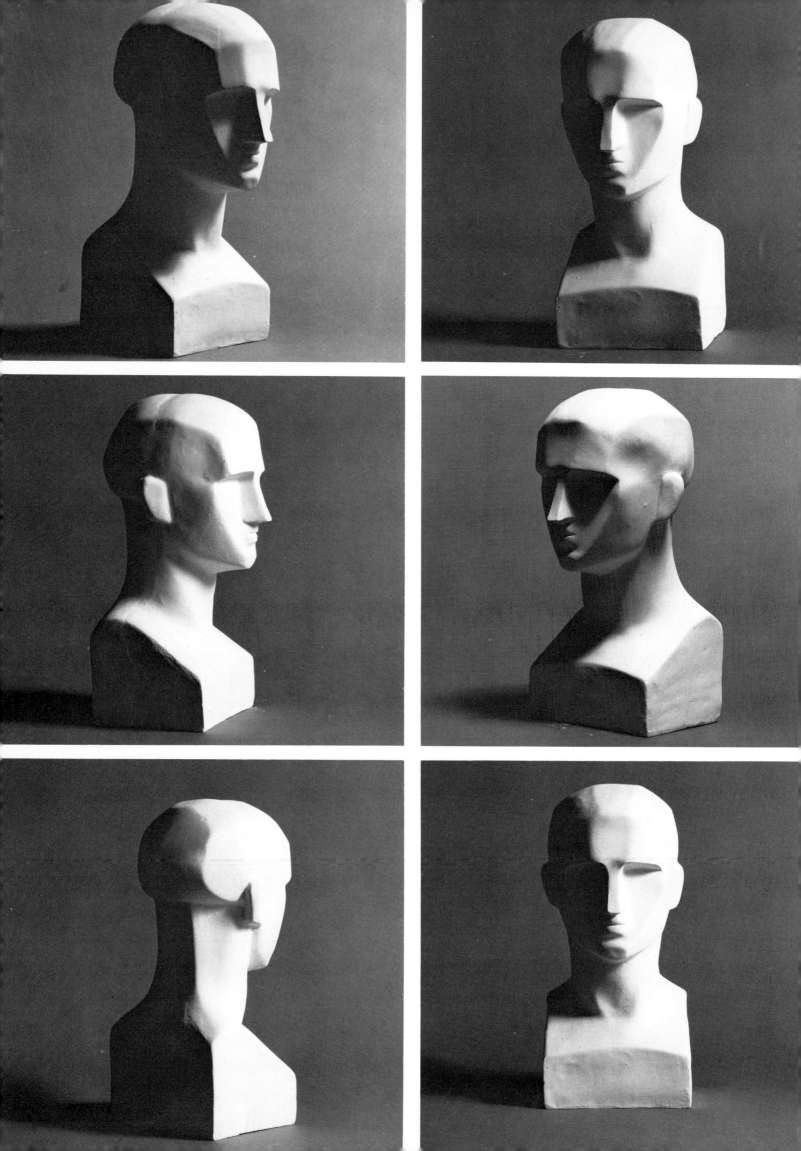

CHAPTER 3
DRAWING THE FIGURE

HEADS

Once you can understand this description of my approach to
drawing, it is an easy step to see how the same principles apply
to doing a portrait, a tree or a house . . . and I made the distinction
and place great emphasis on the word — *understand.* This
approach to drawing is the culmination of my experimentation
with pencils, paper, forms and patterns. To understand the basics
is the stepping-stone to achieving mastery. Hopefully, taking
the approaches I offer as examples that have worked for me,
mixed in with the sum total of your experiences, will result in your
personal style.

Heads are obviously rather complicated to draw. However, if
you think of them as a compound of many shapes and sub-shapes,
you will realize that you can draw any of the individual parts
by analyzing them carefully first.

You have already seen how to draw the major egg-shape of
the head, which is only a modified sphere.

This shape, in turn, is modified by a plane on the front,
containing the features, and planes on the two sides. These
planes can readily be seen when lighted from one side and
are similar to the planes of the cube.

The nose is also a simple form, similar to the cone with
slices removed from the two sides.

I stress this structural approach in your thinking about the
head because most beginners overlook these basics in their
preoccupation with drawing the features. This reverses the proper
order of the drawing process. Until the structure of the head
is established, and the lighting determined, the rather subtle
details of features, such as the placement of the eyes, the length
of the upper lip or the width of the nose will have no form
with which to relate.

Yet, once this basic groundwork has been laid, there is probably
no greater satisfaction than in the rendition of the characteristic
details that successfully represent an individual person.

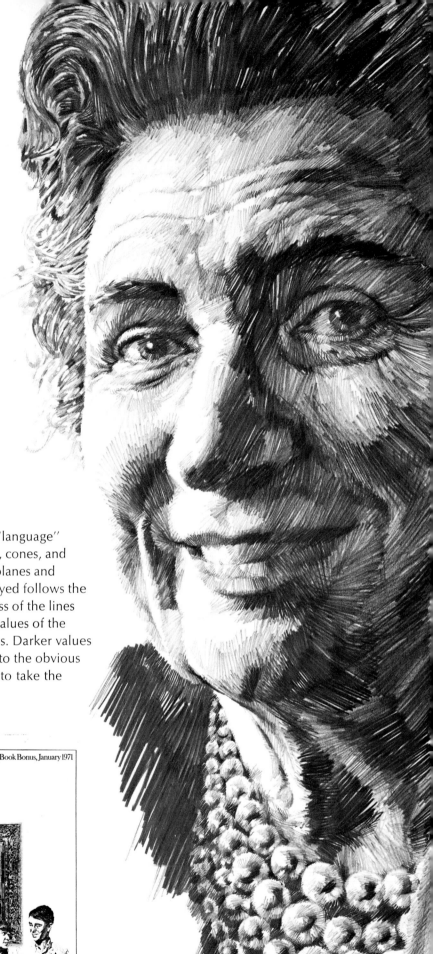

In considering this drawing, we can use the same "language" utilized in discussing the renditions of the spheres, cones, and cubes. The form of the head is broken down into planes and patterns. The direction of the linear strokes employed follows the form of the features, while the weight and thickness of the lines are in relationship to the light, medium and dark values of the head. The lighter the value, the thinner the strokes. Darker values have correspondingly heavier strokes. In addition to the obvious desire to create solidity, I further employ the line to take the viewer in, out, and around the features.

Courtesy, *Ladies Home Journal*

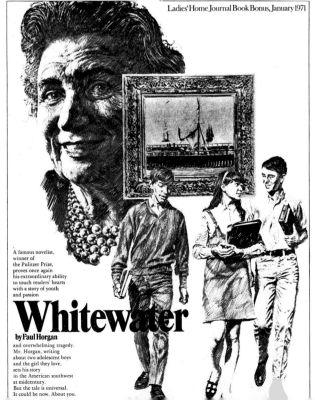

Ladies' Home Journal Book Bonus, January 1971

A famous novelist,
winner of
the Pulitzer Prize,
proves once again
his extraordinary ability
to touch readers' hearts
with a story of youth
and passion

Whitewater
by Paul Horgan

and overwhelming tragedy.
Mr. Horgan, writing
about two adolescent boys
and the girl they love,
sets his story
in the American southwest
at midcentury.
But the tale is universal.
It could be now. About you.

When a section of a drawing is greatly enlarged, you will find
that it can be quite abstract in feeling. This is accomplished within
specific areas and consciously used to create a certain flow to
the drawing rarely is it used for purely the abstract
quality itself.

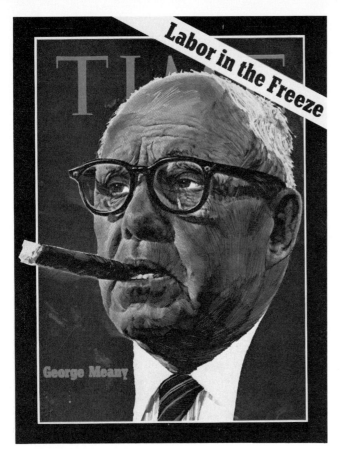

This George Meany "Labor in the Freeze" Time cover was fun to do and enabled me to depart somewhat from the black and white world of Paul Calle. After completing the basic pencil drawing, I had a number of photographic prints made of it on a semi-gloss paper the same size as the original art. With the use of transparent inks and dyes, I "painted" over the prints, making several color variations of the same basic pencil drawing. In addition, utilizing opaque acetate inks, I picked out some highlight areas. The original black and white drawing subsequently was used for newspaper ads.

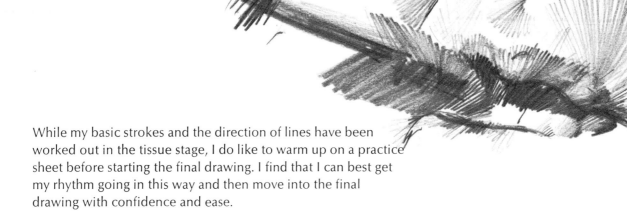

While my basic strokes and the direction of lines have been worked out in the tissue stage, I do like to warm up on a practice sheet before starting the final drawing. I find that I can best get my rhythm going in this way and then move into the final drawing with confidence and ease.

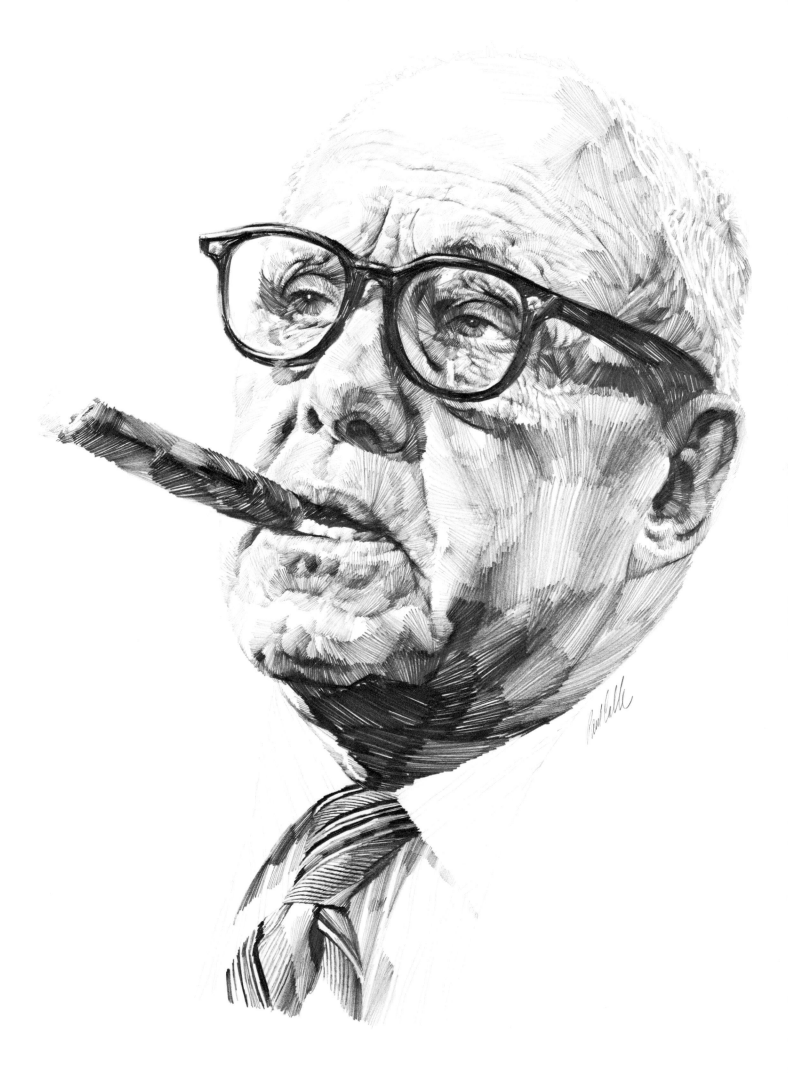

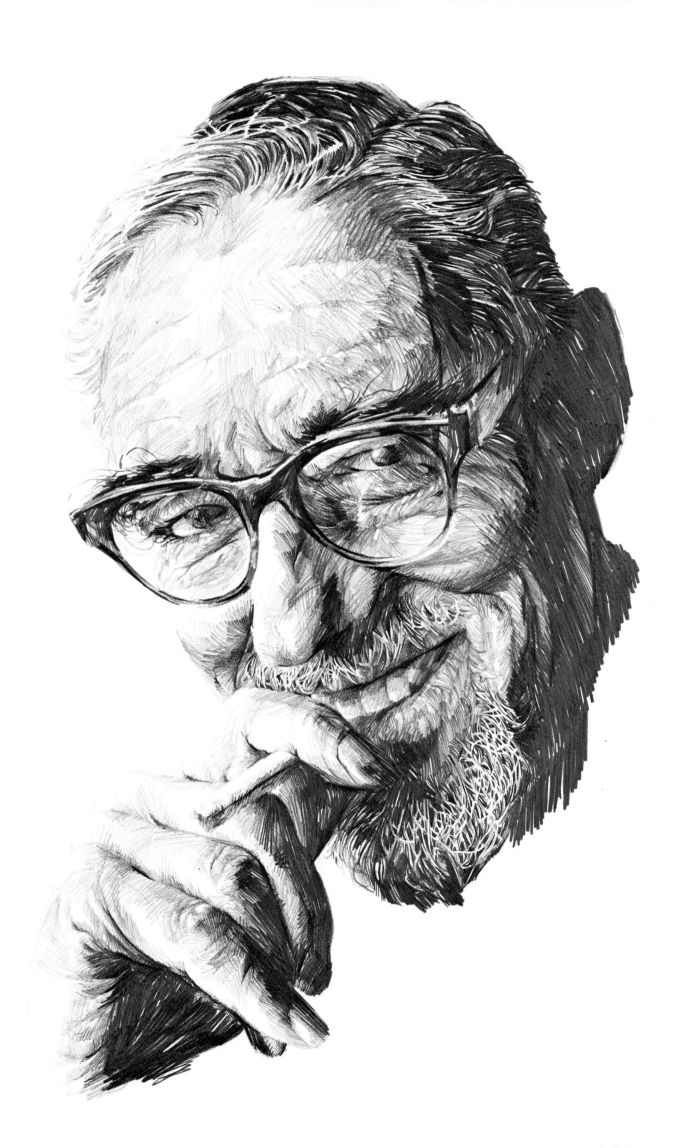

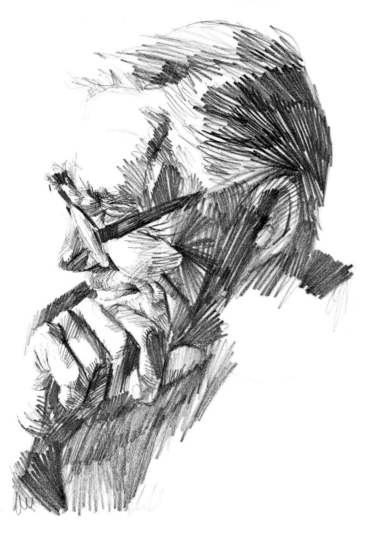

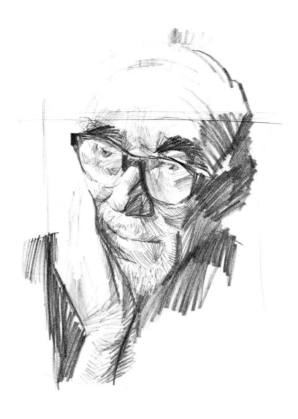

This portrait of the late Barye Phillips was drawn for the Presidents' Gallery at the New York Society of Illustrators. The rough sketches reproduced here are three of many quick studies I did while searching for the gesture that most personified him. You will note that while I was doing that, I was also thinking of solving the "inner problems" of this portrait study: the general form, the necessity for a strong vignette with the important positive effect of the white paper area, the middle grays, the blacks and the ever-important direction of all areas of line.

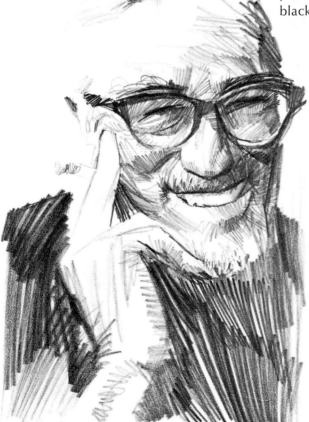

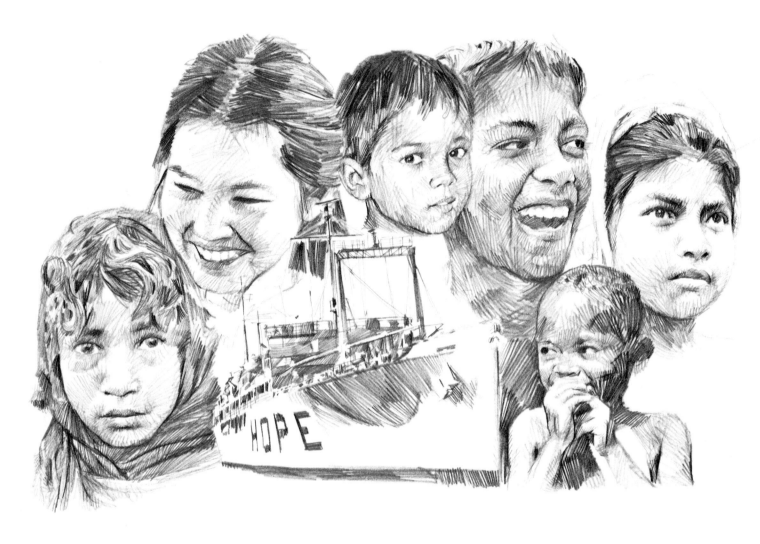

For every solution there obviously are many possibilities in terms of content and composition. My normal procedure is to make several "thinking" sketches for my own use and then to work up, in a more comprehensive form, one or more possibilities which I feel come closest to solving the problem. These are then presented to the client who makes the final determination. The sketches reproduced here were for a Project Hope Christmas Card and will give you some indication of the thoroughness of my comprehensive roughs.

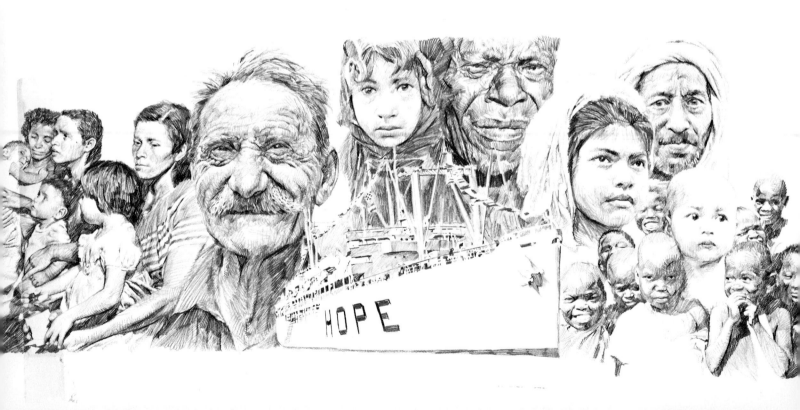

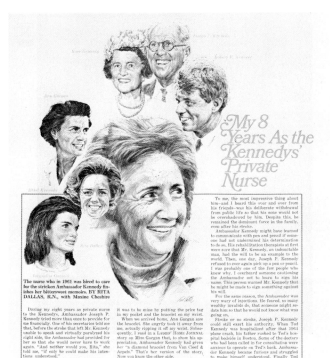

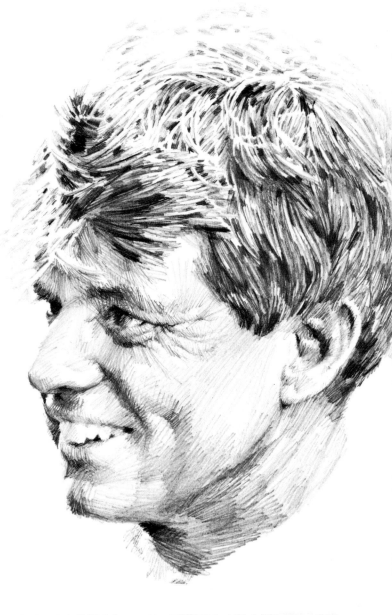

Courtesy, *Ladies Home Journal*

In working toward this montage composition,
I found it necessary to sketch the heads separately.
In some cases, two or more variations were tried.
By cutting them out and shifting them around,
I tried several combinations before coming up with
this solution. The head of Robert Kennedy reproduced
here is the same size as the original art.

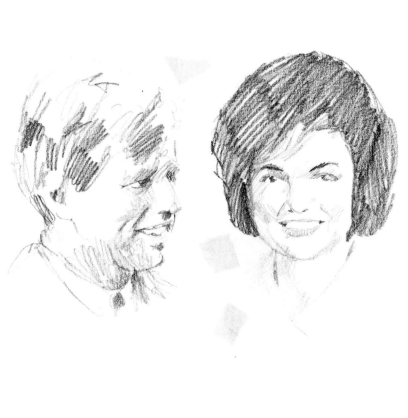

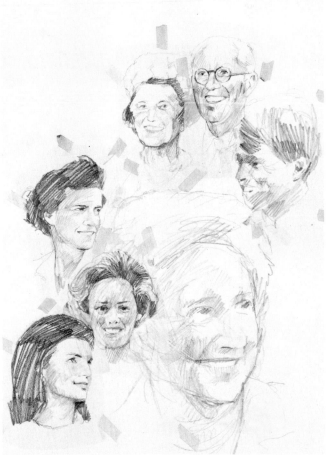

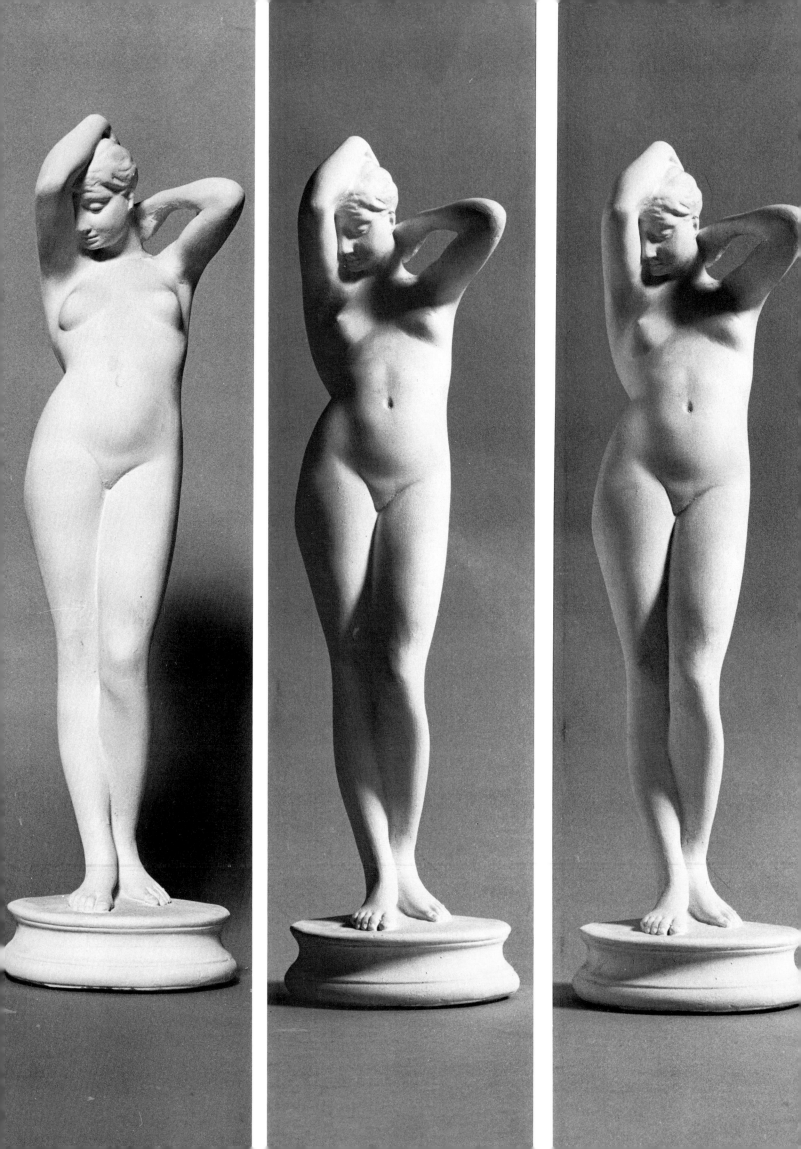

THE FIGURE

Draw from the human figure as much as possible. Only through repeated practice will you be able to understand the basic structure of the body.

As you draw, you will also be constantly forced to make visual measurements, comparing the length of an arm with the torso, the upper leg versus the lower leg, the width of the hips compared to the shoulders. Eventually, you will develop a mental gauge that will tell you when the arm is too long or whether you're making the entire figure too short.

You will also learn to adjust for foreshortening. As an arm goes back, for instance, it will look shorter and the wrist and hands appear smaller.

Drawing from casts is now considered somewhat old-fashioned, but it is a time-tested method developed in art schools over the past centuries and is also an excellent way to learn the proportions and construction of the figure. The three photos of the small statuette on the left illustrate the importance of lighting in posing a figure and how it can be employed to bring out the three-dimensional form of the model. Frontal lighting, on the left, is less effective than strong side lighting. A reflected light, on the right, reduces the density of the shadow areas shown in the center photo and serves to delineate the forms more clearly.

It is important to master drawing from life or from casts before you start working with photographs which can greatly distort the proportions. This drawing is the only method which will enable you to gain a visual understanding of the volume of the figure. When approaching figure drawing remember our discussion involving the basic cone, sphere and cube shapes. Think of the figure in terms of these shapes with their planes and value areas. Reduce it to its simplest elements. And draw, draw, draw!

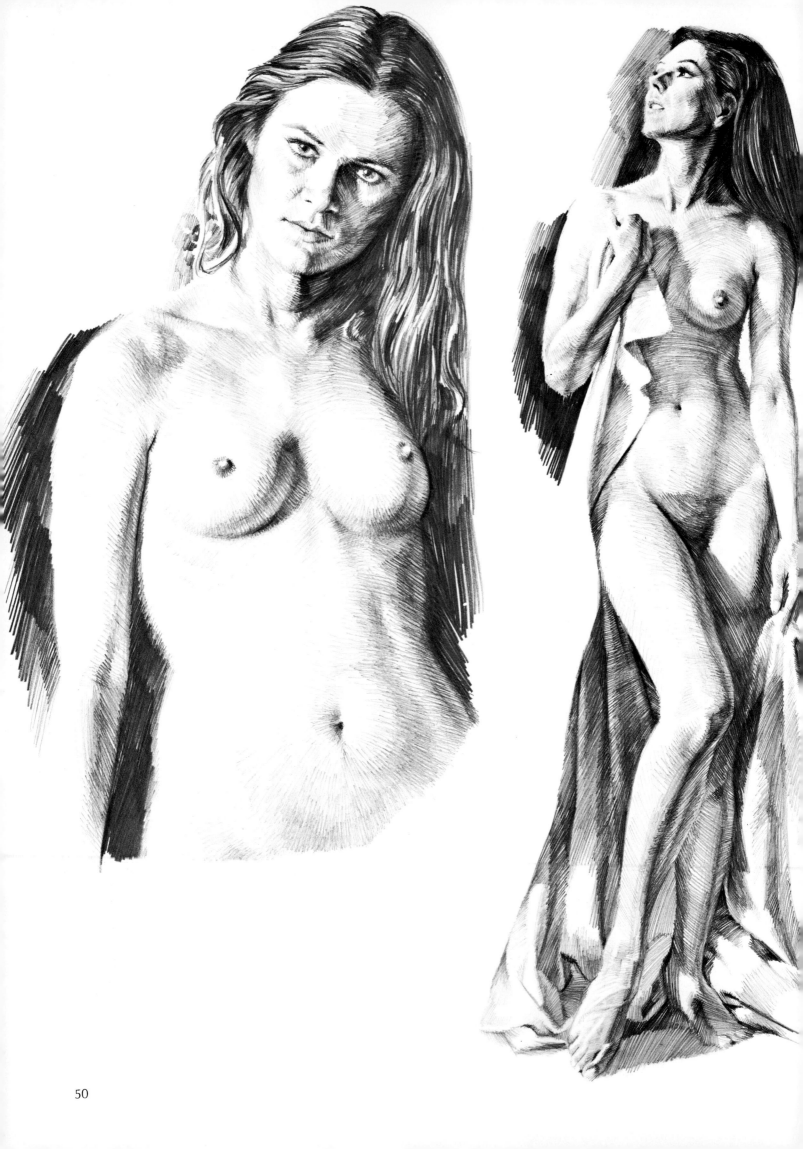

Nowhere is the decision about the placing the direction of pencil
strokes more important than in rendering the human figure.
Notice, in these drawings, that in every case the strokes follow
the form. Even the shadow areas are not simply shaded in, but the
strokes within them are expressive of the underlying bone or
muscle. This requires an understanding of human anatomy and a
close observation of its action. This understanding can only
come from practice; there is no substitute for repeated drawing
from life.

Of course, selectivity is important, too. Just because one knows
all the muscles does not require that they all be included. Part of
the artistic judgment is involved with what to minimize or stress
in arriving at the total effect wanted.

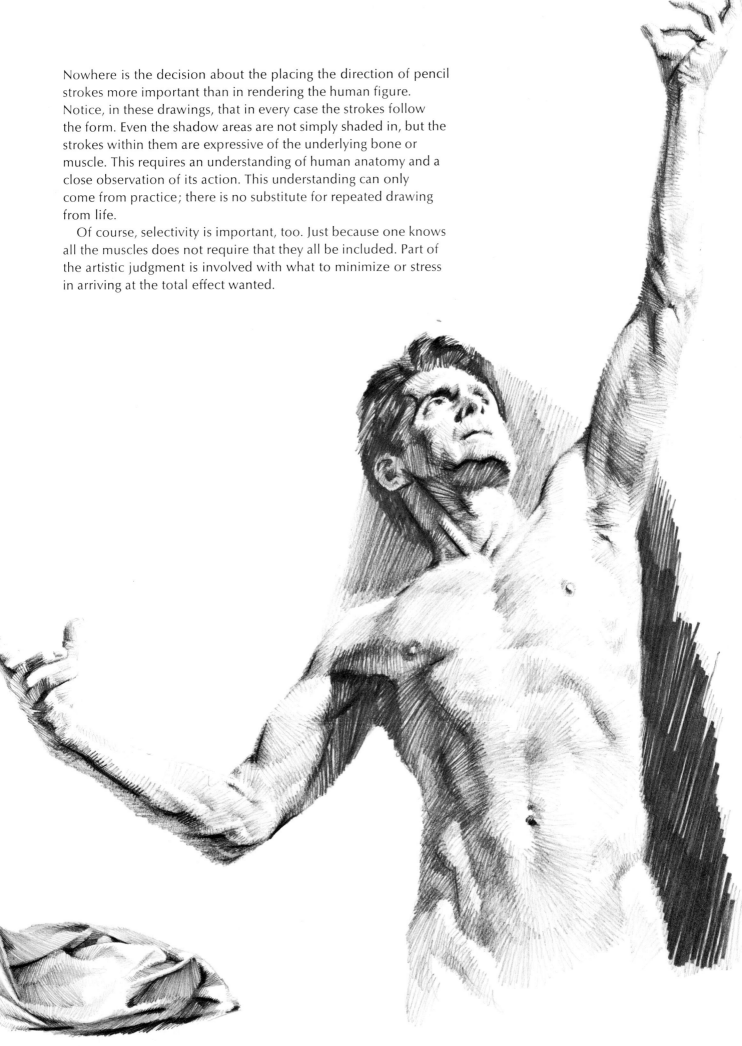

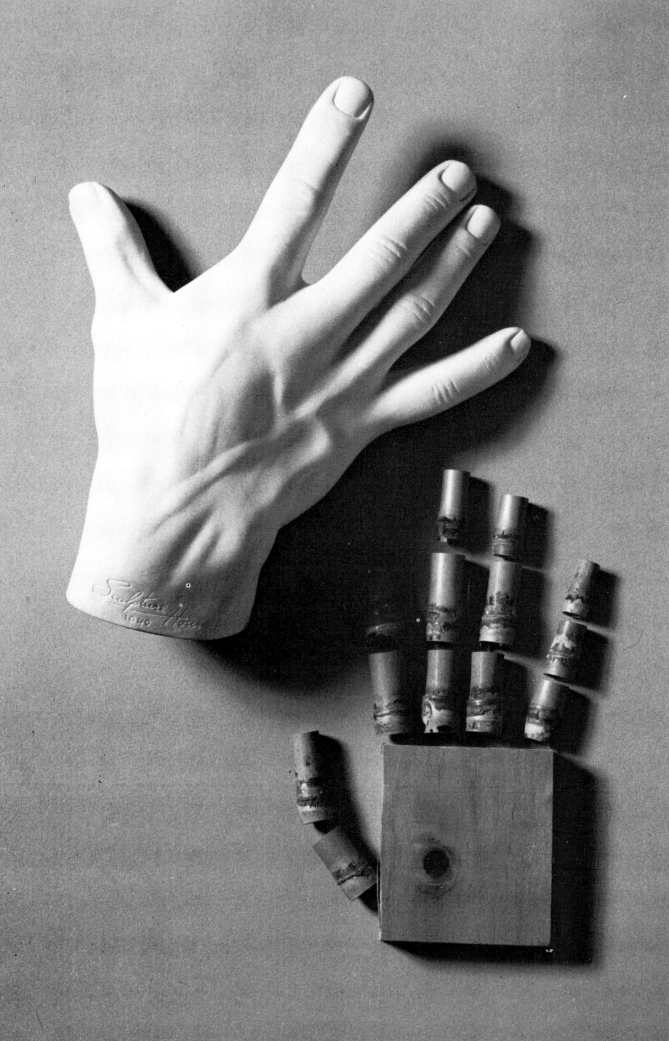

HANDS

There is no mystery to the drawing of a hand. You might think of it as fitting proportionate pieces together. Structurally, I envision the palm as a block of wood and the fingers as attached pieces of bamboo. The knuckles of the fingers are similar to the knobs on the bamboo stalk. In drawing the hand, remember the technique employed in rendering the cylinder and the cube. This will give you the basic foundation in rendering and understanding the structure of all hands in any position.

Next to heads, hands can be the most expressive parts of the figure and as much care should be taken in planning their pose and position in a picture. Many people unconsciously gesture with their hands to reinforce their ideas as they talk. In fact, much can be learned about another person's feelings by looking at his or her hands.

As an artist, you can emphasize this relationship of head and hands in posing your models to communicate the idea of the picture.

To summarize, in drawing the hands, begin with their gesture. A few quick lines blocked in, can easily record the pose, which may express an attitude of tension or fear, relaxation, joy, or sorrow. Once the pose, or gesture, is right you can construct the hand to fit it. Finally, you can add the surface details.

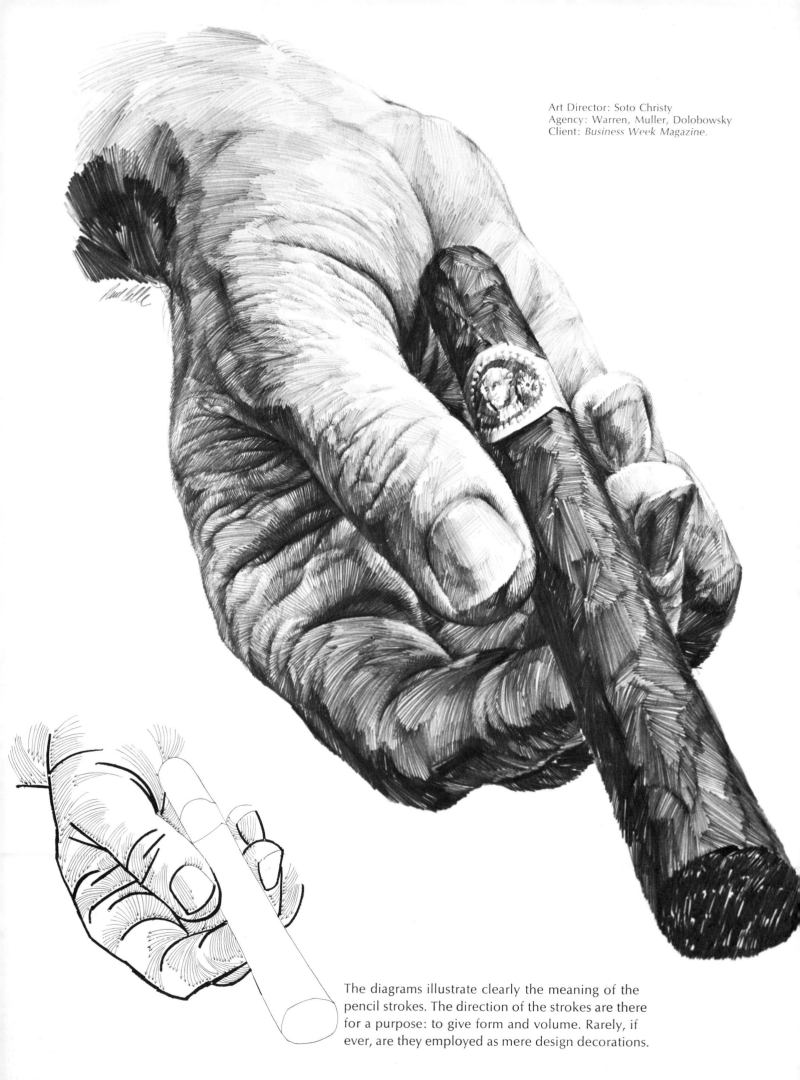

Art Director: Soto Christy
Agency: Warren, Muller, Dolobowsky
Client: *Business Week Magazine*.

The diagrams illustrate clearly the meaning of the pencil strokes. The direction of the strokes are there for a purpose: to give form and volume. Rarely, if ever, are they employed as mere design decorations.

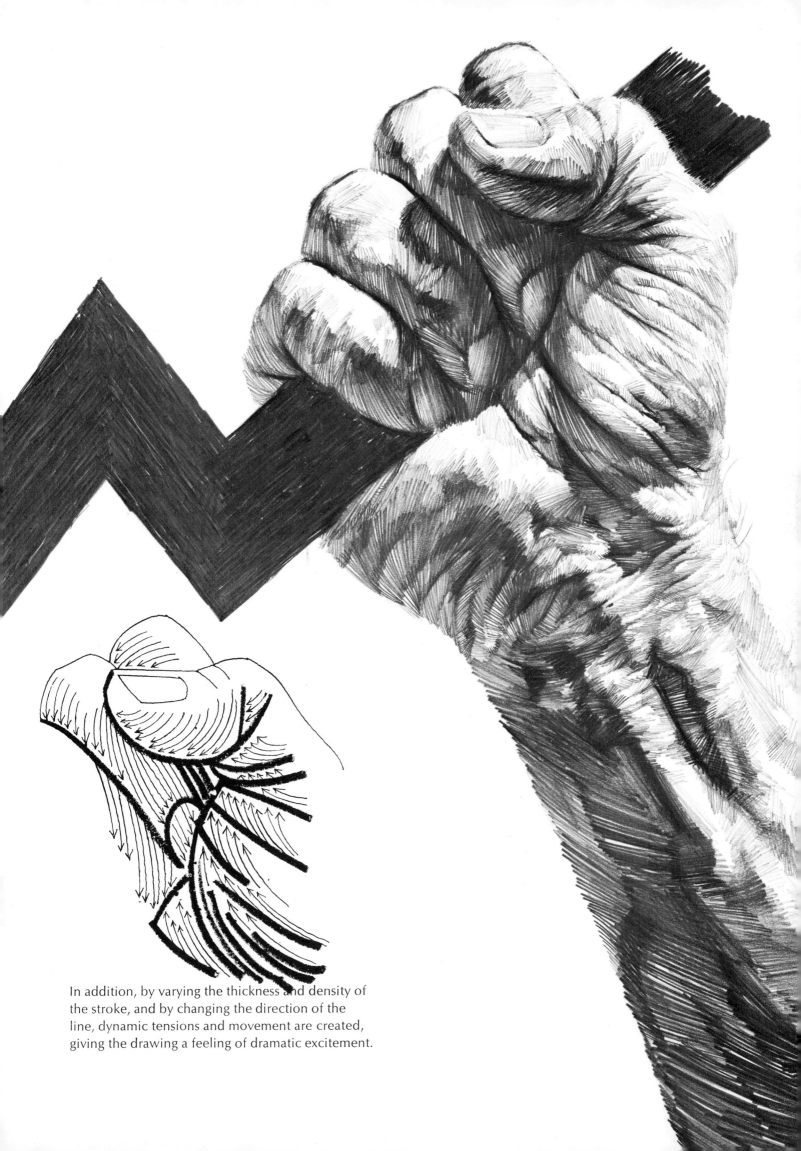

In addition, by varying the thickness and density of the stroke, and by changing the direction of the line, dynamic tensions and movement are created, giving the drawing a feeling of dramatic excitement.

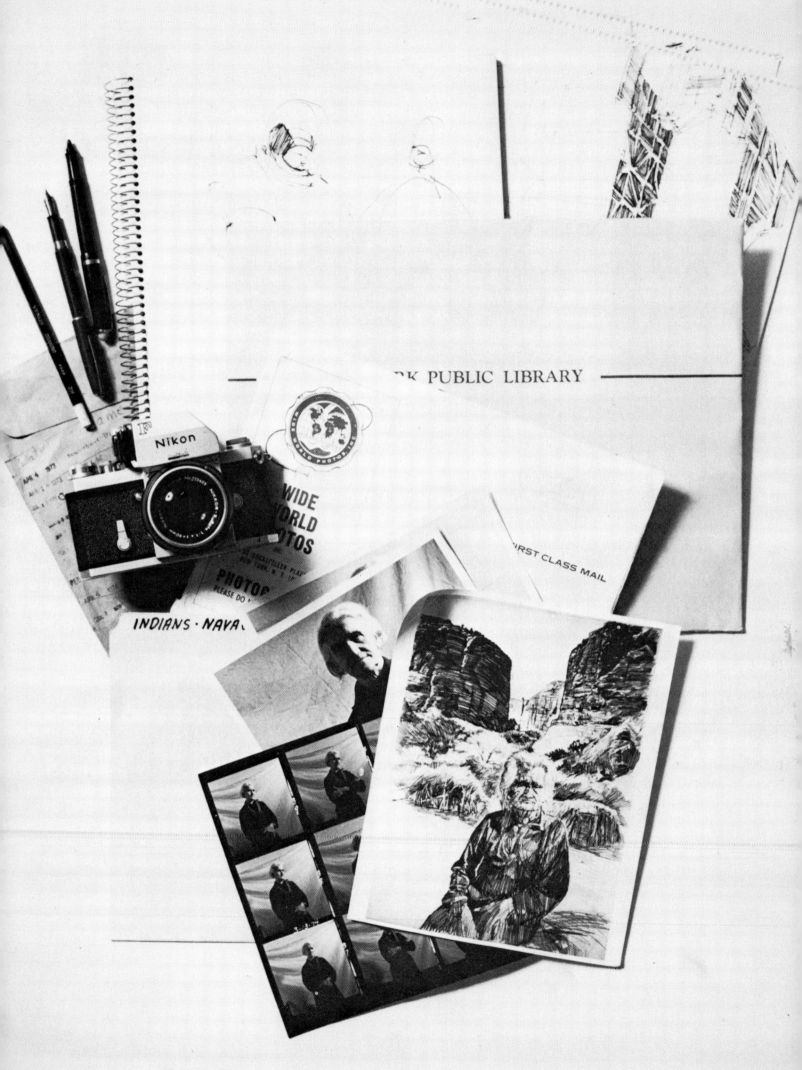

DRAWING FROM NATURE

Whether it be a commercial assignment that requires me to go to a specific location or on pleasure sketch trips or vacations, my sketching procedures seldom vary. I prefer not to execute my finished drawings outdoors, on the spot. Consequently, I proceed to sketch almost exclusively in pen and ink, and my concern is not in specific details of the subject under way. My primary concern is with the general abstract patterns of the composition. Rarely are my sketches very detailed drawings. This spontaneous pen and ink approach frees me from the entrapment of getting bogged down in too many details, and the etching-like quality of the line serves as a guide in helping me to plan the directional quality of the pencil strokes that I employ in the final drawings. At this early stage in the planning of a finished composition, minute detail is of no significance. The essence of the drawings is important. Constantly observe and carefully study all things before you record them either with your camera or your sketchbook . . . preferably both. When the realistic artist comes upon a scene, the sum total of his experience, background and ability should come into play. Will it be the whole scene that originally visually excited him? Should it be a part or a detail? Should he move this, eliminate that, incorporate a visual remembrance of another scene or element? These questions are essential, as the artist functions as composer, arranger and conductor with his entire orchestra. These fundamental impressions either interpreted or sketched are tremendously important, for the sketches serve as graphic shorthand notes to be incorporated later in the finished composition. All of my sketching is supplemented by the use of the camera to record details, and it also allows me to explore additional variations of the subject material.

Redwoods
National Parks Service

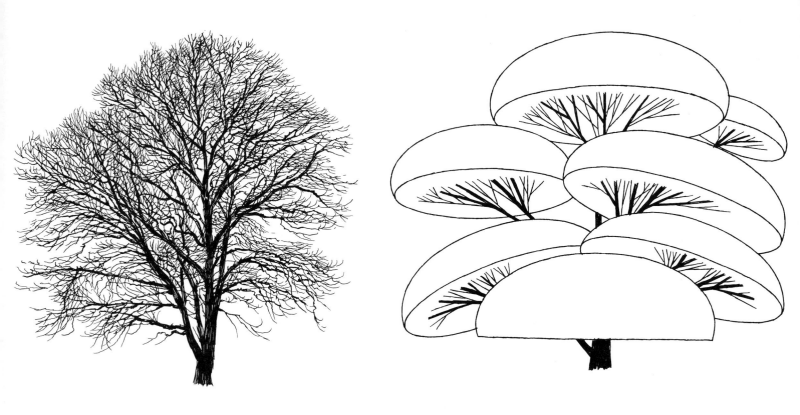

Knowledge of the characteristic silhouette of a particular species, combined with the three-dimensional construction of its leaf masses will enable you to draw trees convincingly.

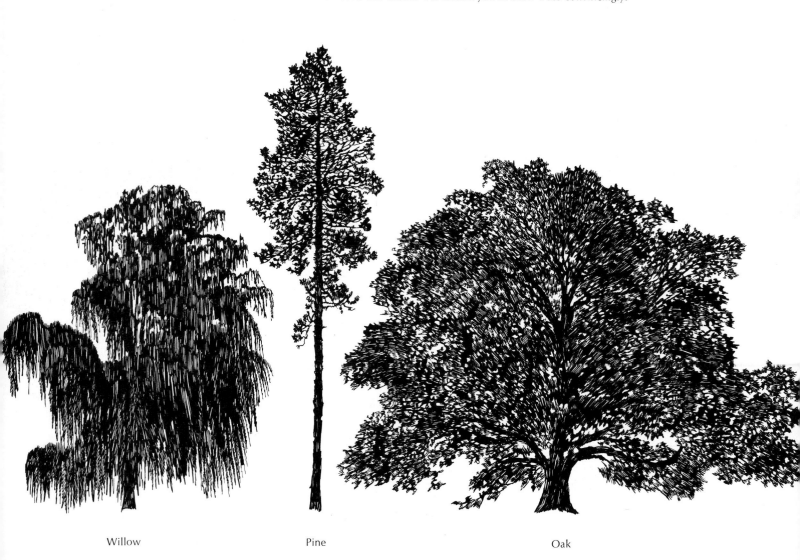

Willow

Pine

Oak

While we are talking about exciting subjects for drawing, I would place trees at or near the top for ideal subjects. They afford an infinite variety of shapes, sizes and textures. A single tree changes constantly with the variance of the light source, not to mention wind or season. The tree, full-bloomed and crowned with its mass of leaves, is an exciting subject to sketch . . . and is there anything more beautiful than a massive, knarled, oak tree in winter with its huge trunk silhouetted against the sky . . . the trunk leading to the massive branches which in turn extend their web-like filigree of branches toward the sky?

Trees, like people, are different and their basic silhouettes differ. A massive beech tree with its rather smooth bark is very different from the heavily textured bark of the oak or hickory. The shape of the birch is so very different from the pine.

Although it's not necessary when sketching trees in summer, with their foliage in full array, to draw the entire branch structure, a knowledge of this structure would enable you to better understand how the leaves mass on the tree. I would strongly recommend drawing in winter to gain a better understanding of tree structure. Just as a knowledge of anatomy may not be necessary in drawing from the model, I feel a study of anatomy greatly enhances your understanding of what you are doing when you sketch the human figure.

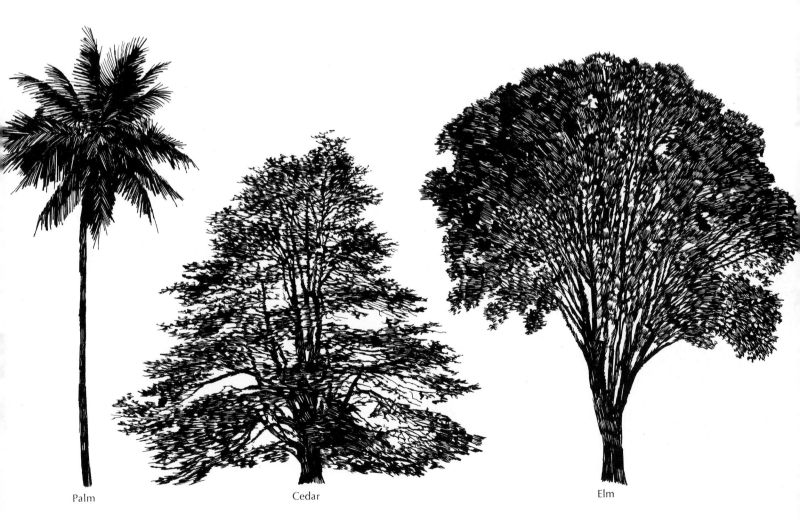

Palm Cedar Elm

64

An assignment for the National Park "Artists in the Parks" program gave me an opportunity to make a strong graphic statement. The drawing is large, 30" x 40", and was executed with my favorite HB pencil. It's a good example of the positive effect of the areas left out and the careful placement on the page. Additionally, the direction of the strokes in the trees creates a fluid pattern giving movement to what might otherwise be a very static composition.

The Governor's Palace. Williamsburg, Virginia
National Parks Service

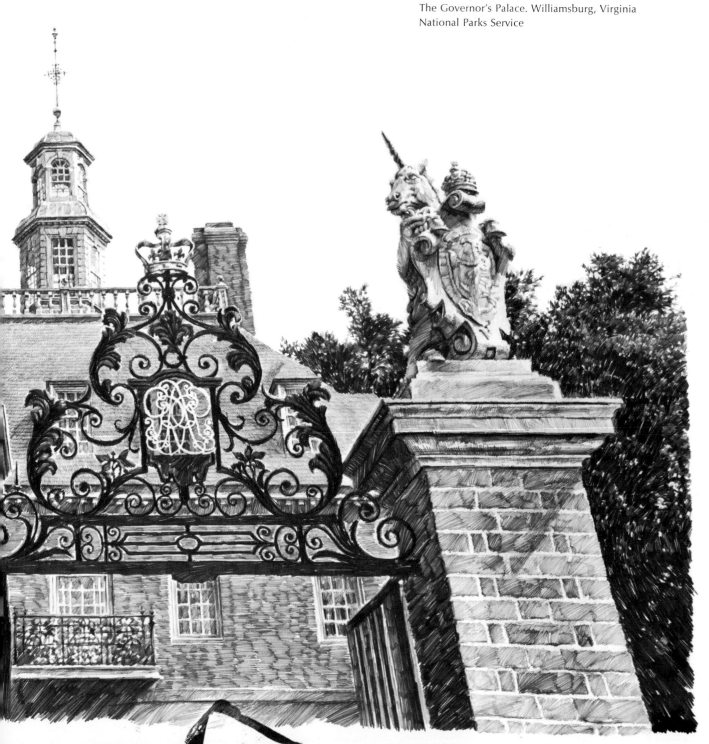

65

Studies of Dr. Howard Minners, head of the medical team for the first manned Gemini Mission. This drawing was made during the medical debriefing aboard the recovery ship Intrepid.

The pen being my normal sketching tool, this drawing is one of the rare times that I sketched on the spot with pencil. While the drawing was started on location, I completed it in my studio, adding to it and sharpening it up with detail from supplementary photographs which I also took. It was executed as part of a Gemini sketchbook assignment for the National Aeronautics and Space Administration. The commission was to record the various facets of the Gemini program of space exploration through the eyes of the artist, and took me from the launch facilities at Cape Kennedy, Florida to the recovery carrier, Intrepid, in the South Atlantic. I completed dozens of pen and ink sketches and twenty pencil drawings. An exhibition of the completed assignment eventually resulted in my being selected to design the first United States Twin Space Stamp commemorating the successful completion of the Gemini program.

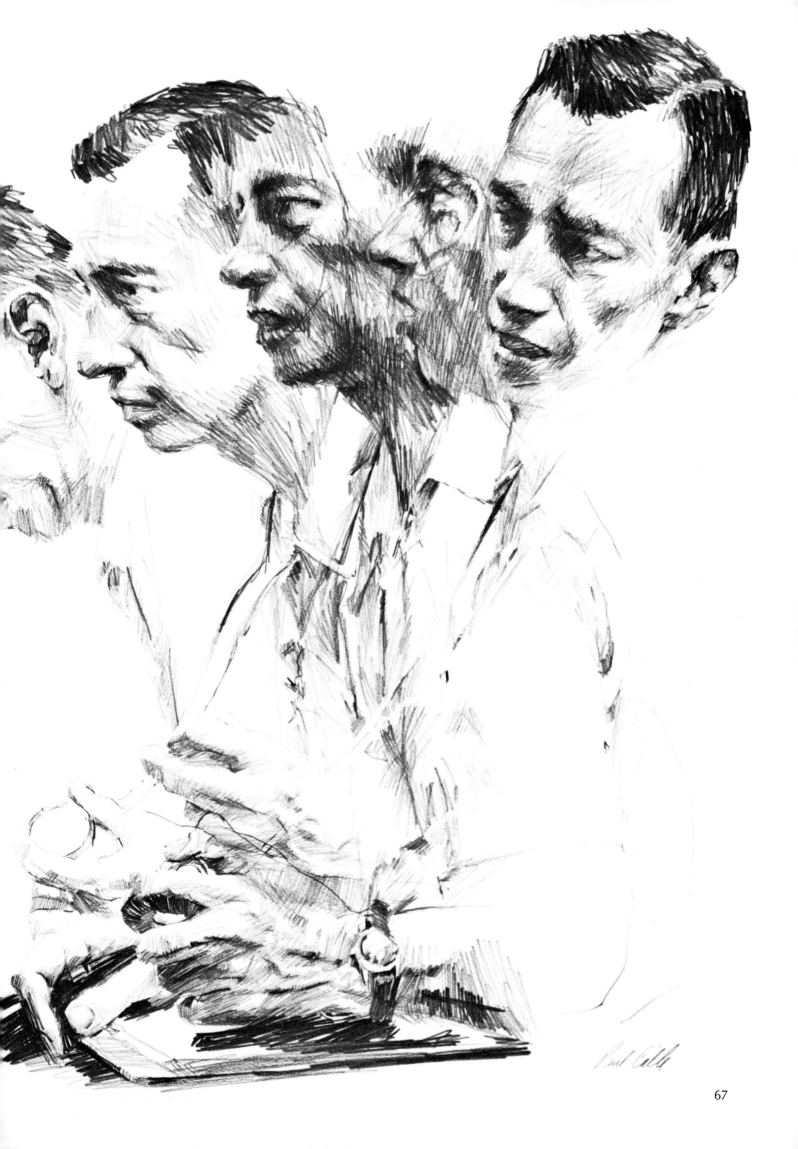

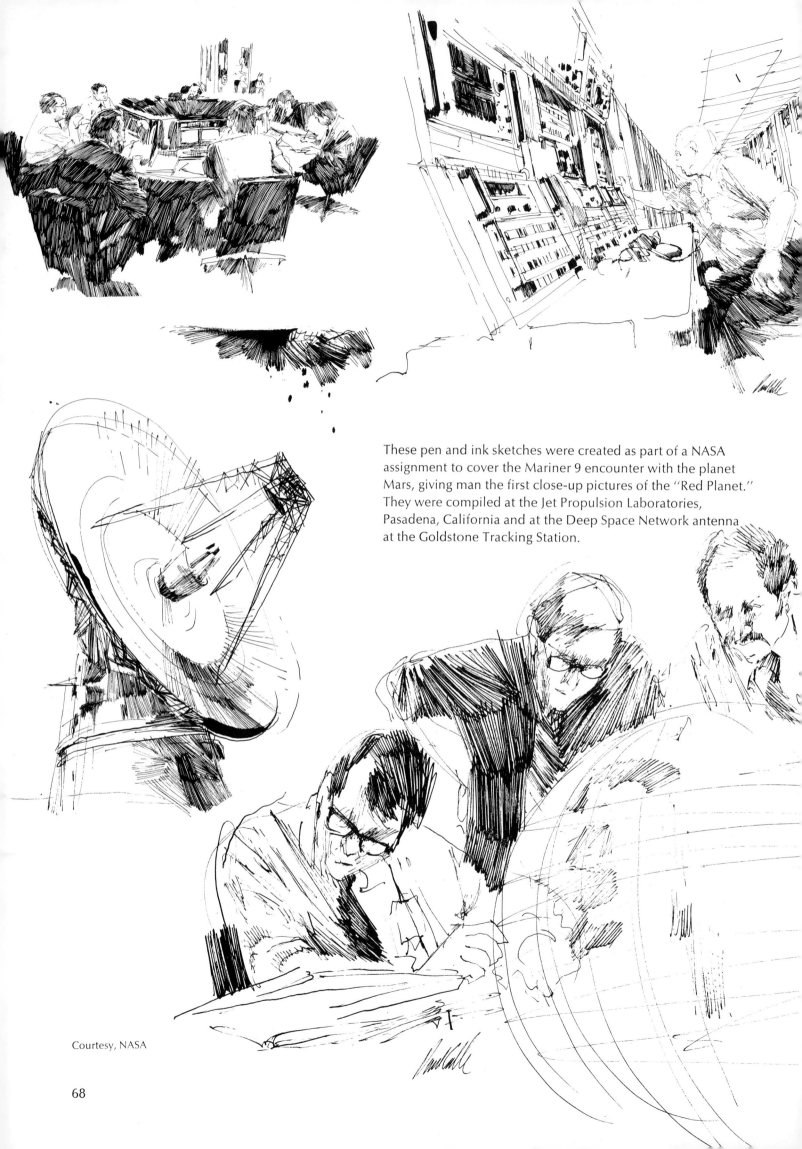

These pen and ink sketches were created as part of a NASA
assignment to cover the Mariner 9 encounter with the planet
Mars, giving man the first close-up pictures of the "Red Planet."
They were compiled at the Jet Propulsion Laboratories,
Pasadena, California and at the Deep Space Network antenna
at the Goldstone Tracking Station.

Courtesy, NASA

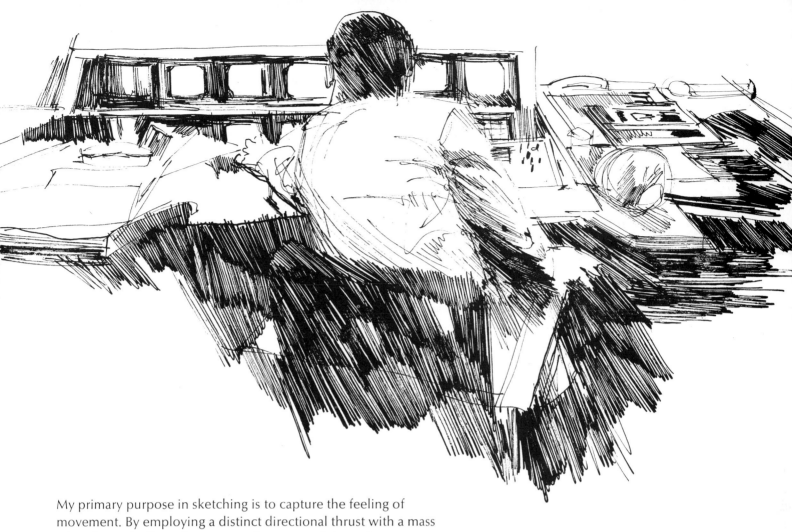

My primary purpose in sketching is to capture the feeling of
movement. By employing a distinct directional thrust with a mass
of strokes, a feeling of movement is generated. I am also
conscious of the placement of the sketch on the page and the
positive effects of the white area. I feel the paper left untouched
is as strong an element as the areas rendered. At this stage, the
details are basically unimportant. The camera can record the
details more quickly and accurately than I'd have time to draw
on the spot. Later, in the studio, I can selectively choose the
information that will complete my concept.

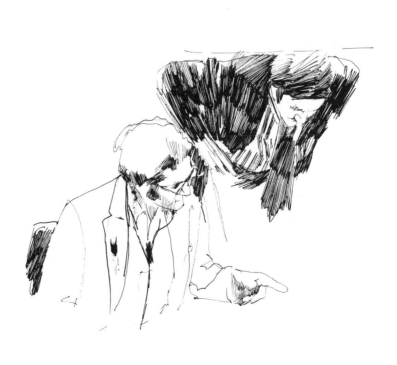

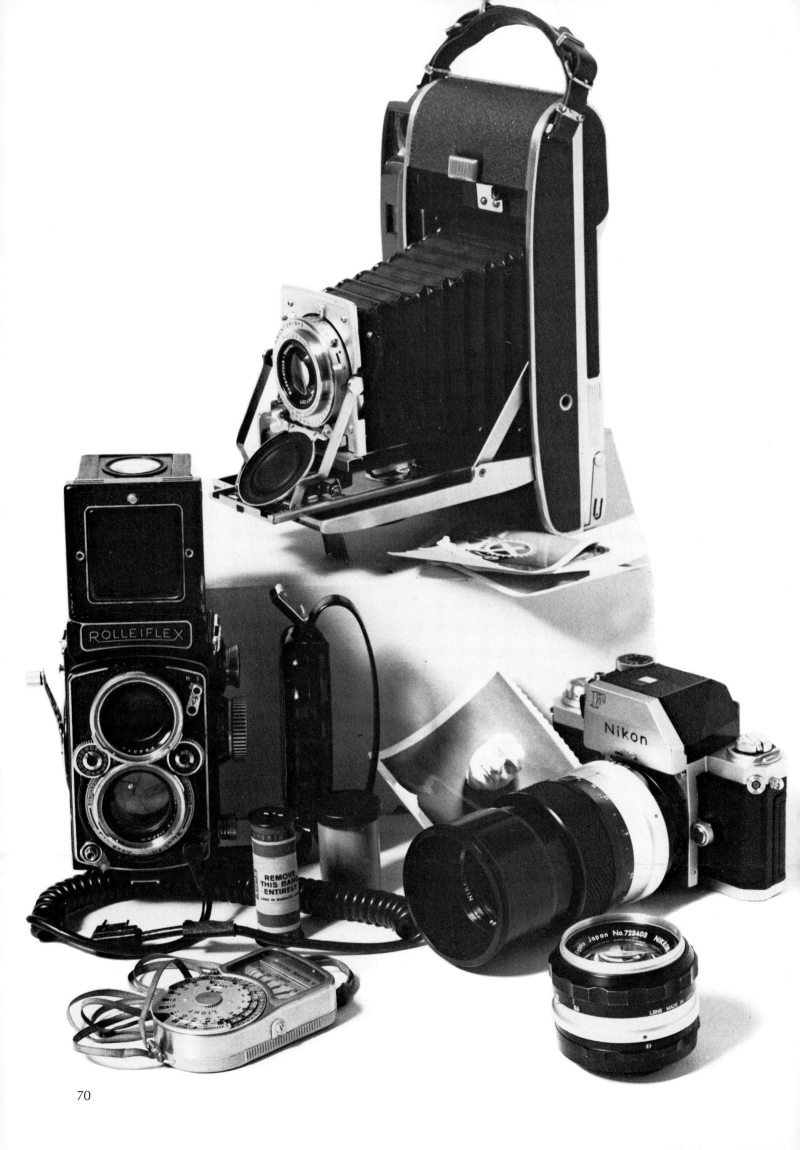

PHOTOGRAPHY

For many years, illustrators have used photography in their work with good or bad results. They have been condemned for it, with justification in some cases, by the fine art community. However, with the discovery and realization that many painters, including Thomas Eakins, Cézanne, Degas, Lautrec, Picasso, and Shahn, have utilized photography in their work in some way, and with the respectability of the meticulously rendered projected photographic transparencies of the current American photo-realism school, a re-evaluation is taking place in the attitude toward artists who utilize photographs. The *utilization* of the photograph is precisely the important distinction. To slavishly copy the photo, without adding to it or subtracting anything from it or interpreting it in any way, seems to me to be a waste of effort. Not to use the photo as a *means* to an end is really missing the value of the camera as a tool for the artist. Previously, I have discussed the ease with which one can record a mountain of material with the camera to supplement the impressions recorded in his sketch book and his own visual observations.

Many illustrators use the camera only after their sketches are O.K.'d, and the time comes to hire models and props and to pose them in the desired positions. In a relatively short span of time the illustrator can, with ease, record a variety of positions and gestures from various viewing angles and experiment with different sources of light. In this way, the artist has numerous variations on the basic theme to choose from.

In conjunction with the pen and ink notes and impressions, I employ my camera as an additional sketchbook. The camera gives me the freedom to satiate my passion for unerring detail. With it I can freeze and record fleeting motions that would be extremely difficult, if not impossible, to capture in quick on-the-spot sketches. The ability to record fast-moving action is a relatively easy exercise with the camera. The photographs that I take are not meant to be, and rarely are, complete compositions in themselves. In them, I am basically interested in recording essential details and elements: the way a leaf or a group of leaves are massed together or lie alone in a corner, the way light and shadow play upon one leaf or the shadows cast upon many, the bark of trees, the structure of a tree, a group of trees or an abstract mass of trees, the play of light on walls, the shadows created by the sun racing across a stone wall deep in the woods. The ease with which one can record many points of view of an interesting subject delights me. These pictures, fragments to be sure, supplemented by the pen and ink sketches which trigger the stored mental images of memory encountered on the scene, can later be arranged in orderly relationships to produce finished compositions.

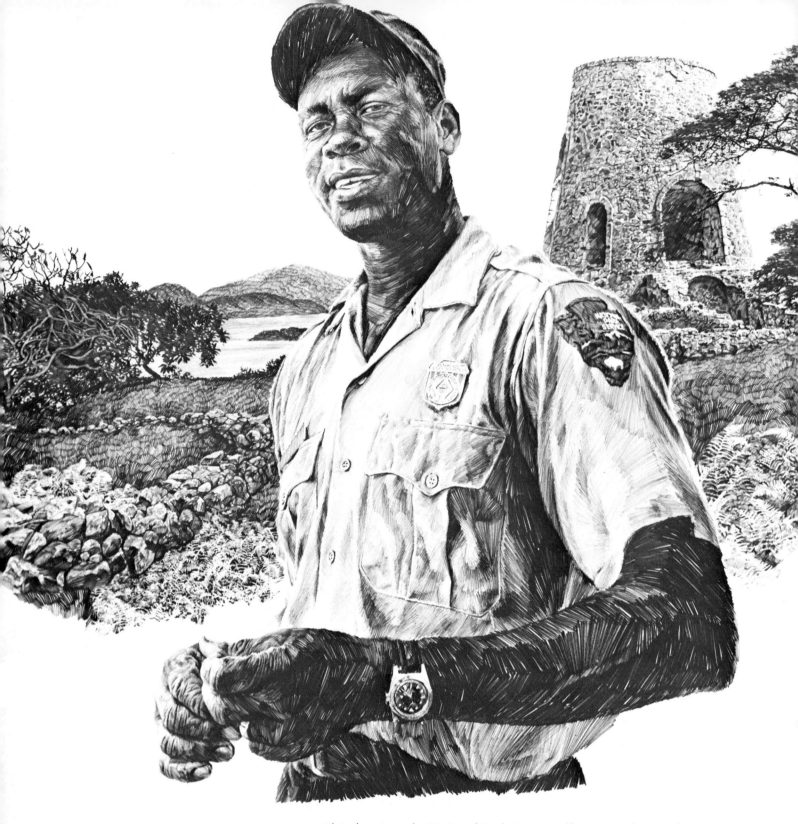

This drawing of a National Park Ranger offers a good example
of the way I employ the camera in relationship to my drawings.
Reproduced here is a portion of several rolls of film shot
on location during an assignment for the National Park "Artists
in the Parks" program.

Working with a general idea of what I was after, the camera
afforded me the speed and mobility to record a variety of
expressions, various angles, and points of view. Once the film
is developed and prints provided, selectivity becomes the key
element. Selectivity is choosing that which is most appropriate to
the mood of the drawing and not becoming bogged down in
merely rendering a specific photograph. As you can readily see,
the final drawing utilizes portions from several photographs.

Nobel Samuel was born and grew up
on St. John Island in the Virgin Islands.
To me, he symbolizes the dedication of the
Park Rangers at its highest level.

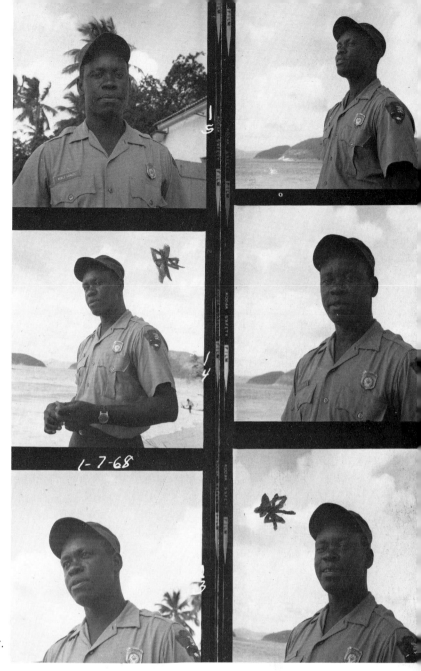

The completed drawing is 30 by 40 inches and is in the
collection of the National Park Service, Department of the Interior.

BALOPTICON

LIGHT BOX

TRANSFER SHEET

DRAWING AIDS

There are several methods available which enable you to transfer your composition (in sketch form) to the finished surface for final rendering.

A Balopticon is an opaque projector that produces an enlarged image onto another surface by means of light, mirror and lens. You place your sketch, photograph or printed material into a receptacle in the projector. The size of the projected image is determined by the distance of the projector from the surface of the paper. The greater the distance, the larger the image. A darkened room is required for the clearest image. You can then trace the outline of your sketch onto the finished surface with the amount of detail governed by your individual requirements and proficiency. I would recommend a 4H or 6H pencil to achieve the best results.

A light box is a large box-like container with fluorescent lights enclosed and a frosted glass top drawing surface. Tape your sketch onto the back of your finished paper and place it on top of the light box. The light emitted from the box enables you to view the sketch through the paper giving you the ability to trace the desired detail. A 4H or 6H pencil is recommended. A major drawback of this method is the necessity to use relatively thin paper for the finished drawing. It is extremely difficult to see through heavy paper and impossible for the light to penetrate through illustration boards of any kind.

Finally, there is the obvious method of drawing directly onto the finished surface, using your sketch only as a visual reference guide. This enables you to be very spontaneous, especially when dealing with relatively simple compositions. However, I find this extremely difficult when dealing with complex compositions. I much prefer thinking it all out by means of a series of rough sketches and arriving at a fairly tightly defined solution before approaching the final version.

Transfer tracing method. You must first create your own graphite carbon transfer sheet. This is easily achieved. Starting with a piece of thin bond or vellum paper approximately 11 by 14 inches, completely blacken the entire surface using a 2B or 4B pencil. When this is accomplished, dip a wad of absorbent cotton into some carbon tetrachloride, or rubber cement thinner, and rub over the entire blackened surface. This removes the excess graphite dust and leaves you with a fine, even, graphite transfer sheet. Apply masking tape to the top corners to secure the sketch to the finished surface. Slip the transfer sheet between the sketch and the surface of the paper, blackened side down. Trace the outline of the sketch onto the surface using a very hard pencil — 6H or 9H is recommended. The degree of transferred detail desired varies from artist to artist. The beginner usually requires a very detailed transfer; however, you will find that you will require less detail as you gain confidence and proficiency.

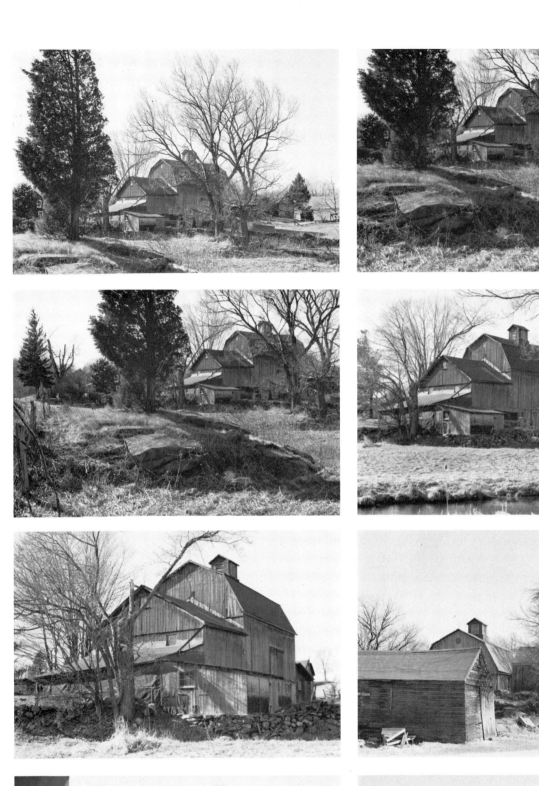

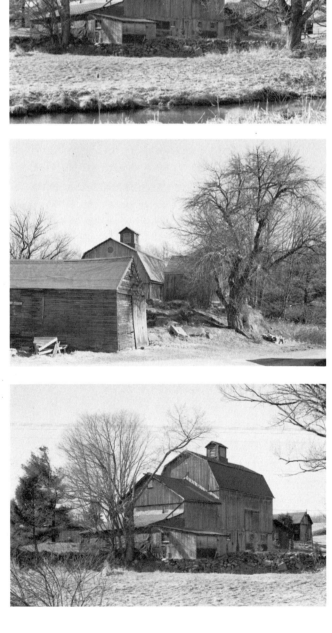

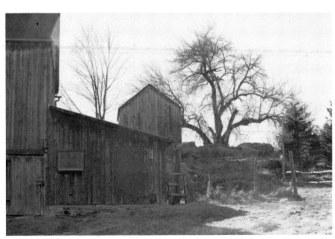

CHAPTER 5
COMPOSITION

The photographs on the left provide a good example of what I refer to as "photographic sketching." Driving through New Milford, Connecticut one day, I was attracted to this barn. In a relatively short period of time, I was able to record an extensive variety of views for future use. The photographs served as detail information for the pen and ink sketches I also executed on the spot. When combined with other material from my file, one result was the drawing of John Clason's oxen on pages 152 and 153.

In taking these photographs, however, I made no attempt to compose the existing elements. While some of the photos work better as compositions than others, they could be improved in every case by shifting one or more of the elements, changing the lighting, the values, scale, etc. A discussion of some basic considerations in making successful compositions may be helpful.

Many times when I am involved in a very complicated composition encompassing several figures and a large assortment of elements, I find that the structure starts to stretch and widen. The composition seems to expand and visually is not as tight and solid as my small preliminary thinking-sketch was. This used to disturb me a great deal. However, over the years I realized what was happening and learned to correct this drifting tendency that I have.

In analyzing the problem, I found that as I got into the individual elements in the composition and started to spell out the form of the figure, the drapery or costumes, the detail on rugs and chairs and interior decoration, I fell in love with each element. I became so enamored with the design of the fabric on a sofa, for instance, that when it came to placing the figure on it, I unconsciously placed the figure in a position to reveal as much as possible of the fabric. While I indicated in my abstract preliminary a dark mass of pots of flowers and greenery in the foreground that served as a strong element to hang the entire composition upon, I found that as I was rendering this mass of flowers and leaves, I simply could not put it in front of that beautifully gowned figure with the folds so beautifully revealed by the light coming in the window! So I had to put it slightly to the side, with perhaps a leaf or two overlapping the lower part of the gown and, of course, being very careful not to hide the wonderfully carved leg of the chair. This can go on infinitely, loving each element in turn until you no longer have a composition, but many elements slightly related to one another in a rectangle.

Don't despair! I think this tendency is a perfectly natural one that is common to most of us. It should be easy to live with and, from the compositional point of view, easy to correct.

My solution has its roots in a class I took in my first year at Pratt Institute. The course was conceived and taught by a remarkable human being, Alexander Kostellow. He was both intellectual and earthy, terrifically honest and direct in his criticism, yet humanly concerned with the development, progress and understanding of his young students. I treasure the memory of hours spent in his class and am forever grateful for the discipline and stimuli he engendered in my development as a creative individual.

In our composition class, the students were assigned a circus scene involving people, clowns and animals. We were asked to prepare our preliminary pencil drawings, 20 by 30 inches. When we returned to class the following week and proudly presented the carefully composed (or so we thought at the time) drawings, we were then given the problem of redoing the entire scene, without eliminating any elements or reducing in size any animals or people. We were to keep everything the exact size as before except that the size of our rectangle was now reduced to 16 by 20 inches. At the time this seemed like an insurmountable task, impossible to achieve. Of course the only way to accomplish this was to overlap objects. The round ball on the ground could no longer have the luxury of lying alongside the clown. In order to fit in, it had to be worked in front of the clown's beautifully rendered shoes or behind him with just a portion showing that indeed it was a round ball. Similarly the clown, of necessity, in order to "tighten" the composition was placed in front of one of the elephant's four beautifully rendered wrinkled legs. It still read as an elephant and we quickly found that it wasn't necessary to show every element in its entirety. Tigers overlapped lions, hands and arms suddenly seemed just perfect, partially covering the circus posters and on and on we went overlapping, moving and switching elements from one side to another. Once again we came in with our "new" composition.

Then, once again we were confronted with the impossible, to

redo it entirely, the same as before with no reduction of size or elimination of any element and our size was now 14 by 16 inches. Through the process of overlapping and moving and switching we soon arrived at a truly tight, orderly composition and this discipline with variation I employ to this day. If I don't have the luxury of a great deal of time I will simply cut the preliminary drawing up and then move the elements around, overlapping some areas and separating other elements. In addition there are many occasions when I will get photostatic copies of my sketch several inches larger than the original and one several inches smaller. Then by cutting them up I will have a variety of sizes to move about and compose with.

You may wonder why a certain element is leaning this way in or that way out in one of my pictures. This is not by chance; rather it is an attempt to get the viewer's eyes to follow definite "lines of continuity." I plan an abstract pattern in which the folds of some drapes may form an abstract line with the arm of a figure on the other end of the composition to bring the viewer's eye across. Similarly, you will notice that the pencil strokes, although abstract in quality, upon examination have a definite directional quality leading you in and out of the composition.

Principles of composition are taught and many books have been written on the subject. While they can be valuable, I have found that conforming to the rules at the expense of experimentation is useless.

Composition essentially is an organization of elements within a given area. Composition is also an arrangement of values and patterns. Successful composition is a well-organized combination of these. On any given subject, several successful solutions are possible. The ultimate determination is up to the artist. Rarely is it arrived at by accident.

Much investigation can be accomplished with the camera in a short time. This "photographic sketching" enables me to record a variety of angles and points of view. In my studio, I have the time to rearrange the elements necessary for a successful composition.

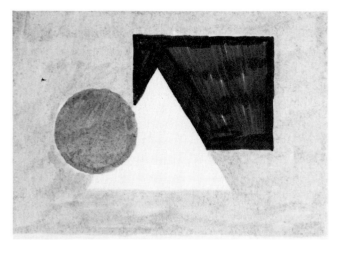
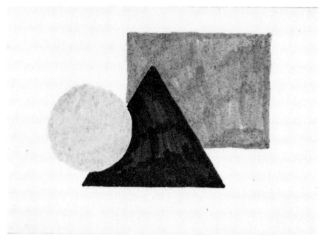
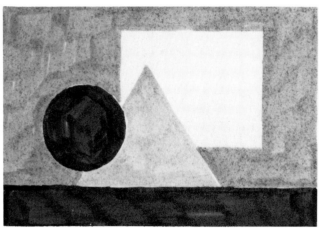
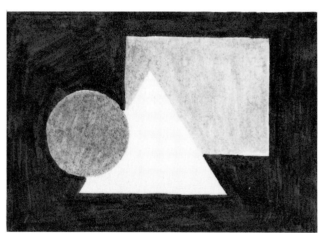

In this series of diagrams, you can see how easily values can be shifted about and rearranged to change the mood of the composition. While the composition remains essentially the same, variations of the value scale change the mood of the drawing entirely and add to the dramatic import. The patterns of light and shade determine the mood and atmosphere, so great care should be taken when establishing them. Additionally, this value control establishes the foreground, middle and background. This illusion of depth is easily achieved through the control and manipulation of the values. The variations are endless and can range from the dark foreground silhouetted against a light background to the light foreground illuminated against the dark background. Although both situations achieve great illusions of depth, they create entirely different moods.

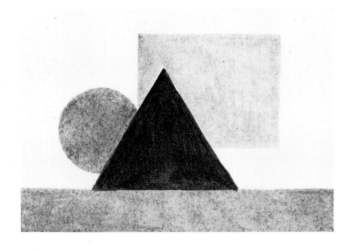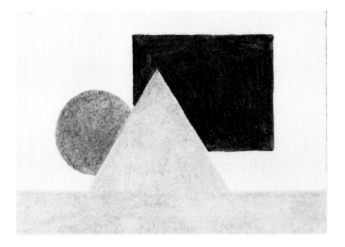

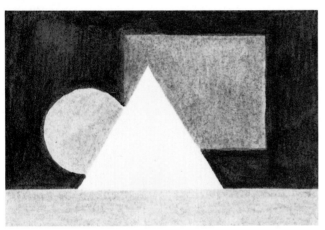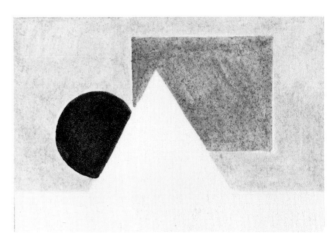

Normally, we accept a progression of values in a picture to show depth. That is, objects farthest away are lightest in tone, middle values are in the middle ground, and the strongest contrasts and darkest darks are in the foreground.

We can also accept the reverse progression in which the lightest values are in the foreground and the darkest darks indicate the greatest depth.

When the value changes are not progressive, you will note that this illusion is destroyed, even if objects are overlapped. The tendency then is to eliminate a feeling of depth and to keep the objects on the same plane.

Control your values so they suit the specific purpose of your drawing. Pictures that are uninteresting are, more often than not, the result of poor control and organization of the value patterns. With careful determination of the values, the control and positioning of light and dark areas, along with the directional flow of pattern strokes, you can lead the observer to the central point of interest.

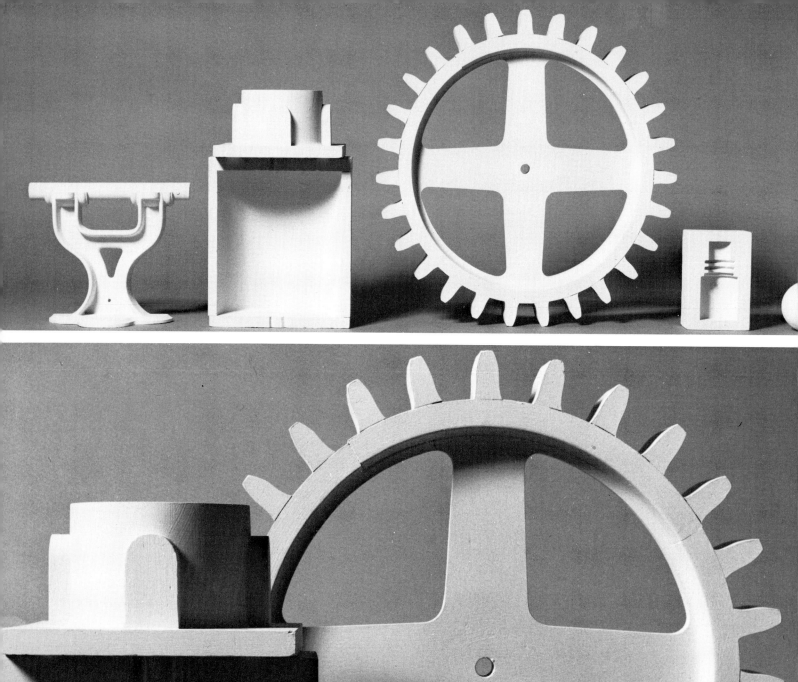
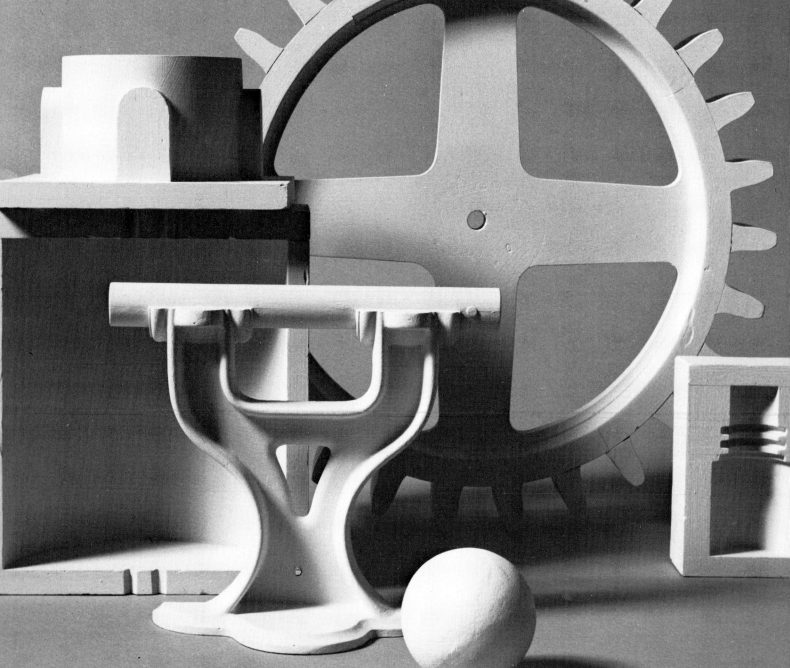

PERSPECTIVE, OVERLAPPING

Dictionary descriptions of perspective vary from "the art of picturing objects so as to show relative distance or depth," to "the appearance of objects determined by their relative distance and position," to "the art of depicting objects on a plane so as to show three dimensions and indicate distance away from the observer." The artist has several means of employing perspective in his compositions to give the appearance of distance. Many other books have discussed vanishing points and the mechanics of perspective, and every artist should have a working knowledge of these principles. The subject is too complex to cover in detail here, but I would like to concentrate on one of the most important devices I utilize to give my drawings the illusion of depth and distance. I find that most beginning students are quite unaware of the simple compositional device of the overlapping of objects.

I feel I can best illustrate the simplicity of overlapping by returning to our "language forms." In this illustration, I have placed a number of mechanical forms in a variety of sizes on the same plane. It is immediately evident that in their relative position to each other, not knowing their size relationship, we have no idea which would be closest to us and which would be farthest away.

We can correct this by the simple means of overlapping one object with another. By the device of overlapping, we have created an illusion of depth and distance even though the object farthest from us is larger than the nearest object.

If you substitute people, or houses, trees, or boats for the mechanical forms, you can see how valuable overlapping can be in establishing perspective in a composition.

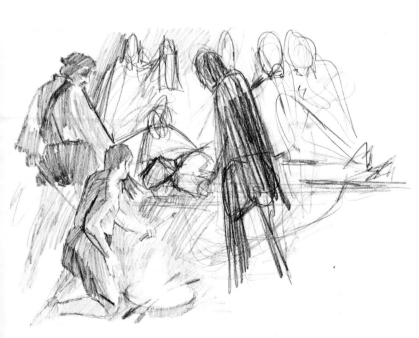

Initially I make a number of rough abstract compositional sketches, working out problems by the employment of various shapes and patterns, attempting to create flow patterns that lead the viewing eye toward the significant areas of dominance and subordination. Once I solve the basic arrangement, the need for models, costume, props and photography comes into play. With the aid of the photographs, shapes are translated into figures, patterns of light and shade into drapery and character studies.

In reviewing this sketch with the completed Ambroise Paré drawing, I am sorry I eliminated the figure on the left. I think it would have aided the dynamic thrust of the composition. I wonder what prompted me to eliminate him?

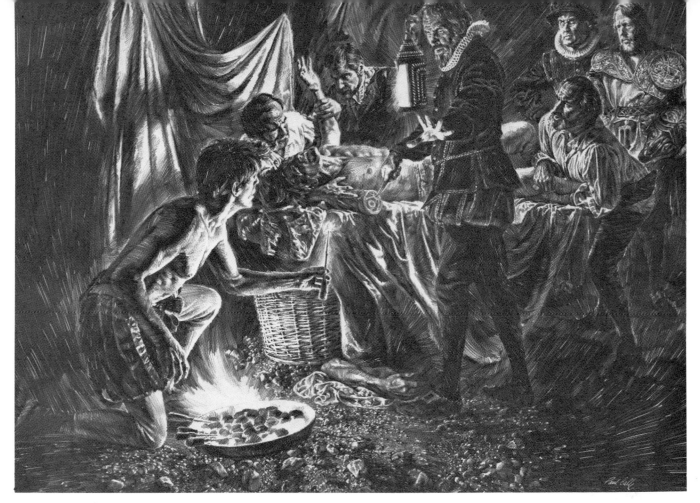

Courtesy, Schering Laboratories

This compositional diagram will clearly explain "lines of continuity" that I refer to so often. In the placement of the figure, notice how your eye follows the dominant flow even though the actual line direction is broken by cross elements, then is picked up again in the flow of the drapes or the direction of an arm. Secondary tension lines are created along with the movement in the pattern flow.

85

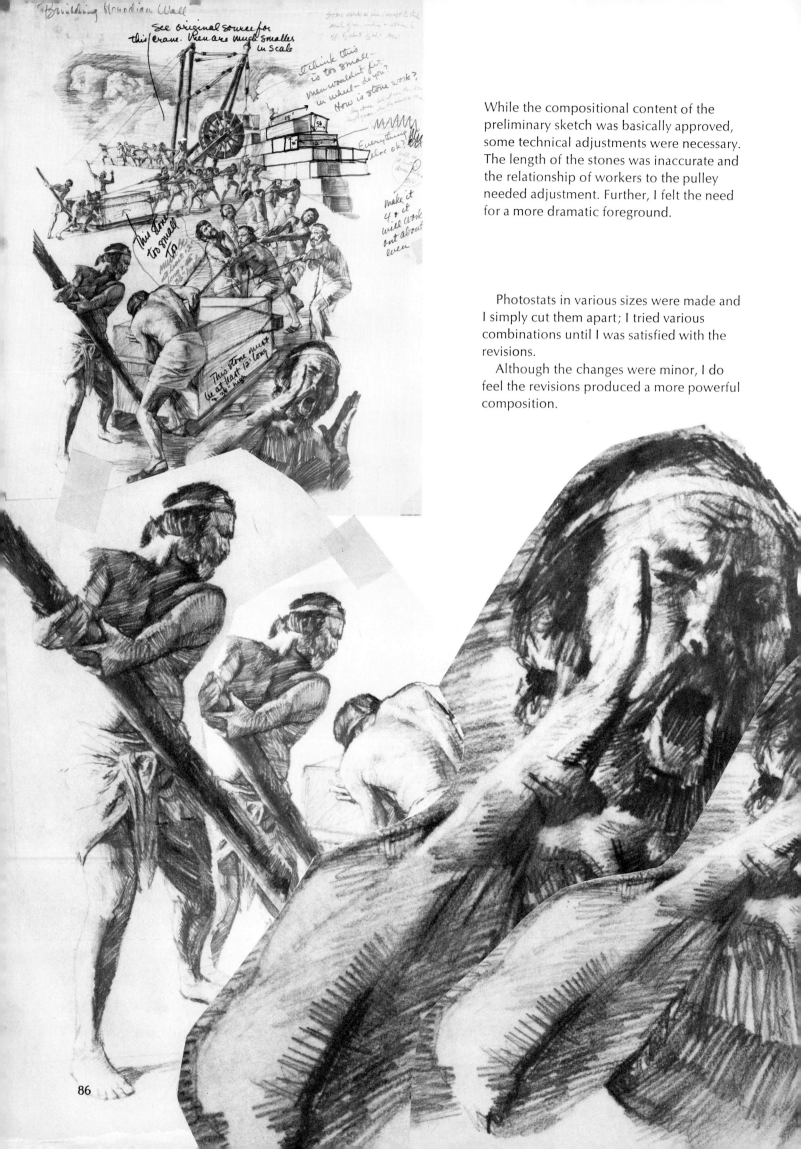

While the compositional content of the preliminary sketch was basically approved, some technical adjustments were necessary. The length of the stones was inaccurate and the relationship of workers to the pulley needed adjustment. Further, I felt the need for a more dramatic foreground.

Photostats in various sizes were made and I simply cut them apart; I tried various combinations until I was satisfied with the revisions.

Although the changes were minor, I do feel the revisions produced a more powerful composition.

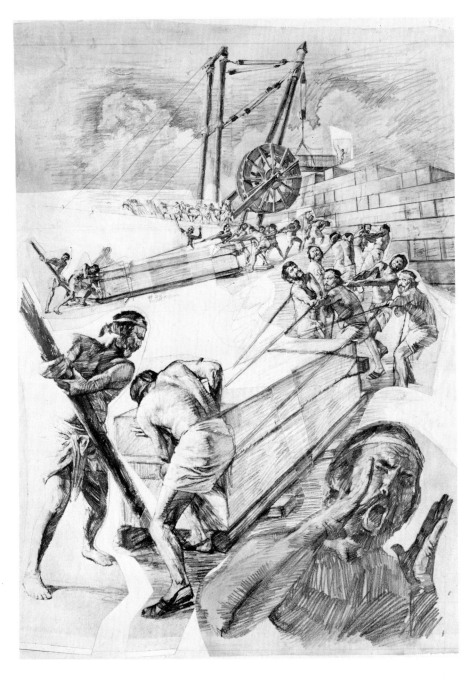

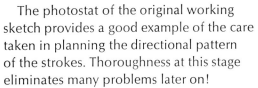

The photostat of the original working
sketch provides a good example of the care
taken in planning the directional pattern
of the strokes. Thoroughness at this stage
eliminates many problems later on!

CHAPTER 6
PROBLEM SOLVING

Problem solving, to me, is just another way of saying "making pictures," and I thoroughly enjoy making pictures. I consider myself extremely fortunate in never having been stereotyped as to subject content. This has enabled me to walk down many avenues with the visual world around me serving as inspiration and stimuli. Whether my drawings are destined for books, editorial art, advertising or hanging in galleries, the essential problems remain the same. One must visually articulate an idea or emotion in a pleasing and dramatic way. The subject should be approached with the interest and enthusiasm that will result in an original, personal artistic expression.

Since 1963, I've been associated with the National Aeronautical and Space Administration Fine Art Program acting as a reporter and interpreter, documenting the historic journey into space. I've designed United States Postage Stamps, illustrated for editorial art and advertising, traveled as a participant in the U. S. Air Force Historical Art Program and the National Park Service Cooperative Art Program.

In this section, I will present some typical assignments and describe the steps taken in solving the particular problems presented by them. Although the final execution of the drawing is all that will ever be seen by the client or the public, my pictures never spring into being, fully realized, without many preliminary steps.

The problems for each assignment are different; sometimes they hinge on the research of an historical or scientific fact or circumstance, costume, or a particular place. At other times the problems are dramatic — how to present a situation graphically in keeping with the mood of a story or situation. Or, requirements of space or size require compositional compromises. These and many other considerations must be solved in the process of successful picture making.

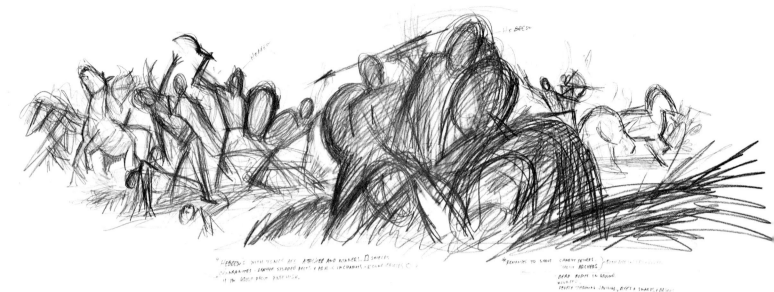

As originally conceived, this illustration was planned as a two-page spread that resulted in this first investigation of compositional possibilities.

Design considerations necessitated a change to a single page composition that subsequently produced this battle scene. Further simplification of the foreground produced the vignette reproduced here.

The reason I enjoy the vignette concept so much is the feeling I have of viewer involvement. Consciously or unconsciously, the mind tends to fill in the "unfinished" areas resulting in a more intimate relationship with the viewer.

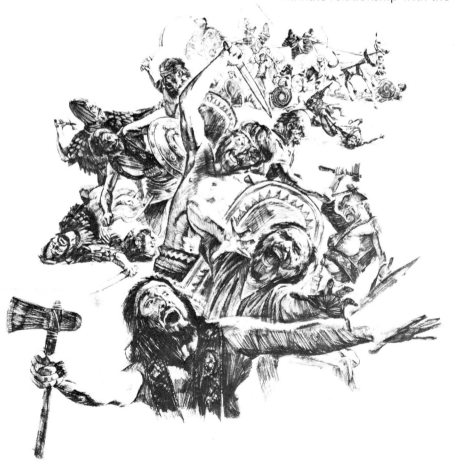

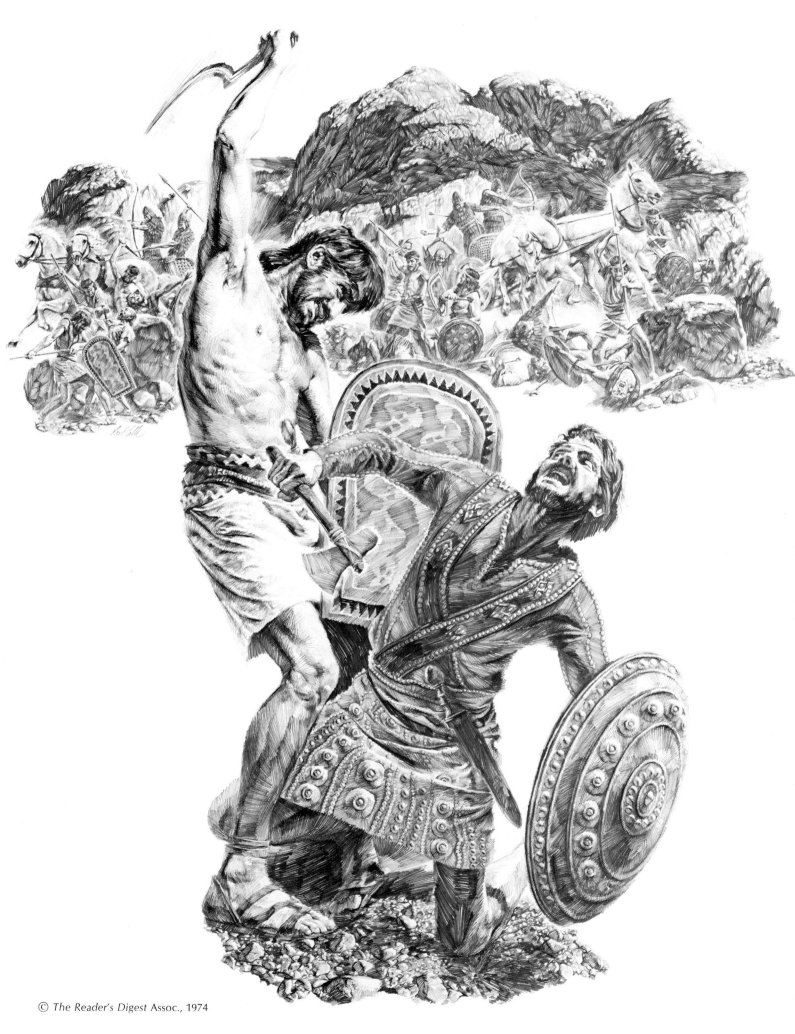

91

Rough value sketch, worked out beforehand to establish the foreground, middle and background.

Preliminary sketch that was submitted to client and approved with minor changes.

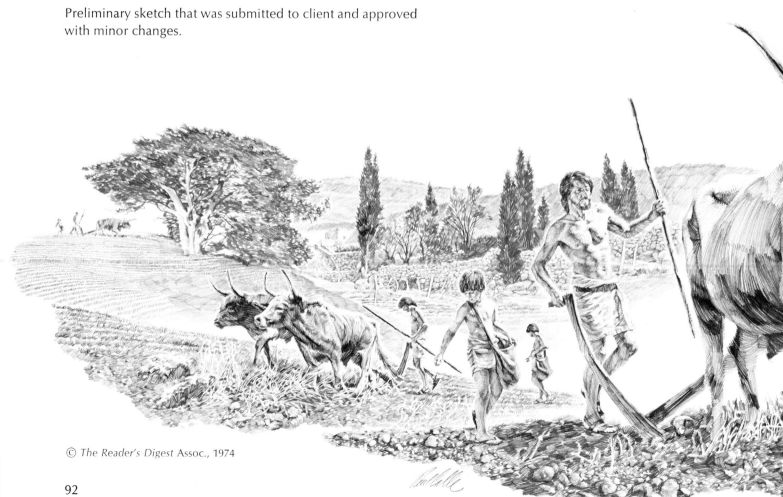

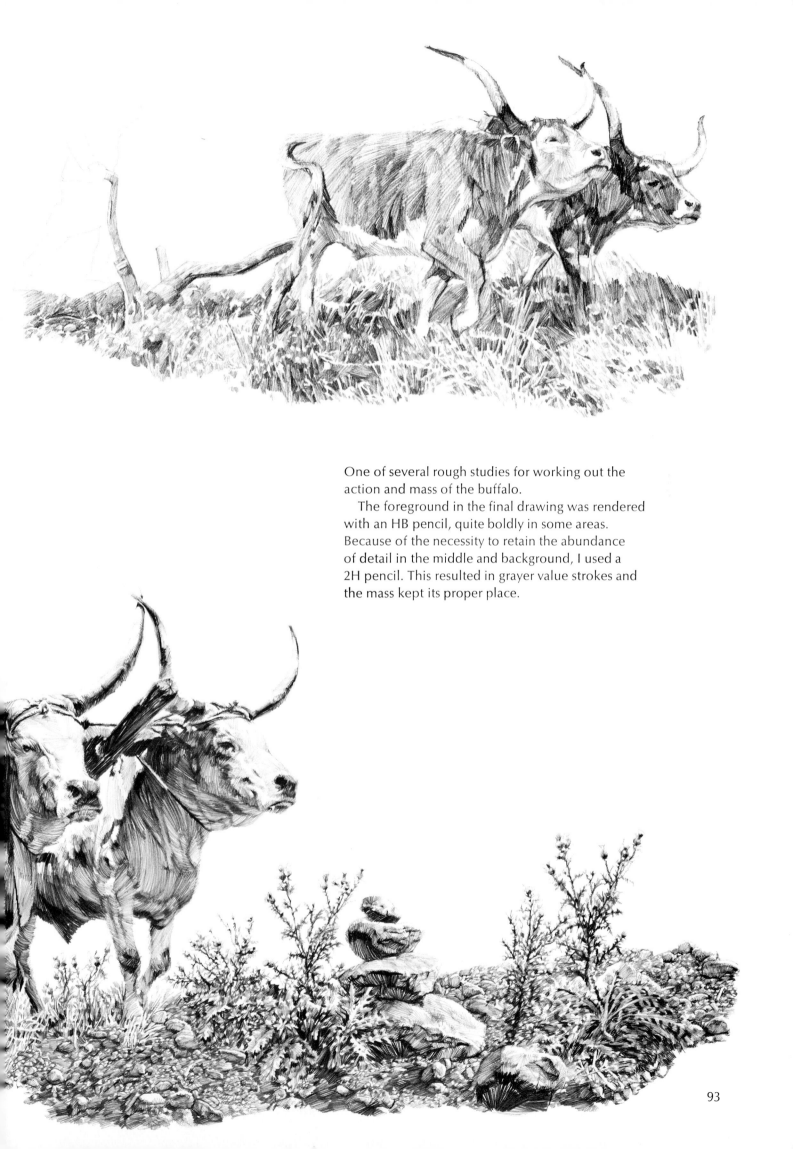

One of several rough studies for working out the
action and mass of the buffalo.

The foreground in the final drawing was rendered
with an HB pencil, quite boldly in some areas.
Because of the necessity to retain the abundance
of detail in the middle and background, I used a
2H pencil. This resulted in grayer value strokes and
the mass kept its proper place.

Once I read the script, the situation was quickly discovered. However, it took three rather comprehensive sketches before I decided on the final composition.

Although subordinate in size as related to the entire composition, the strong directional flow of strokes leads you immediately to the figures. My aim is to arrive at a sense of organization in my drawings. The thoroughness with which I plan my preliminary sketches is simply to avoid problems and indecision later on.

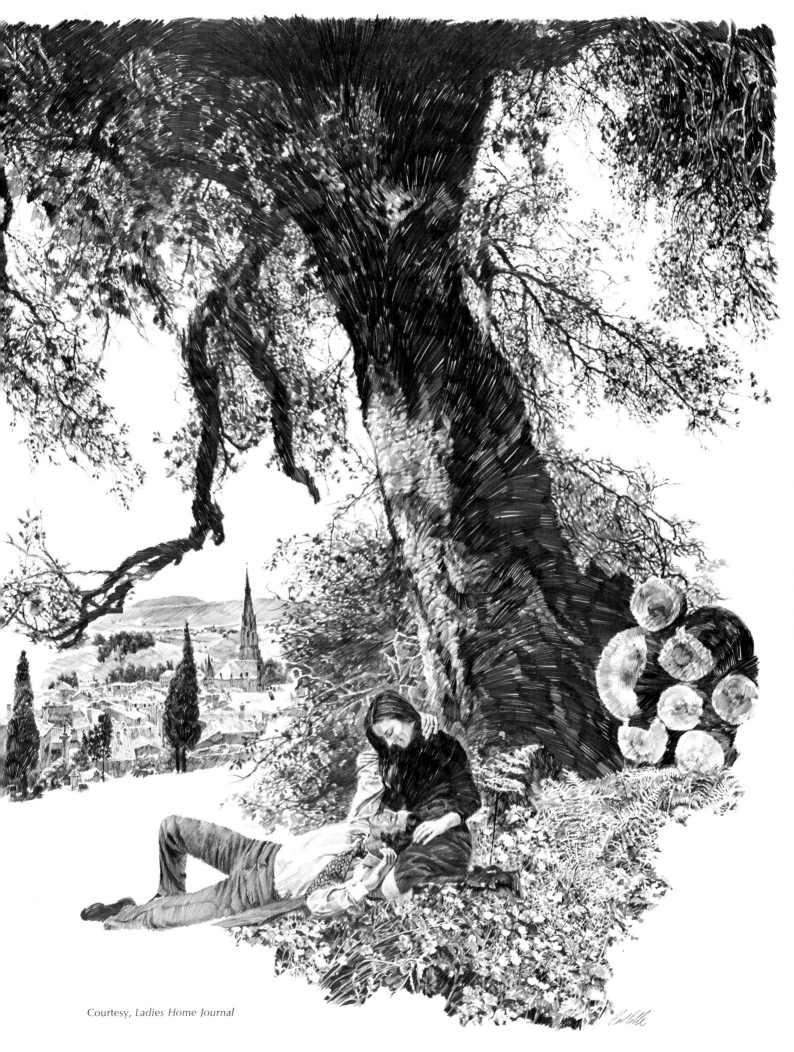

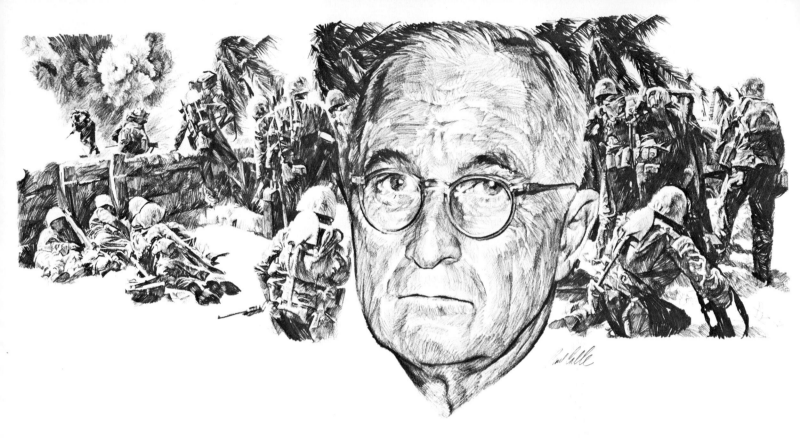

The drawings reproduced here are good examples of the vignette composition I enjoy doing. They appeared, along with several others, in the White House Historical Association book, *The Living White House*, which was published in cooperation with the National Geographic Society.

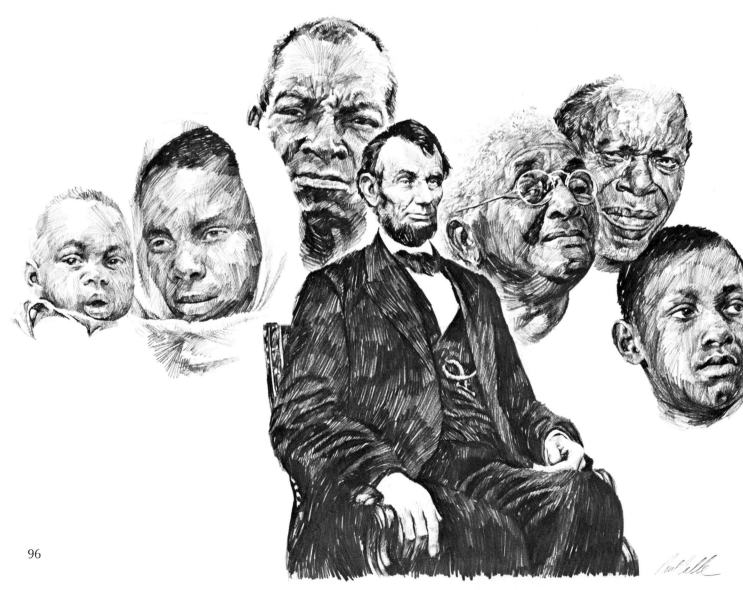

What has been left out is as important to the composition as what has been put in. Good use of the white area and the placement on the page are important considerations.

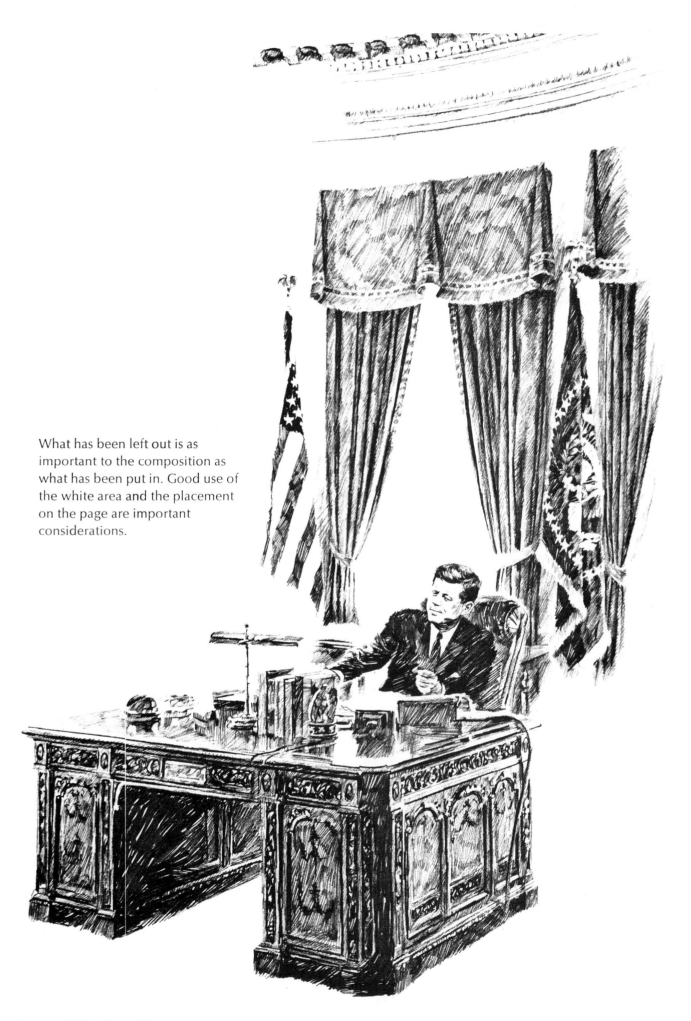

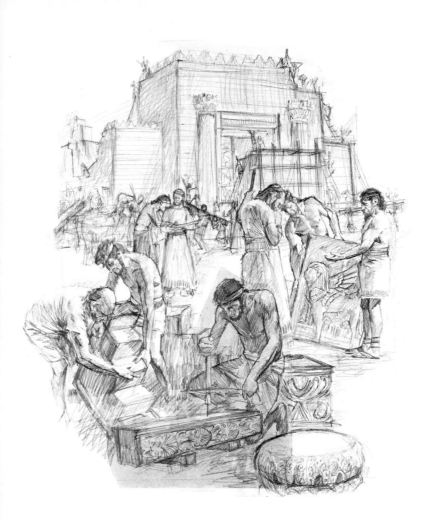

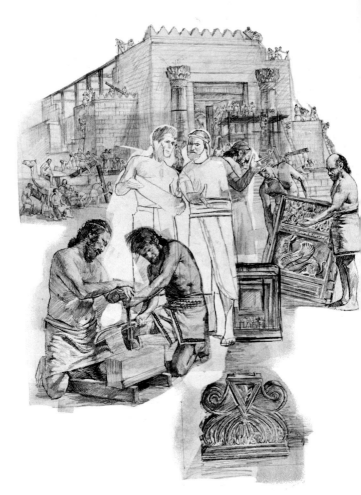

The first preliminary sketches were produced with the aid of material from my picture file. While the basic content was included in the original sketch, various stages evolved before the final drawing was achieved.

Several rough studies were tried before I arrived at the proper attitude for the main figures.

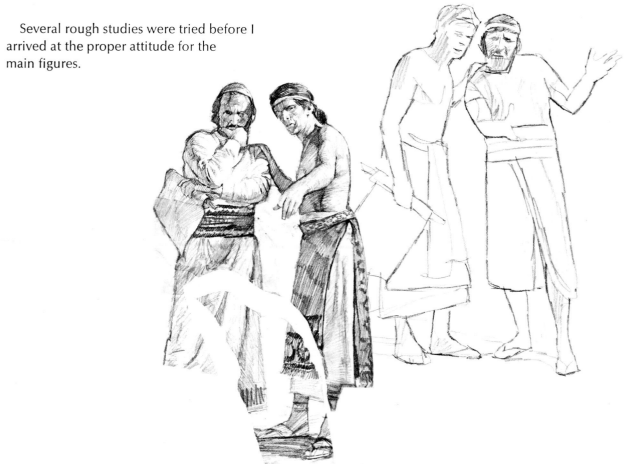

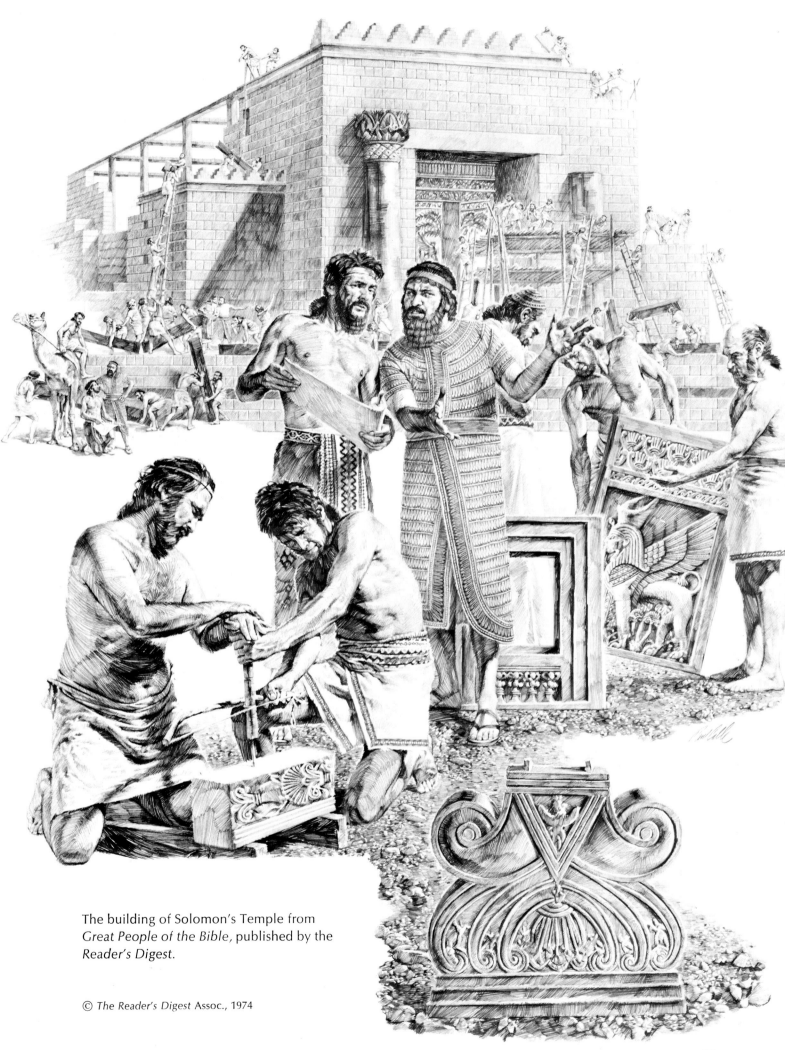

The building of Solomon's Temple from
Great People of the Bible, published by the
Reader's Digest.

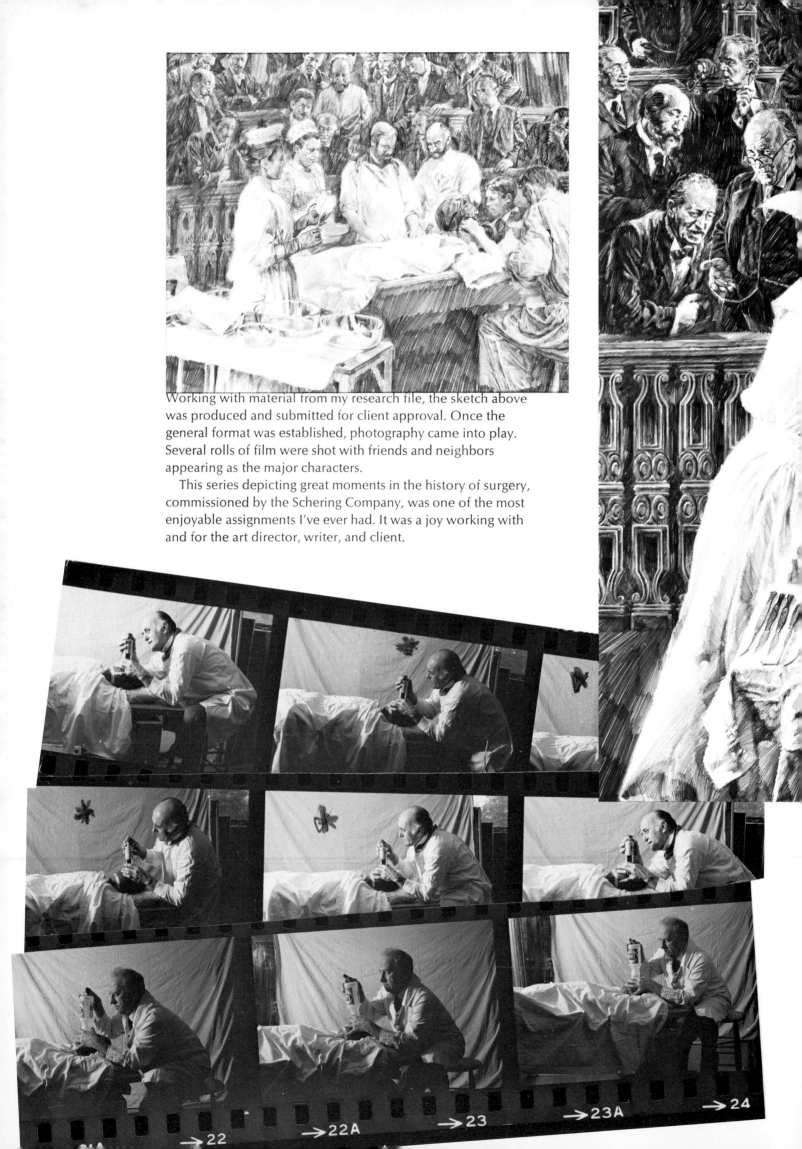

Working with material from my research file, the sketch above
was produced and submitted for client approval. Once the
general format was established, photography came into play.
Several rolls of film were shot with friends and neighbors
appearing as the major characters.

This series depicting great moments in the history of surgery,
commissioned by the Schering Company, was one of the most
enjoyable assignments I've ever had. It was a joy working with
and for the art director, writer, and client.

22 22A 23 23A 24

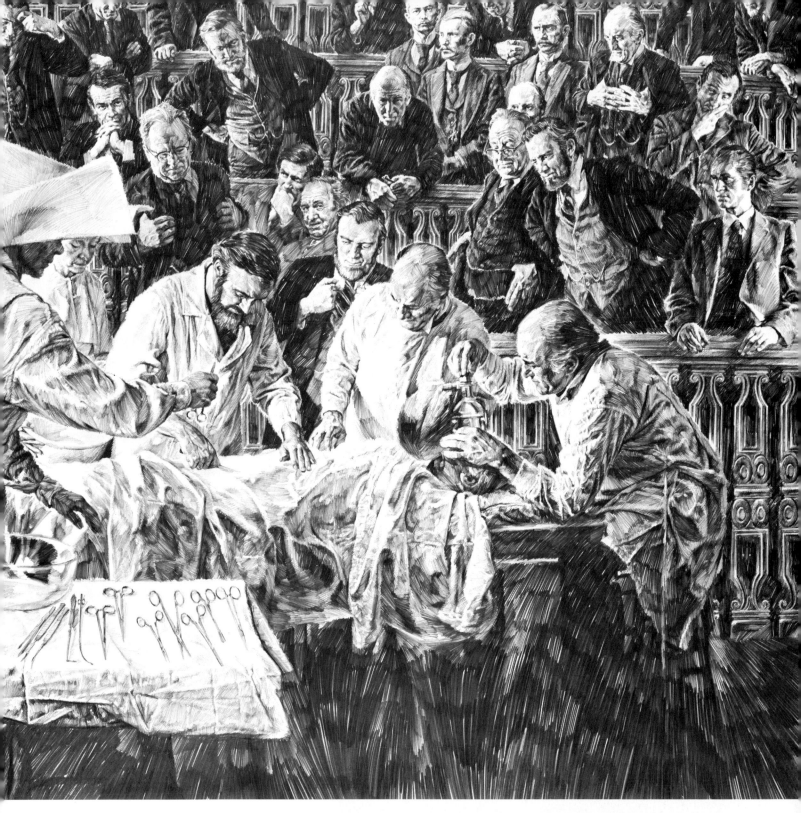

Courtesy, Schering Laboratories

This detail of character studies is reproduced at the same size as the original and gives an indication of the variety in the weight and direction of the pencil strokes. The technique is more reminiscent of an engraving or etching than the traditional pencil technique.

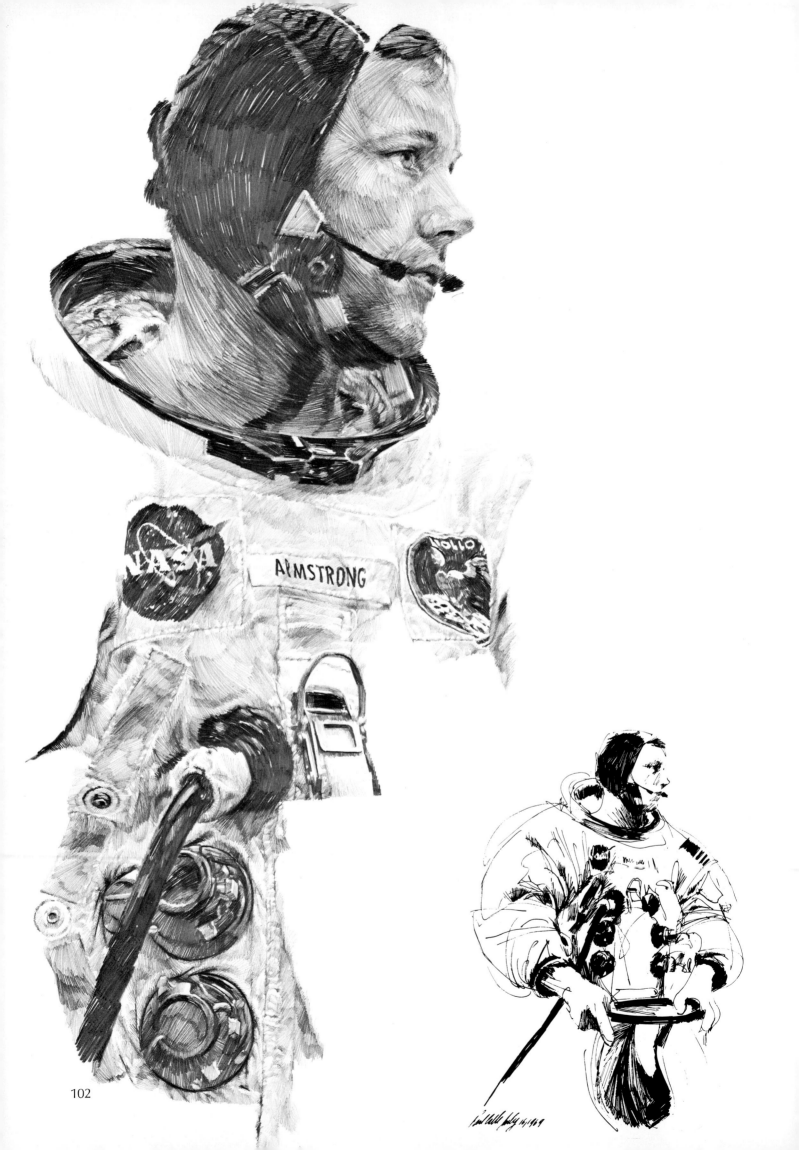

NASA

ARMSTRONG

APOLLO

102

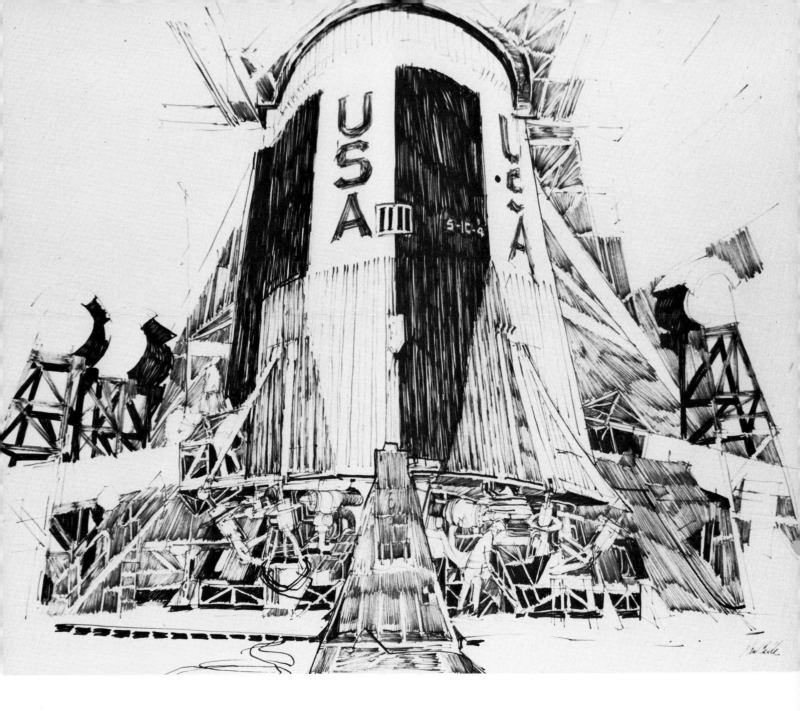

Courtesy, NASA

NASA

In 1962, Mr. James E. Webb, administrator of the National Space
and Aeronautics Administration, acting upon the advice given
him by Linton Wilson, Secretary of the United States Fine Art
Commission, and David Finley, former chairman of the National
Gallery of Art, inaugurated a program that was destined to play
an important role in my life. They initiated an art program that
had many precedents in history. The combat artists of World
War I and World War II, and the documentation of the Civil War
by artists such as Winslow Homer are immediately called to
mind. But the roots go even deeper into the 16th and 17th
centuries when explorers were accompanied by artists who
recorded the experiences they encountered. Most recent examples
have been the Air Force Historical Art Program and the National
Park "Artists in the Parks" program.

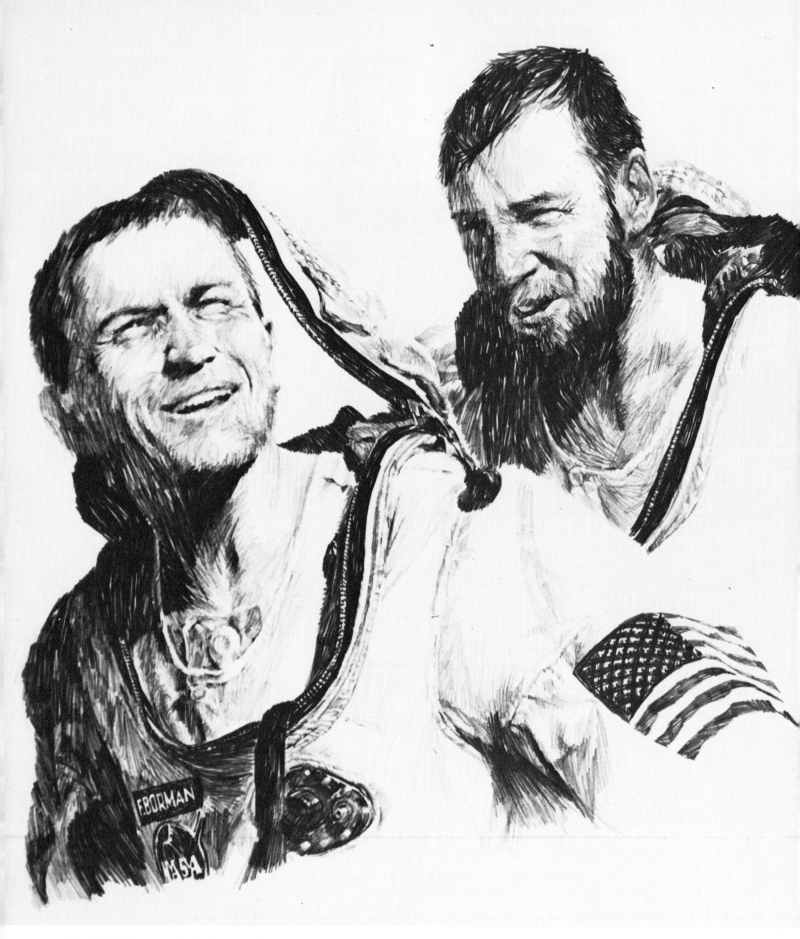

Gemini VII Astronauts Frank Borman and
James A. Lovell, Jr., after making the world's
longest manned orbital flight in 1966.

The exploration of the vast frontiers of space by the United States will undoubtedly be recorded as one of the most significant events in the history of man since creatures left the oceans and sought to change their basic environment.

What made the NASA Fine Art Program unique was that, unlike past undertakings, NASA had the singular significant advantage of being able to pinpoint an event of historic proportion. As Mr. Webb stated, "Important events can be interpreted by artists to give a unique insight into significant aspects of our history-making advances into space. An artistic record of this nation's program of space exploration will have great value for future generations and may make a significant contribution to the history of American art . . ."

I believe that the late H. Lester Cooke, Curator of Painting at the National Gallery of Art in Washington, D. C., best summed up the aspirations of all who have taken part in this program when he wrote at its inception, "Perhaps this project will help to prove to future generations that the United States in the sixties produced not only engineers and scientists capable of shaping the destiny of our age, but also artists worthy to keep them company."

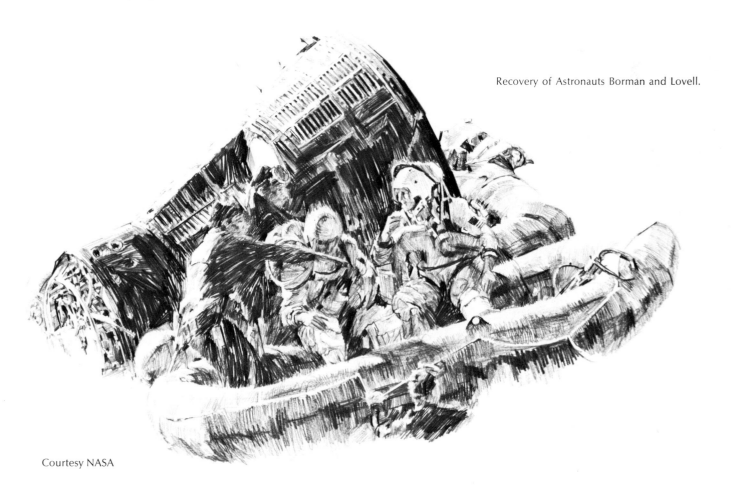

Recovery of Astronauts Borman and Lovell.

Courtesy NASA

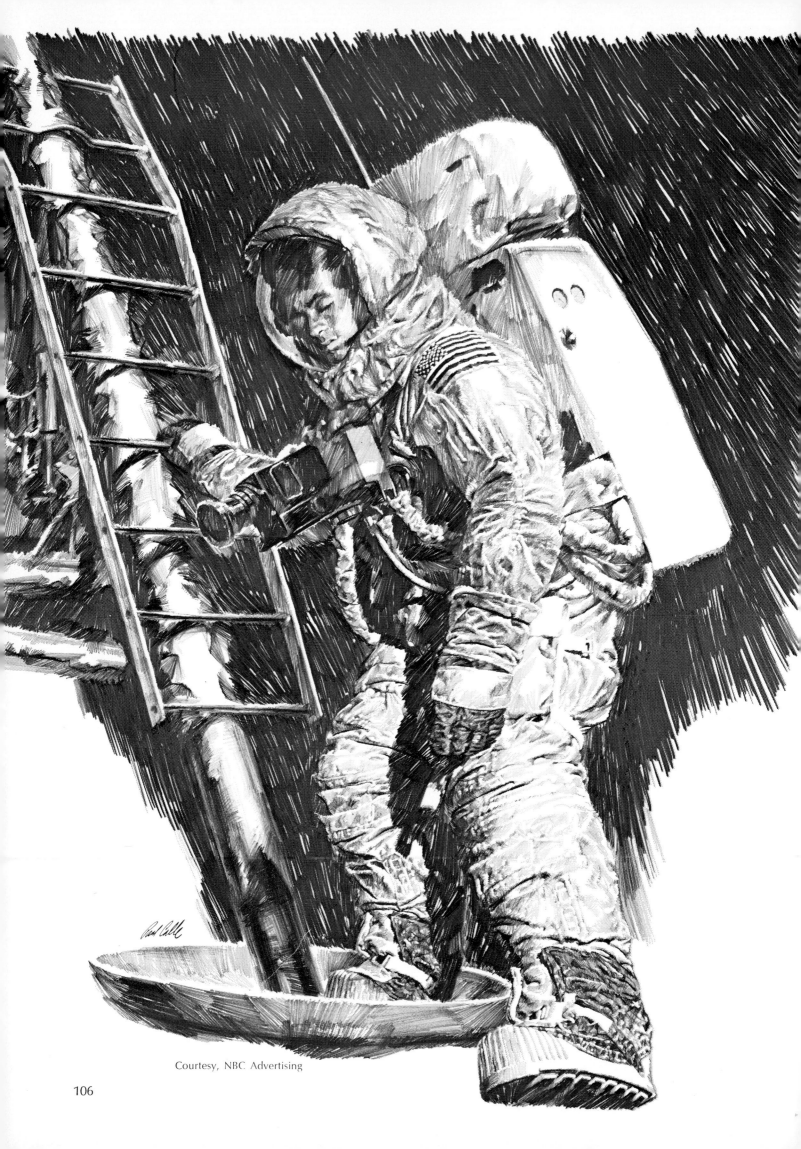

Courtesy, NBC Advertising

106

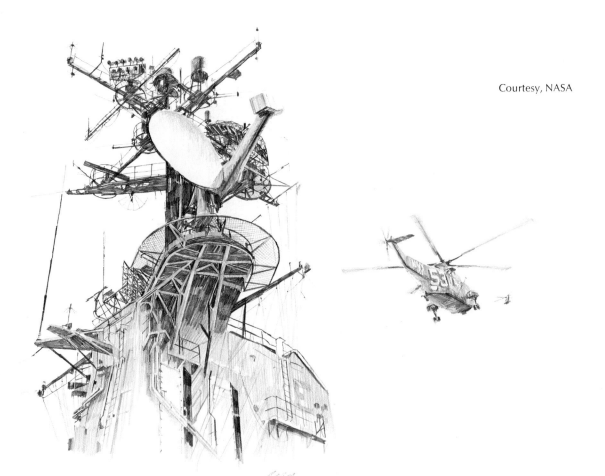

This diagram of the drawing depicting the first step on the moon is a good example of the functional use of the direction of line. The nature of the thrust, or direction of the stroke, is such that your eye is led down toward the foot where the headline and copy are. The drawing was commissioned by the National Broadcasting Company and appeared as a full-page ad in the *New York Times*.

THE LONGEST JOURNEY BEGINS WITH A SINGLE STEP

The step is, of course, the one that will be taken by astronaut Neil Armstrong when—early Monday morning—he becomes the first man to set foot on the moon.

In one sense, Armstrong's step will be the climax of an astounding procession of preliminary adventures in space. Yet the nearly incredible event we'll be watching Monday morning will be more of a beginning than an ending.

For who would now doubt that there are longer—much longer—journeys ahead? Or that one day this trip to the moon may take on the quaintness which now surrounds the Wright Brothers' 40-yard flight made less than 66 years ago?

And today the thrill of discovery is no longer the exclusive province of the explorer. Through television, and the far-flung operations of the networks' news divisions, millions upon millions of

spectators will be experiencing the exultation of astronaut Armstrong's first step onto a never-never land. And all those other first-steps in the wondrous journeys that lie ahead.

Such coverage is, for television, not merely a responsibility. We take it as a unique privilege.

NBC NEWS

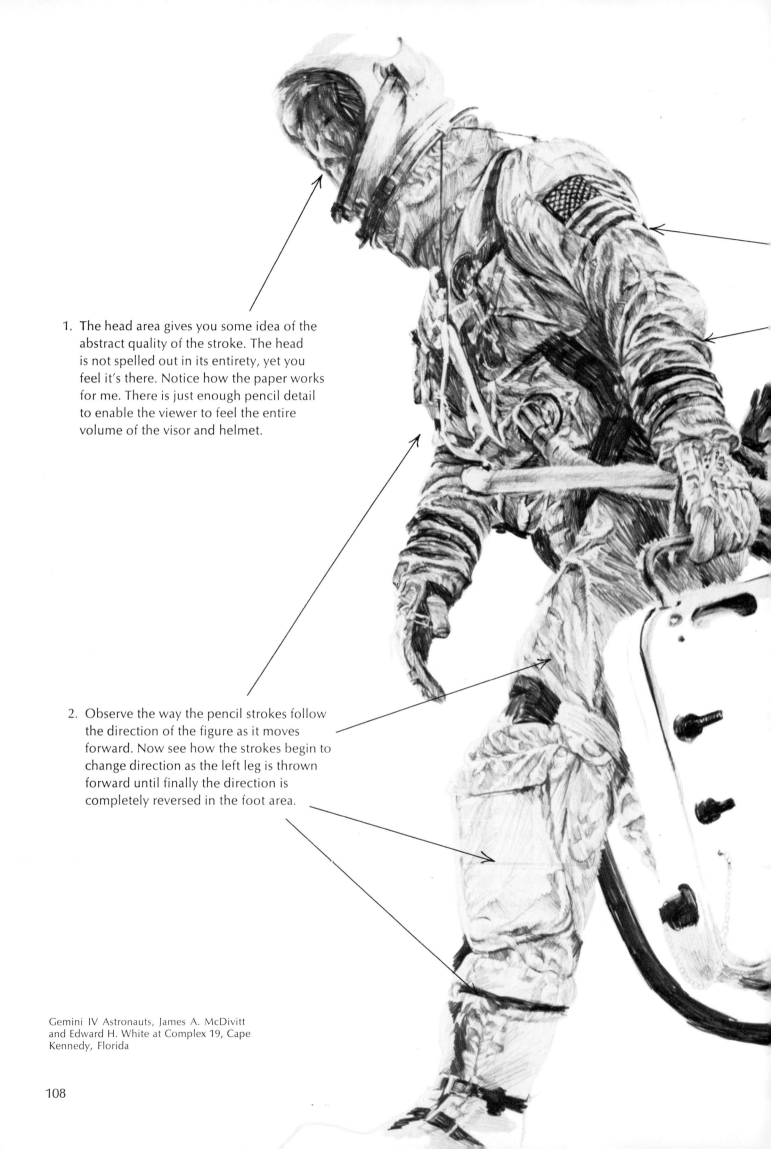

1. The head area gives you some idea of the abstract quality of the stroke. The head is not spelled out in its entirety, yet you feel it's there. Notice how the paper works for me. There is just enough pencil detail to enable the viewer to feel the entire volume of the visor and helmet.

2. Observe the way the pencil strokes follow the direction of the figure as it moves forward. Now see how the strokes begin to change direction as the left leg is thrown forward until finally the direction is completely reversed in the foot area.

Gemini IV Astronauts, James A. McDivitt and Edward H. White at Complex 19, Cape Kennedy, Florida

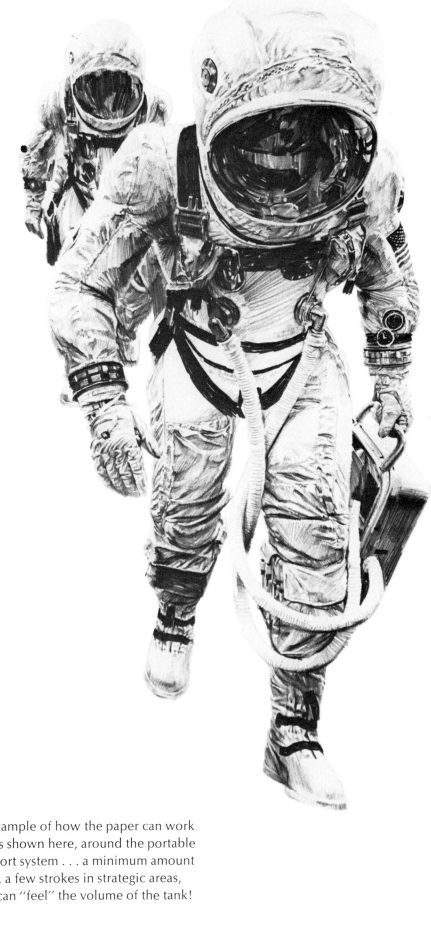

3. Note the variety and direction of the strokes employed in the rendering of this arm. They move in, around, and finally down as an indication of the weight being carried.

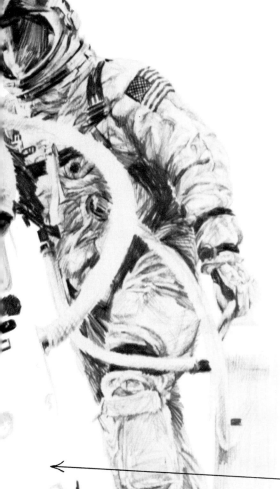

4. A fine example of how the paper can work for you is shown here, around the portable life support system . . . a minimum amount of detail, a few strokes in strategic areas, yet you can "feel" the volume of the tank!

5. Here you can see all the strokes in direct opposition creating a feeling of movement.

Courtesy NASA

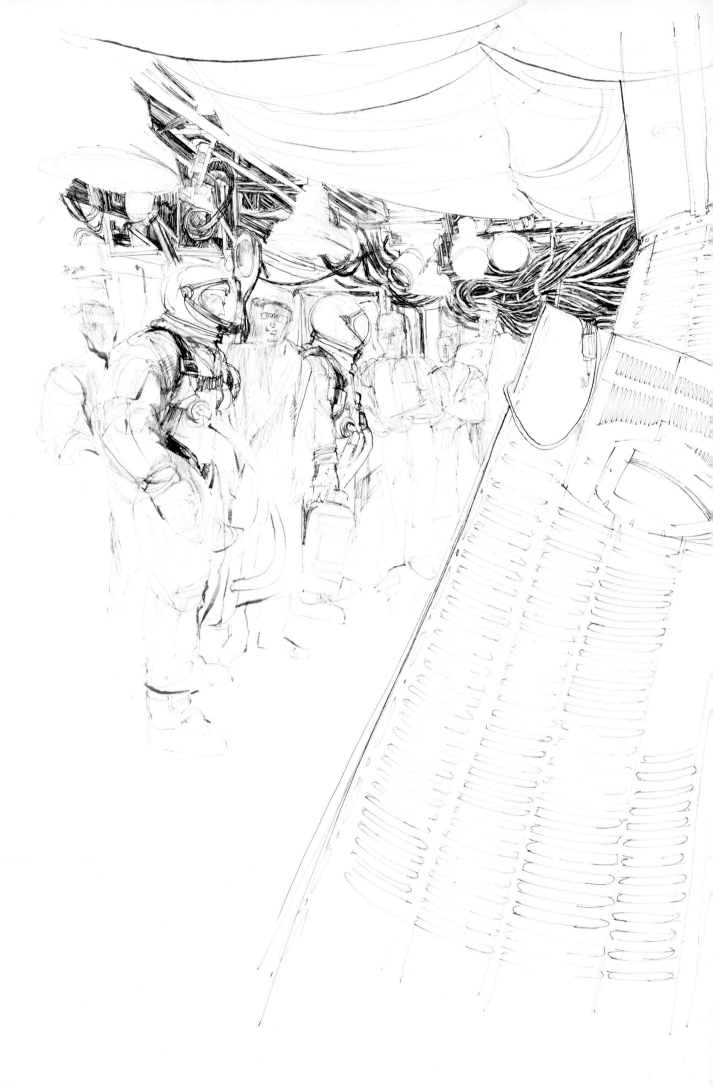

The NASA Fine Art Program has always attached great importance to the immediacy and spontaneity achieved in on-the-spot sketches. Great care has been taken to gather and preserve even seemingly insignificant scrawls.

This sketch of the astronauts about to enter the spacecraft was part of my assignment to document the activities of the Gemini project — an assignment that took me from the launch facilities of Cape Kennedy to the recovery carrier in the South Atlantic. While sketching, I am aware and conscious of the positive nature of paper left untouched. The abstract shape of areas left out is as important as those covered.

The final drawing was 22 by 30 inches on D'Arches Satiné finished paper executed from material recorded in my "photographic sketchbook" and photographs from the NASA files.

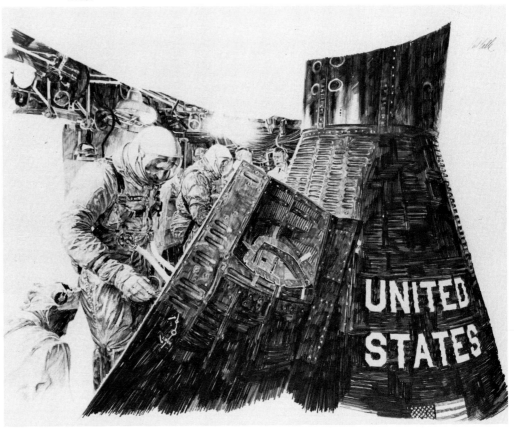

Courtesy NASA

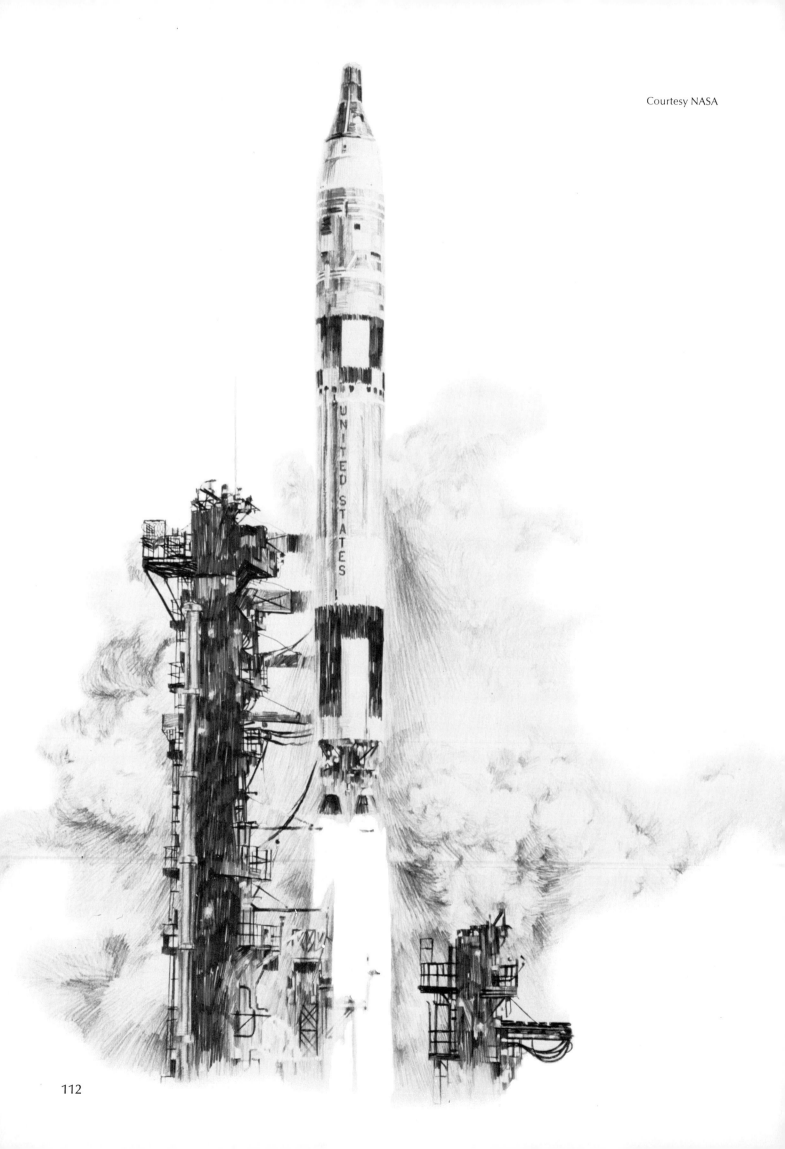

112

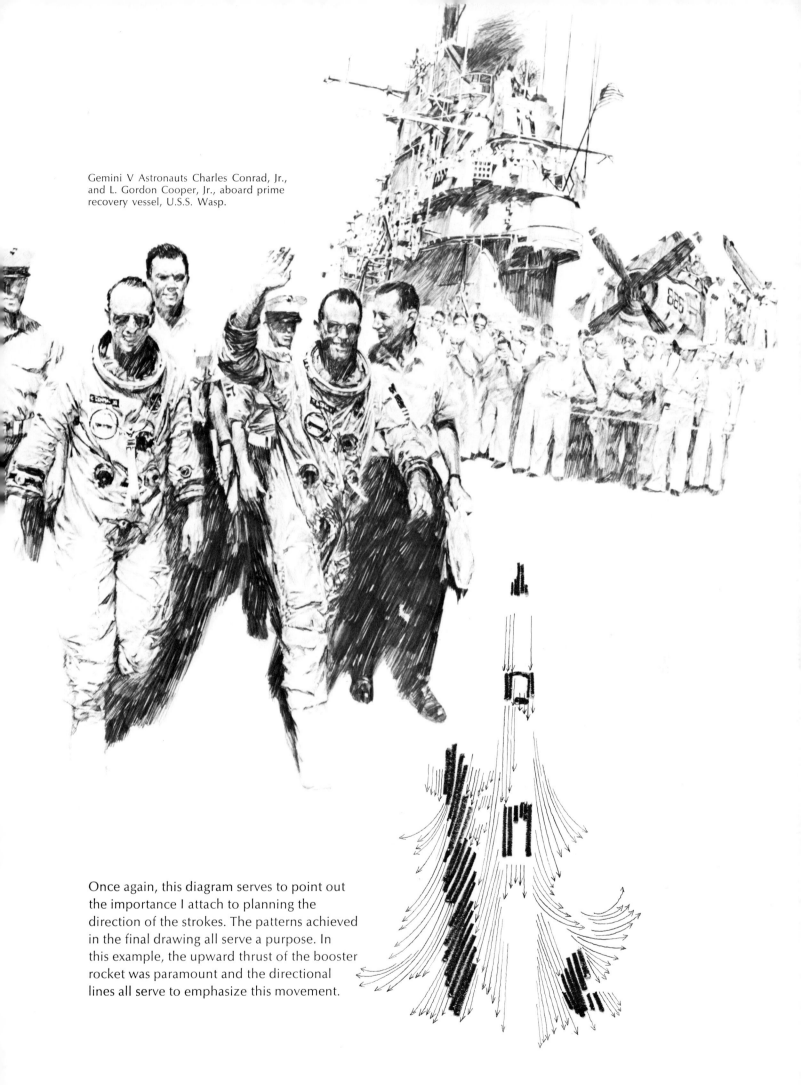

Gemini V Astronauts Charles Conrad, Jr., and L. Gordon Cooper, Jr., aboard prime recovery vessel, U.S.S. Wasp.

Once again, this diagram serves to point out the importance I attach to planning the direction of the strokes. The patterns achieved in the final drawing all serve a purpose. In this example, the upward thrust of the booster rocket was paramount and the directional lines all serve to emphasize this movement.

INDUSTRIAL

In direct contrast to the historical importance that NASA attaches to the on-the-spot drawings (they actually form an integral part of all NASA assignments), my industrial commissions for the most part do not require this approach. My sketching is kept to a minimum and basically is of interest only to me. While on industrial assignments, research material is gathered mainly through photographs that I take at various locations. Time always seems to be at a premium, and I find that the camera affords me the opportunity to make the maximum use of it. In a relatively short period of time, I am able to record several variations on any given situation from various angles and points of view. With the additional use of wide angle and fish-eye lenses that are available, highly unusual perspective viewpoints can also be explored and recorded for possible use, all with relative ease and mobility. Additionally, I gather as much printed material as is available at the site. Company stock photographs, annual reports and brochures can often serve as valuable research material.

Back in my studio, once the film has been processed and contact sheets provided, the process of selection comes into play and the process of extracting pertinent material begins.

Material is selected that will, when combined graphically, provide the best possible solution for the situation to be portrayed. This is always a difficult time, for there usually are several possibilities to every situation. On rare occasions, one photograph will suffice; however, the combination of several is more the norm.

Of course, the experience of having been at the actual site gives me the added authority to make more effective judgments in the selection of the right elements, and to create the impression of authenticity in the final drawing that the simple rendering of details from stock photographs could never match.

The drawings, reproduced here and on the following page, were from an annual report commissioned by the St. Joe Minerals Corporation and were executed on D'Arches 140 lb. Satiné paper. The pencil was HB.

ZINC CASTING
Herculaneum, Missouri

Underground lead mining.

The drawings reproduced here were made for an annual report for St. Joe Minerals Corporation. Over a period of ten days, I viewed zinc mining at Balmat-Edwards Division in upper New York State; zinc smelting at Monaca, Pennsylvania; zinc casting at Herculaneum, Missouri; construction of a new mine shaft at Bushy Creek, Missouri and the construction of a new sulfuric acid plant in Southeast Missouri.

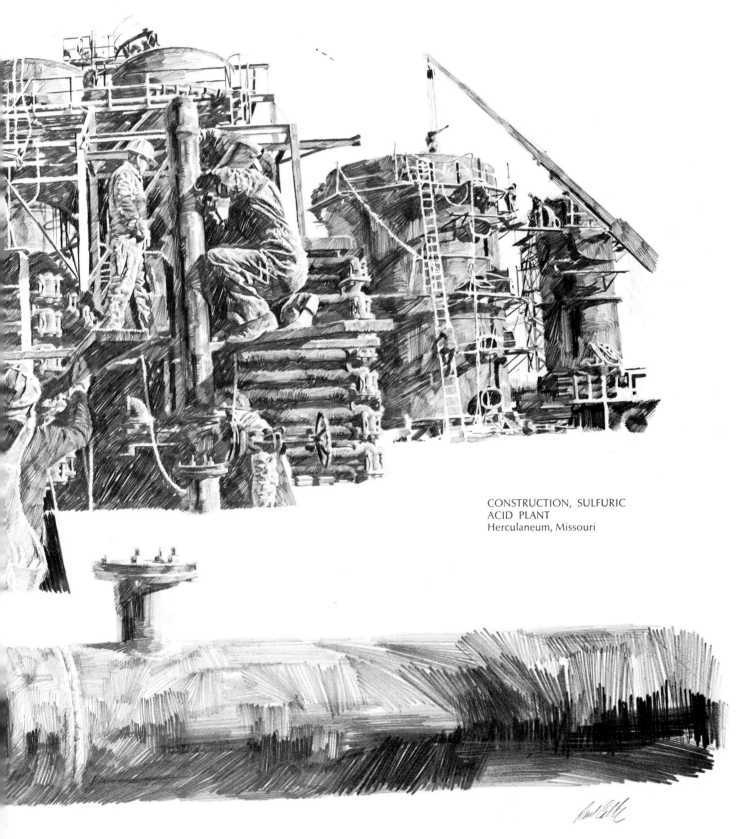

CONSTRUCTION, SULFURIC
ACID PLANT
Herculaneum, Missouri

INDUSTRY · SHIPBUILDING

INDUSTRY · CONSTRUCTION

A Cargo of Propane
Explodes at Sea

It is impossible for me to overstress the value and importance I attach to keeping a pictorial research file. For the student, it is a project worth beginning at an early stage in one's development and for the professional, it is a necessity that will prove to be an invaluable time-saving research aid.

This assignment for the Continental Insurance Company offers an excellent case in point. It would have been impossible to visit all the plant sites and localities to gather the pictorial material necessary to complete the assignment in the required time. By utilizing my research files, supplemented by additional material borrowed from the picture collection of the public library, I was able to assemble this montage of industrial plants in a relatively effortless and time-saving way.

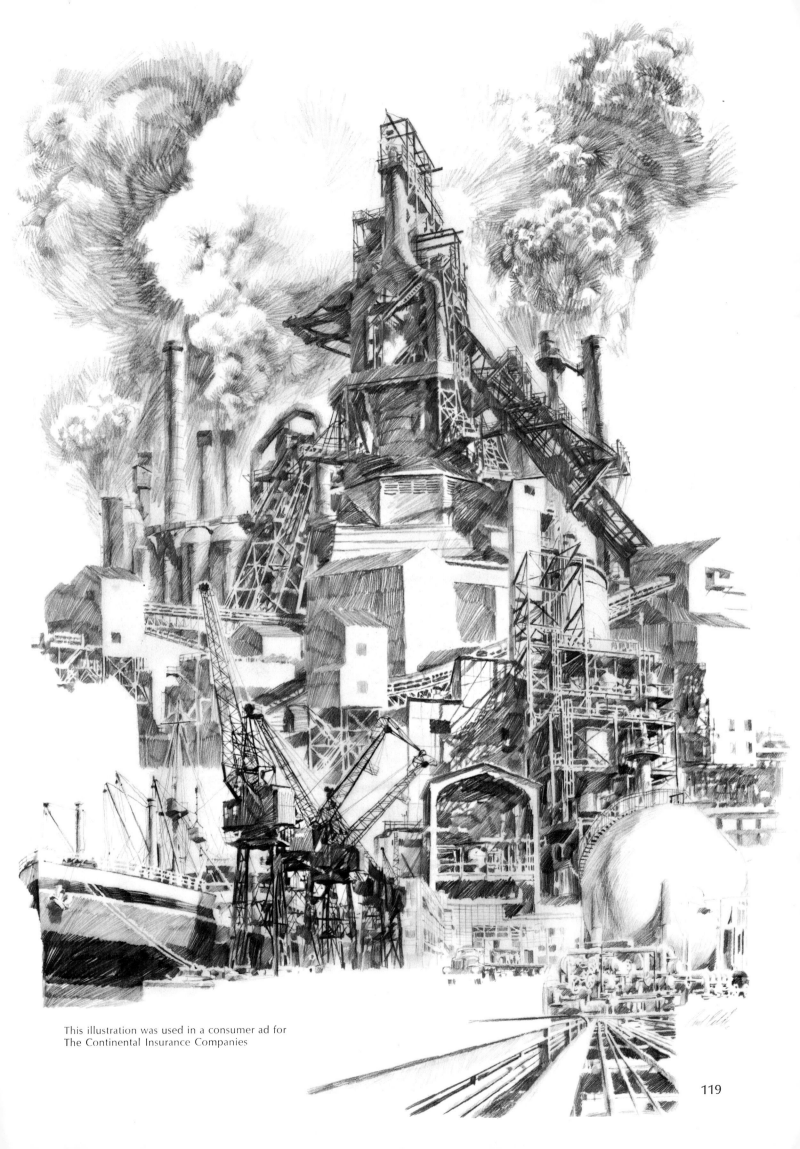

This illustration was used in a consumer ad for
The Continental Insurance Companies

119

 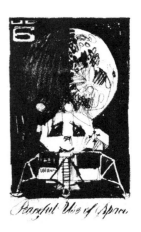

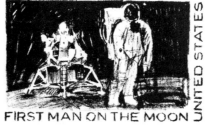

FIRST MAN ON THE MOON STAMP

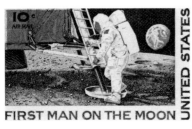

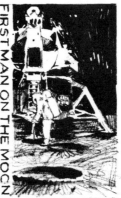

FIRST MAN ON THE MOON

U.S. Postal Service Photos. Further reproductions prohibited without written authorization from the U.S. Postal Service.

POSTAGE STAMPS

Designing stamps is truly a unique experience! The subject matter is chosen for its national significance, usually of historic importance, and the conception of the design must be thought of in terms of art in miniature form. Rather than "think big" the designer must think small!

I have had the privilege of designing several commemorative stamps for the United States Postal Service. Each stamp presented a unique challenge due to the nature of the event commemorated. I imagine that if I have any claim to fame, it would be as the artist who designed the historic air mail stamp that commemorated that moment when man first landed and set foot upon the moon. This historic scientific achievement afforded the post office an opportunity for a truly spectacular commemorative issue. And spectacular it became with distribution and sales of over 152,264,000 stamps!

The assignment came as the outgrowth of a series of assignments executed for the NASA Fine Art Program. Proceeding in complete secrecy, the Postmaster General, Mr. Winton M. Blount, advised Mr. Stevan Dohanos, chairman of the Postmaster General's Citizens Stamp Advisory Committee, of the plan to issue a commemorative, and I was recommended for the assignment on the basis of my previously designed Twin Space Stamps of 1967. The fact that I was also working on a NASA project in connection with the Apollo 11 mission to the moon afforded me easy access to material and key personnel at NASA who could help with technical problems.

My initial rough thinking sketches explored the concept of a design incorporating the Moon, Earth and the lunar landing module. My second series of rough pencil sketches evolved into the "First Man on the Moon" concept. In the evolution of the design, it quickly became obvious that the first step on the Moon was the most dramatic moment, and with that final sketch we knew we had our design!

The master die, from which all subsequent plates were made and stamps printed, was carried to the surface of the Moon by the Apollo 11 crew, and the "Moon Letter" with its die proof was cancelled by the astronauts on their way back to Earth after the landing on the Moon.

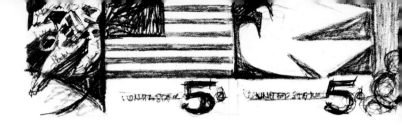

TWIN SPACE STAMP

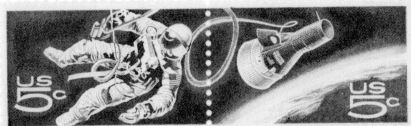

The design for the first "Twin Space Stamp" presented me with a challenge unique in postal stamp design at the time. The assignment was to design a commemorative issue that would symbolize the successful conclusion of the NASA Project Gemini program of space exploration. The unique aspects of the challenge was to conceive a design that graphically would be pleasing when used as a double stamp, and, when one twin was separated from the other, the design of the single stamp had to be a complete composition on its own.

In this series of pencil sketches, you can easily see my approach to design conception. I literally made a list of all aspects of the Gemini program that I felt were significant. This ranged from the tangible scientific and engineering achievements of the men and spacecraft to NASA's stated aim of the peaceful exploration of space for all mankind. Again, I followed my usual procedure by executing a number of "thinking" rough sketches encompassing all the possible combinations I could think of. When I exhausted all these approaches, I arranged to meet with Stevan Dohanos to discuss the rough designs. At our meetings, we attempted to eliminate any designs that in this second look really were not significant subjects. Sometimes elements are found that are strong in several designs, and by combining them, one can come up with a singular design concept.

In the case of the "Twin" stamp, we found very early that the first United States walk in space was visually most exciting and seemed to summarize the success of the Gemini Project. Together, we chose four designs and then I prepared comprehensive sketches which were submitted to the Citizens Stamp Advisory Committee.

The First Walk in Space was chosen as the design best suited to symbolize the successful conclusion of the Gemini Project, and the finish was painted in tempera.

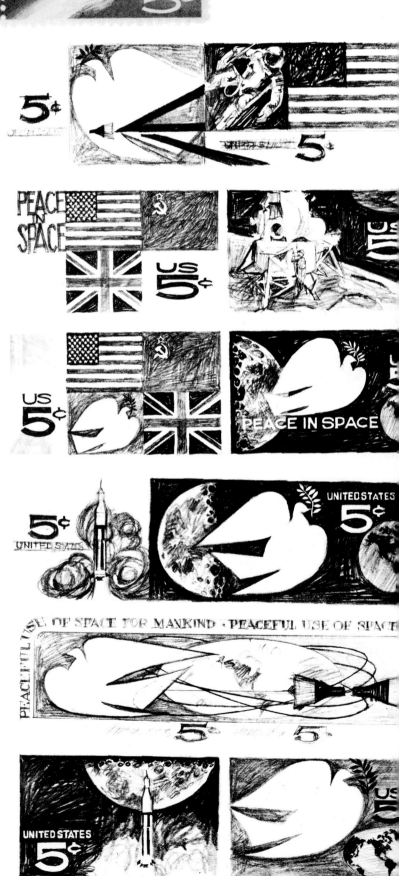

122

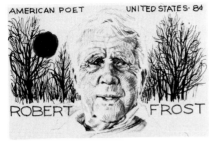

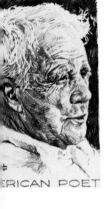
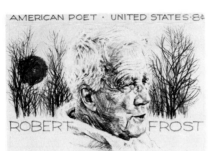

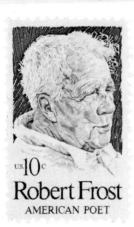

ROBERT FROST DOUGLAS MACARTHUR

In both the Douglas MacArthur and Robert Frost Commemorative Stamps, the desire of the Postal Service was for a simple design featuring a strong portrait.

I proceeded to execute a variety of portraits in pencil based upon photographs acquired from various sources. In the case of Douglas MacArthur, my primary sources of reference were the news services: Associated Press, Wide World, and United Press International. Mr. Frost's publisher, Holt, Reinhart and Winston, was most helpful in providing me with a variety of photographs. After completing the designs, primarily portrait studies, I thought it important that there should be some alternate selections.

I conceived a series of designs that I felt gave an added dimension to the men. For Douglas MacArthur, I created a number of designs utilizing the West Point motto of Duty, Honor, Country that seemed to best exemplify the man. The Frost design encompassed a portrait intertwined with the sky, trees and rocks the author loved and so often wrote about.

The original thoughts of the Postal Service prevailed and we did end up with the "portrait" design. However, I had the personal satisfaction of exploring all the possibilities I felt were significant.

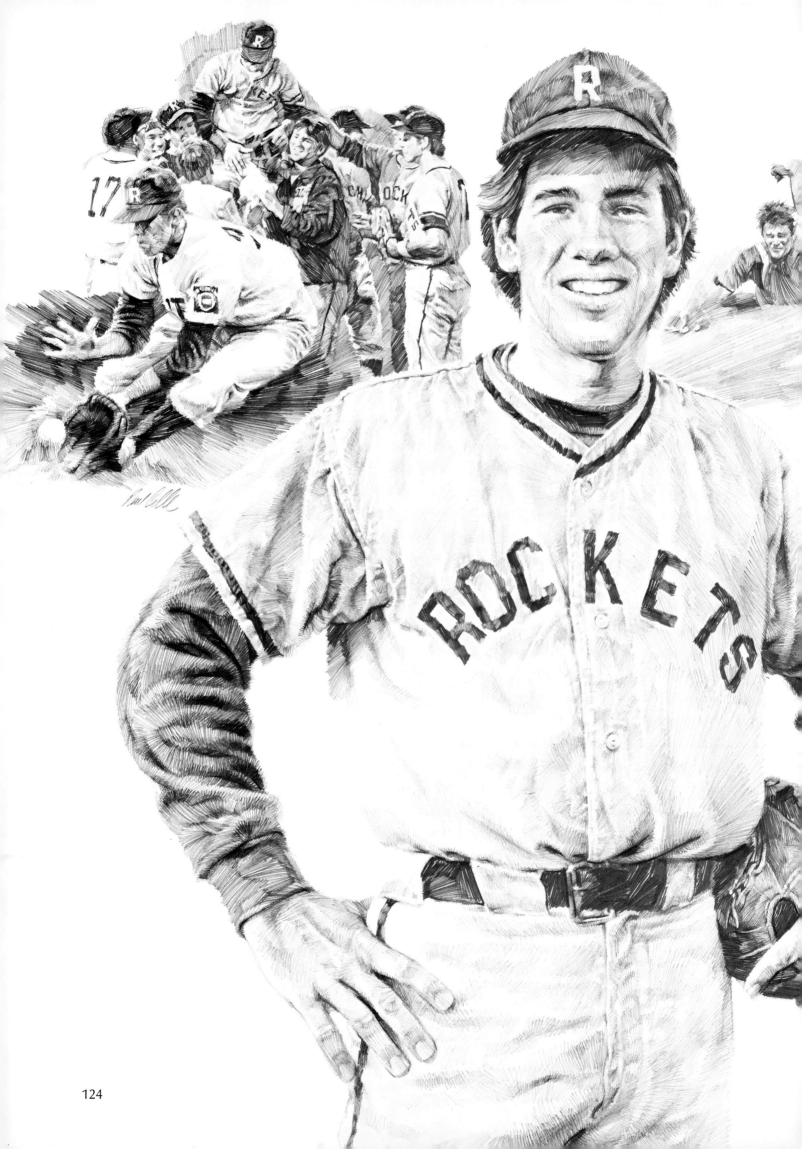

124

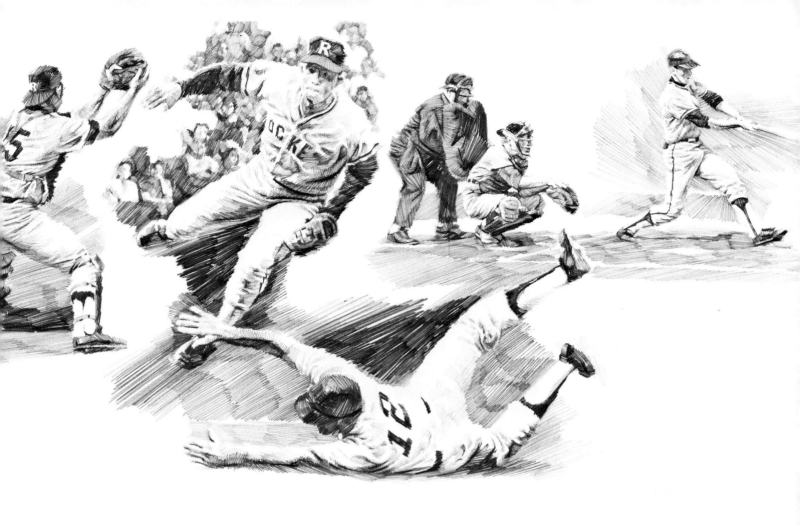

SPORTS

There are some illustrators who tend to specialize in certain subject categories. I am not sure whether this is a conscious effort on the artists' part or if they have become pigeon-holed by art directors. In going through this book, it should be quite evident that I have not been limited as to subject content. I enjoy making all kinds of pictures. Whether the subject be sports or designing United States postage stamps, I find it a challenge and a joy!

"Shortstop" by Bill Gutman for *Boys' Life,* original 30 by 40 inches on Strathmore 4 ply Bristol.

Courtesy, *Boys' Life* magazine

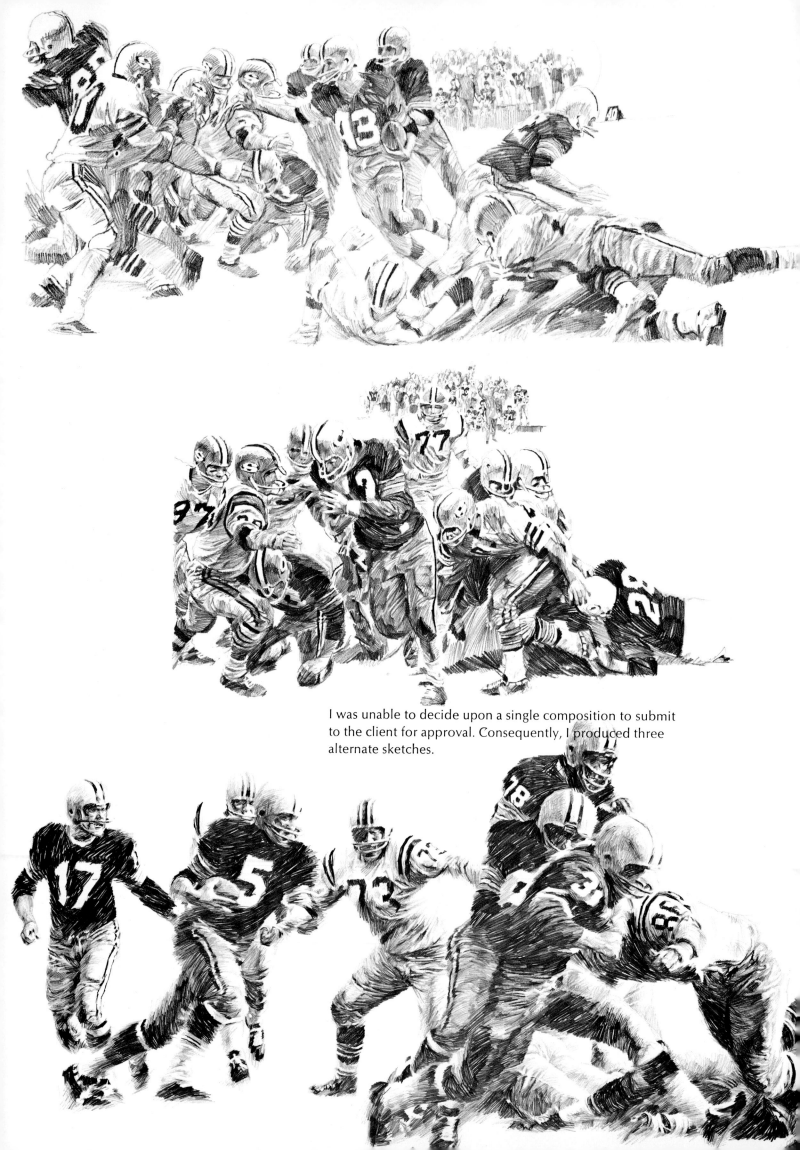

I was unable to decide upon a single composition to submit to the client for approval. Consequently, I produced three alternate sketches.

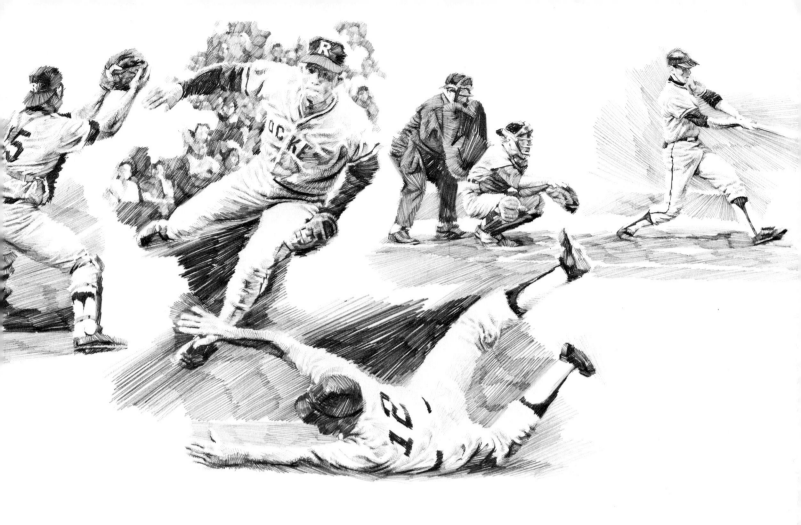

SPORTS

There are some illustrators who tend to specialize in certain subject categories. I am not sure whether this is a conscious effort on the artists' part or if they have become pigeon-holed by art directors. In going through this book, it should be quite evident that I have not been limited as to subject content. I enjoy making all kinds of pictures. Whether the subject be sports or designing United States postage stamps, I find it a challenge and a joy!

"Shortstop" by Bill Gutman for *Boys' Life,* original 30 by 40 inches on Strathmore 4 ply Bristol.

Courtesy, *Boys' Life* magazine

125

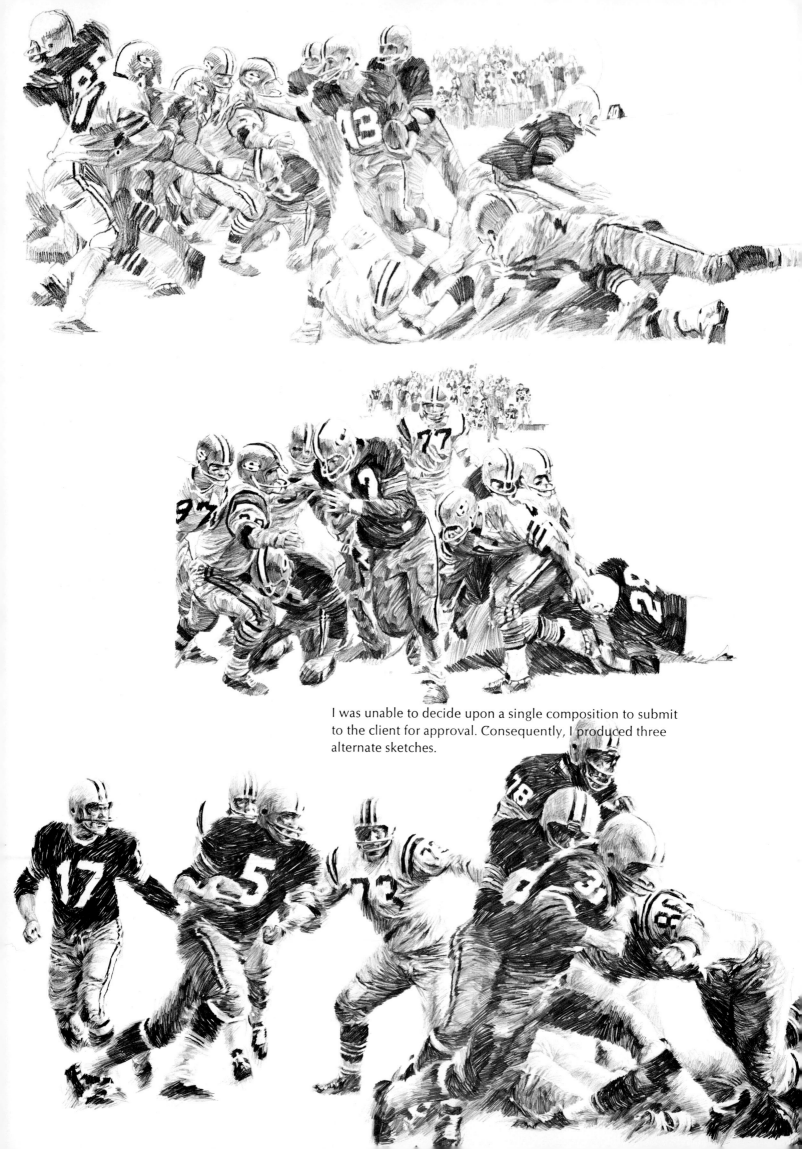

I was unable to decide upon a single composition to submit to the client for approval. Consequently, I produced three alternate sketches.

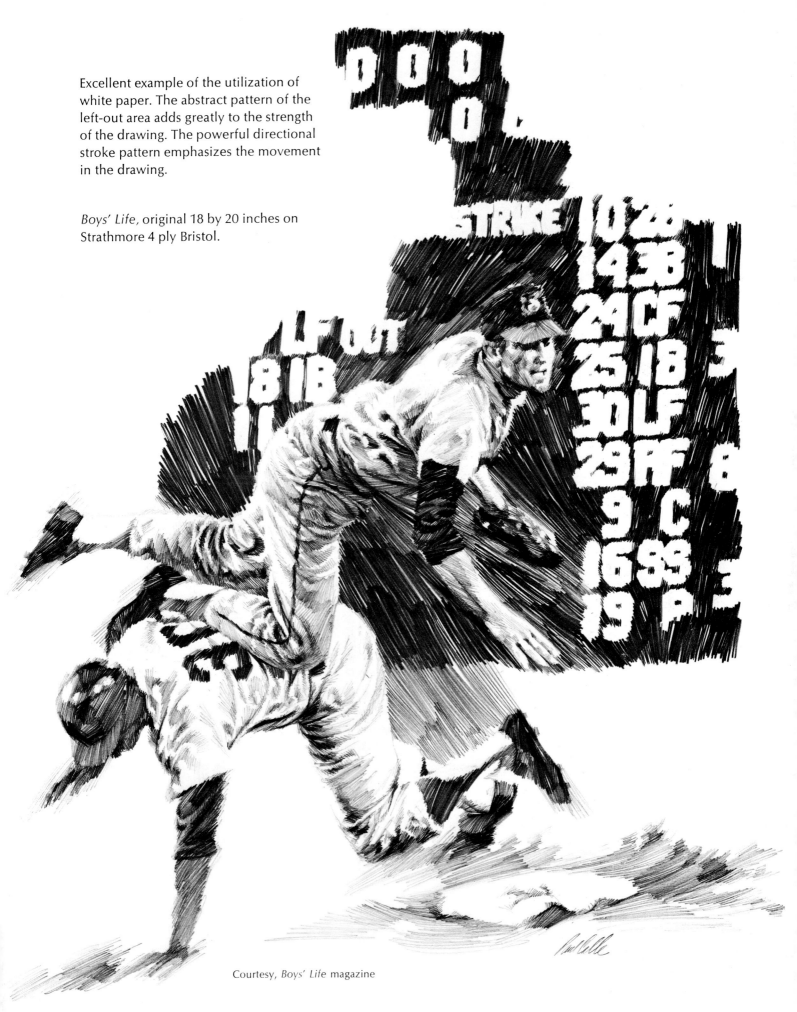

Excellent example of the utilization of white paper. The abstract pattern of the left-out area adds greatly to the strength of the drawing. The powerful directional stroke pattern emphasizes the movement in the drawing.

Boys' Life, original 18 by 20 inches on Strathmore 4 ply Bristol.

Courtesy, *Boys' Life* magazine

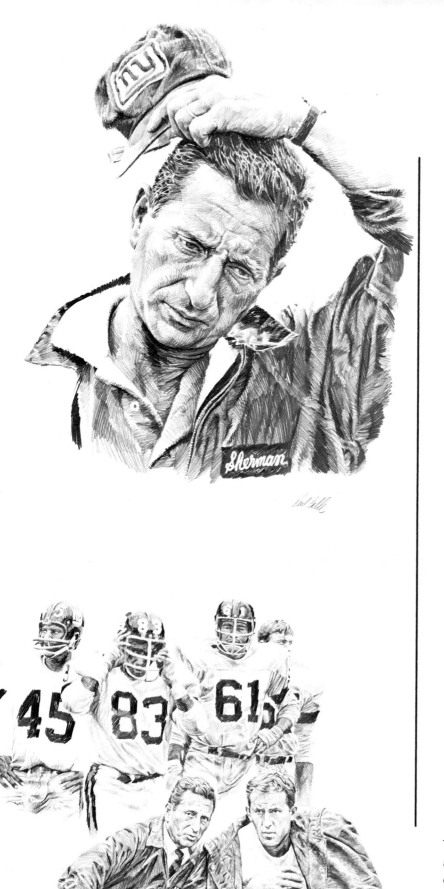

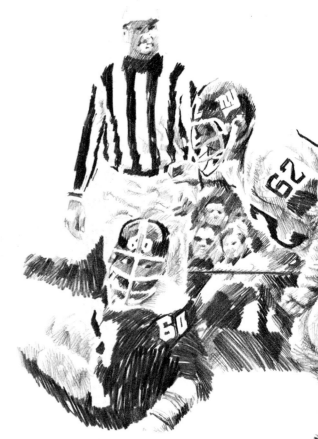

Three of a series of drawings for a story about the New York Football Giants executed for *The Saturday Evening Post*. Good use of the white paper created what I feel is a strongly designed vignette.

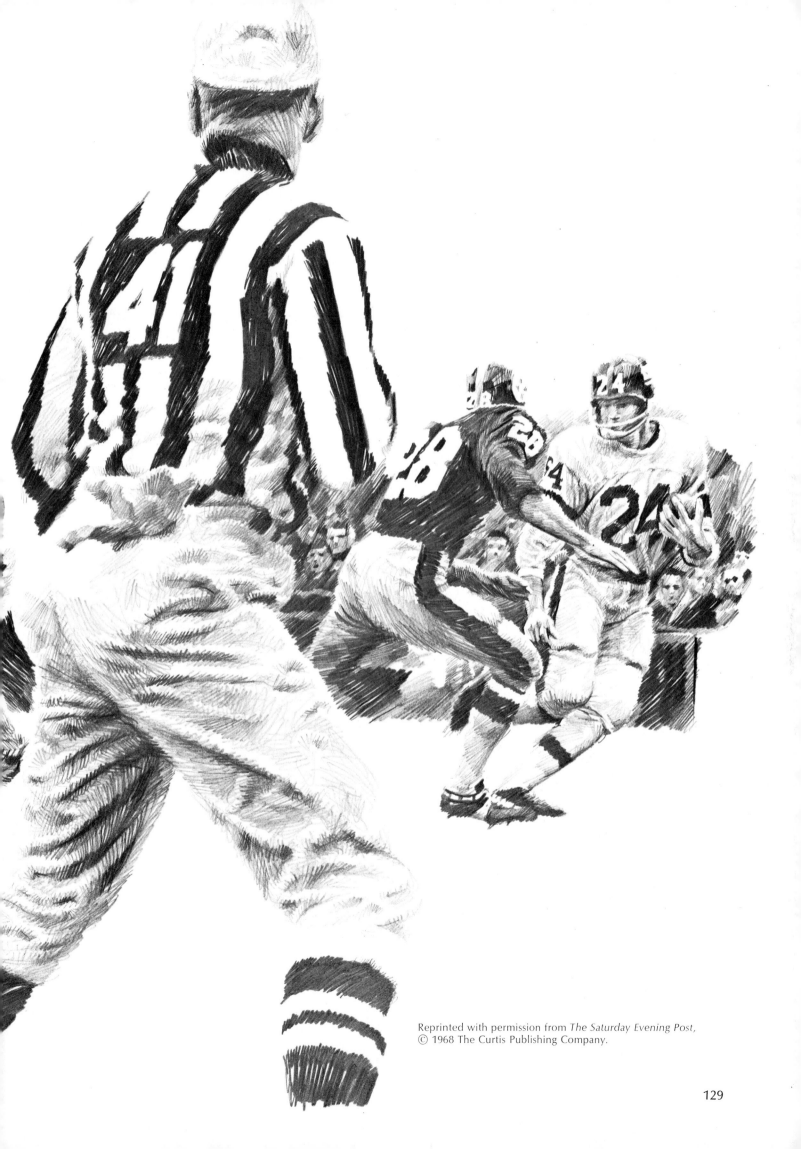

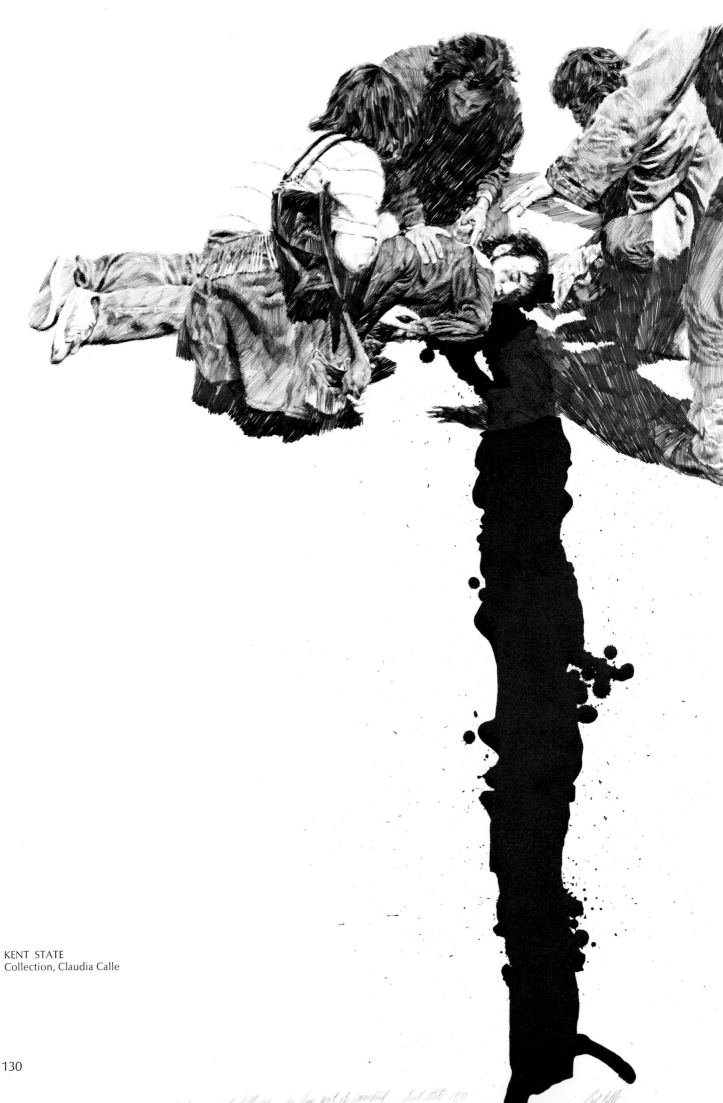

KENT STATE
Collection, Claudia Calle

130

EDITORIAL
ILLUSTRATION

Earlier, I wrote about my appreciation of not being stereotyped as to the subject content of assignments. Although it's true that the assignments have called specifically for my pencil technique, the subject material has ranged over a broad spectrum; and I have always been grateful for this, accepting each assignment as a new challenge.

While a large portion of my work has been produced for advertising, the majority of my assignments have been in the editorial illustration category. Among the magazines I have illustrated for are *McCall's, Redbook, Ladies' Home Journal, The Saturday Evening Post, Boy's Life, National Geographic, Look* and *Holiday*. The scripts I accept to illustrate are for the most part ones that emotionally attract me to the possibility of making a good picture. One must remember that the primary purpose of editorial illustration is to produce a picture that will stimulate the viewer to read the story. At its best, editorial illustration is a cooperative venture between the art director and the artist, a joint effort between two people who respect each other's contributions. Usually a general discussion takes place about possible situations in the script and the relationship of the story to the special interests of the specific magazine audience. When a solution is reached and the format is established, the illustrator is given (or should be given) the freedom to exercise his feelings for the dramatic import of the story. While reading the script, I usually make quick pen and ink compositional sketches of possible solutions. The quick sketches, which have meaning only to me, are then refined to make them visually legible when submitted for approval to the art director.

Since my work is very realistic, a considerable amount of research goes into my final drawings. Consequently, I am an ardent believer in the value of a well-kept research file. My file contains not only pictures scrapped from books and magazines, but also my "photographic sketch books." The final version of the illustration is further enhanced by additional employment of models, costumes, and props.

What starts out in the beginning as a companion piece to the written word . . . hopefully (from the artist's viewpoint), ends up as the dominant element. Unlike the traditional concept of the landscape painter who paints the scene before him, the illustrator is given a script to work with, and the picture is conceived in his imagination.

The illustration at left, not commissioned, but for exhibition, was my own editorial comment about the tragedy at Kent State.

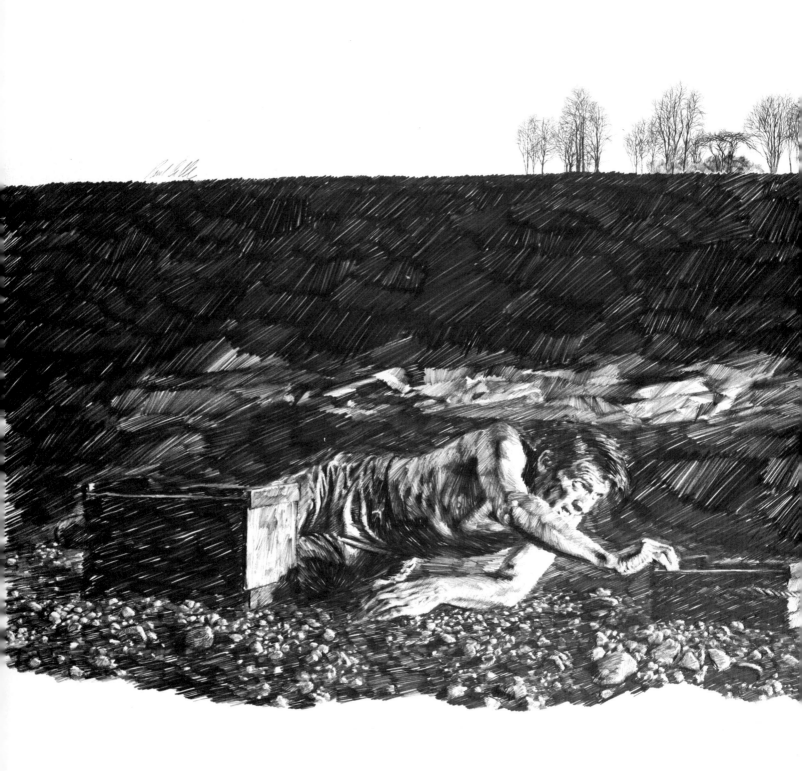

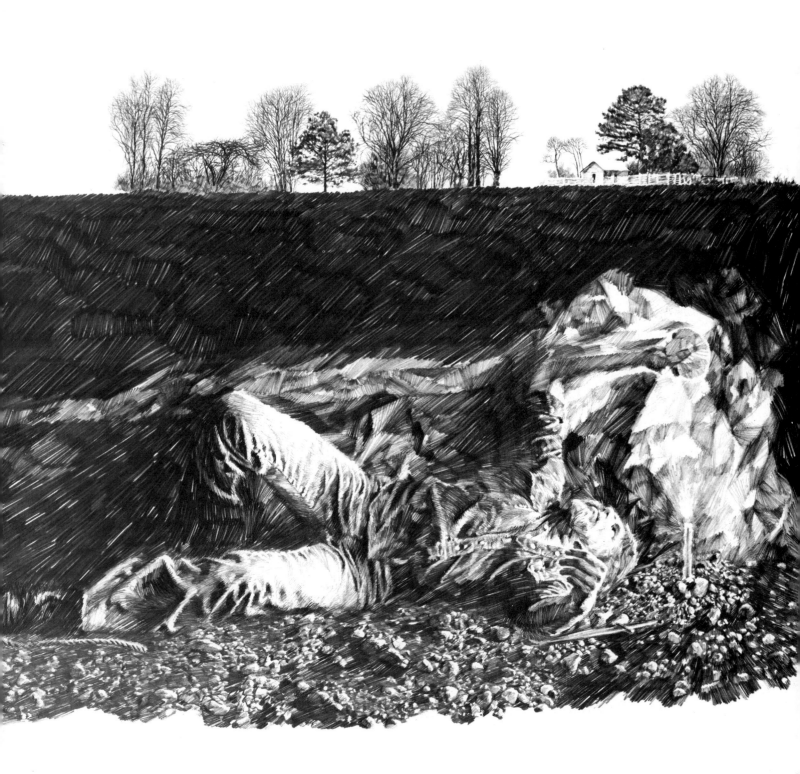

The original drawing is 14 by 40 inches. The pencil was HB and the paper was a 4-ply Strathmore, plate finished. The story was for *Boys' Life* magazine and was reproduced as a four-page spread.

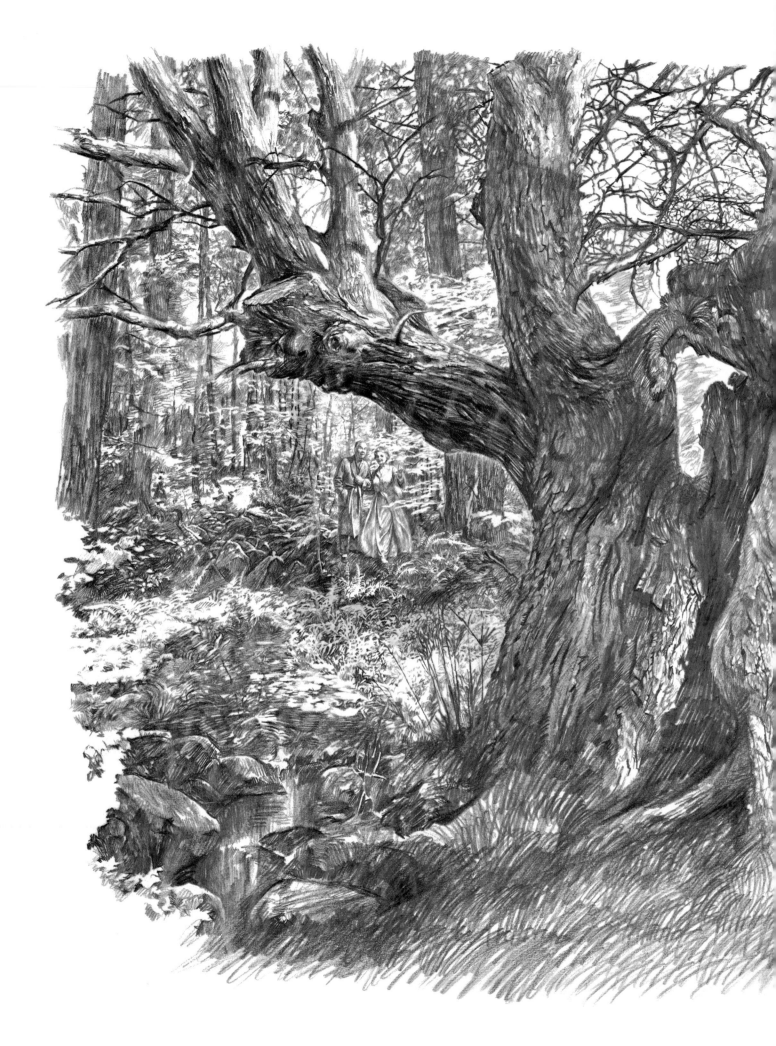

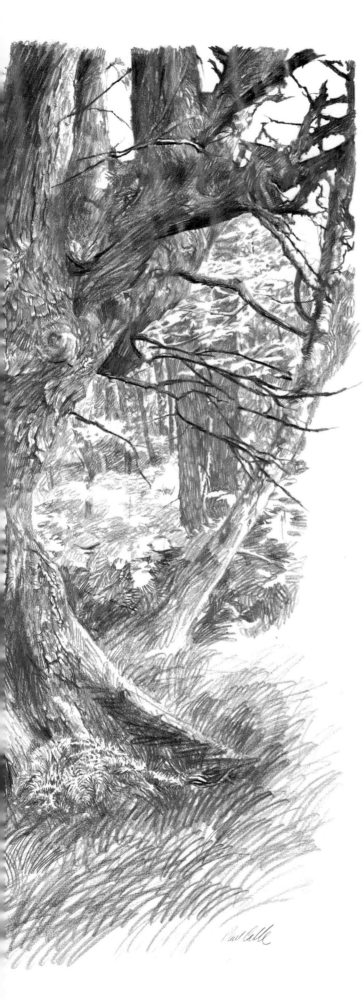

I have written earlier of the thoroughness with which I prepare preliminary drawings that I submit for clients' approval prior to its transfer to the final paper for finish. When this preliminary sketch was submitted to *McCall's Magazine* for approval, the art director decided to reproduce it as finished art. The sketch was drawn on Friedman's 214 tracing paper using an HB pencil.

Courtesy *McCall's Magazine*, September, 1967.

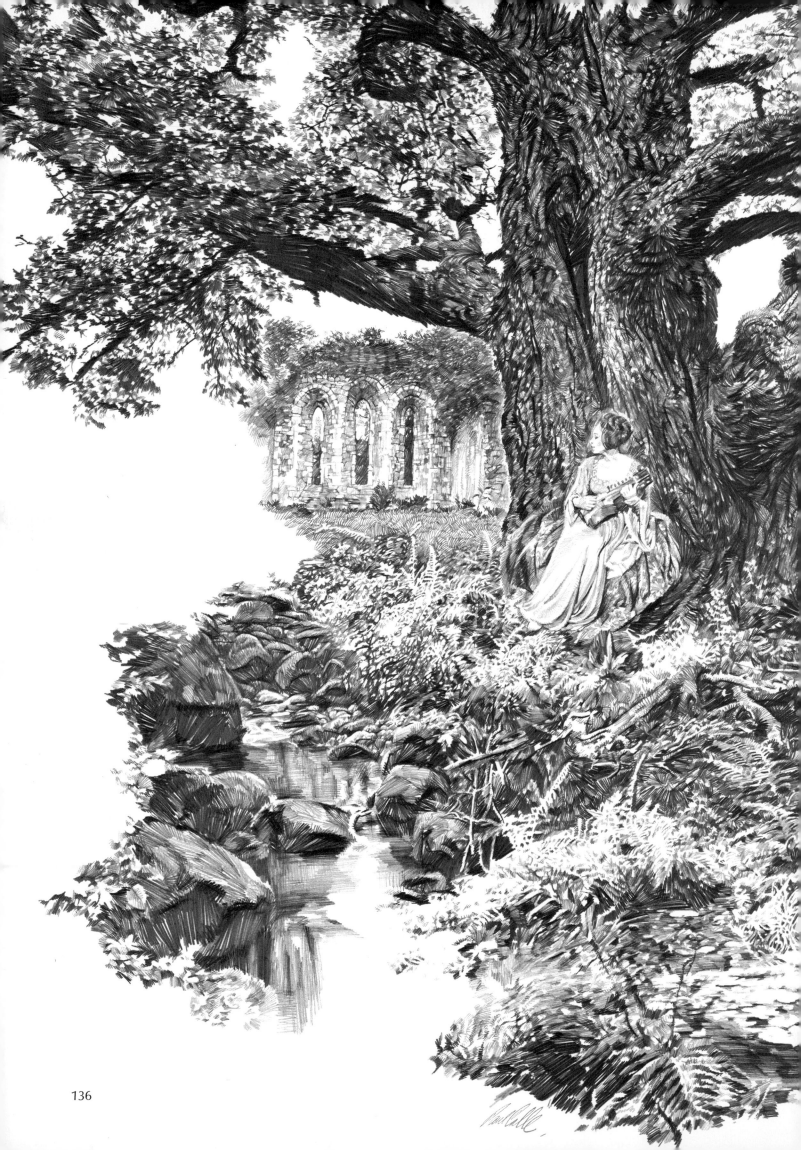

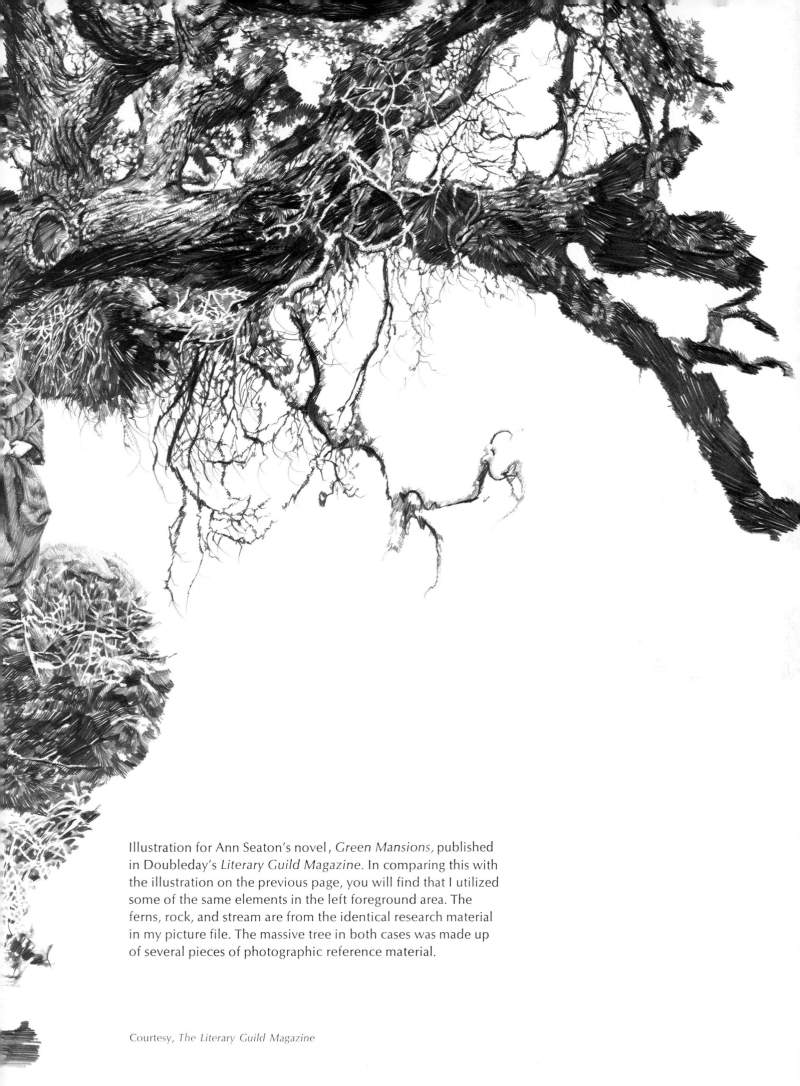

Illustration for Ann Seaton's novel, *Green Mansions,* published
in Doubleday's *Literary Guild Magazine*. In comparing this with
the illustration on the previous page, you will find that I utilized
some of the same elements in the left foreground area. The
ferns, rock, and stream are from the identical research material
in my picture file. The massive tree in both cases was made up
of several pieces of photographic reference material.

Courtesy, *The Literary Guild Magazine*

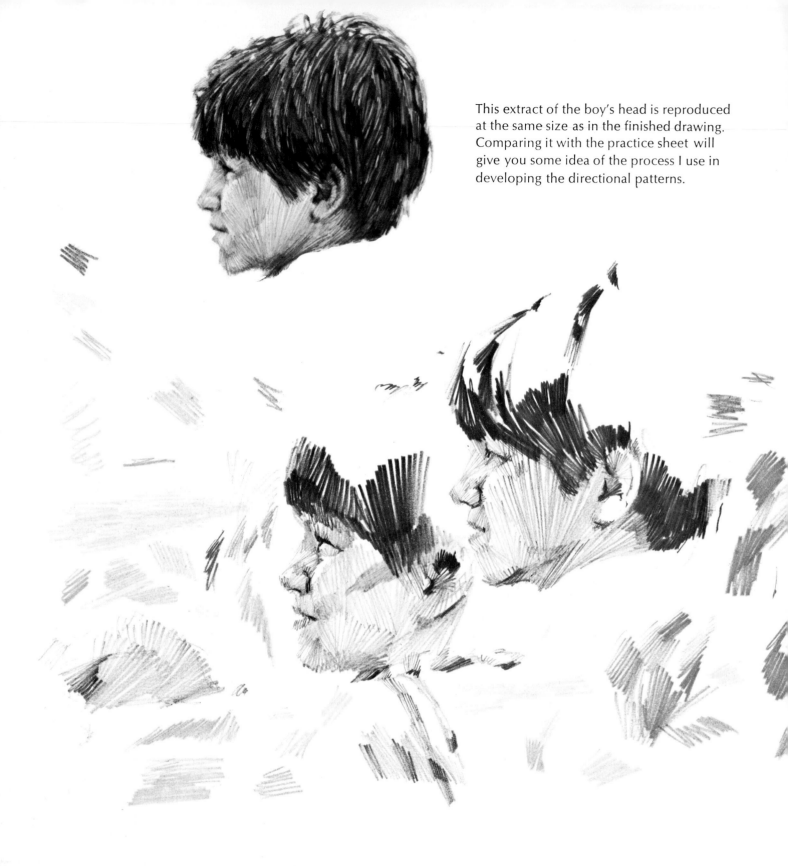

This extract of the boy's head is reproduced at the same size as in the finished drawing. Comparing it with the practice sheet will give you some idea of the process I use in developing the directional patterns.

In addition to the comprehensive sketch I produce prior to executing the final drawing, I find it valuable to spend some time in a "warm-up" period. That is, utilizing the same grade of pencil and identical paper to be used in the final rendition, I execute a series of trial sketches and various stroke patterns to get my hand limbered up. This warm-up session rarely lasts more than five or ten minutes, but it enables me to achieve a fluidity of line. I also find it to be of great value psychologically, enabling me to proceed to the final rendition with more assurance.

138

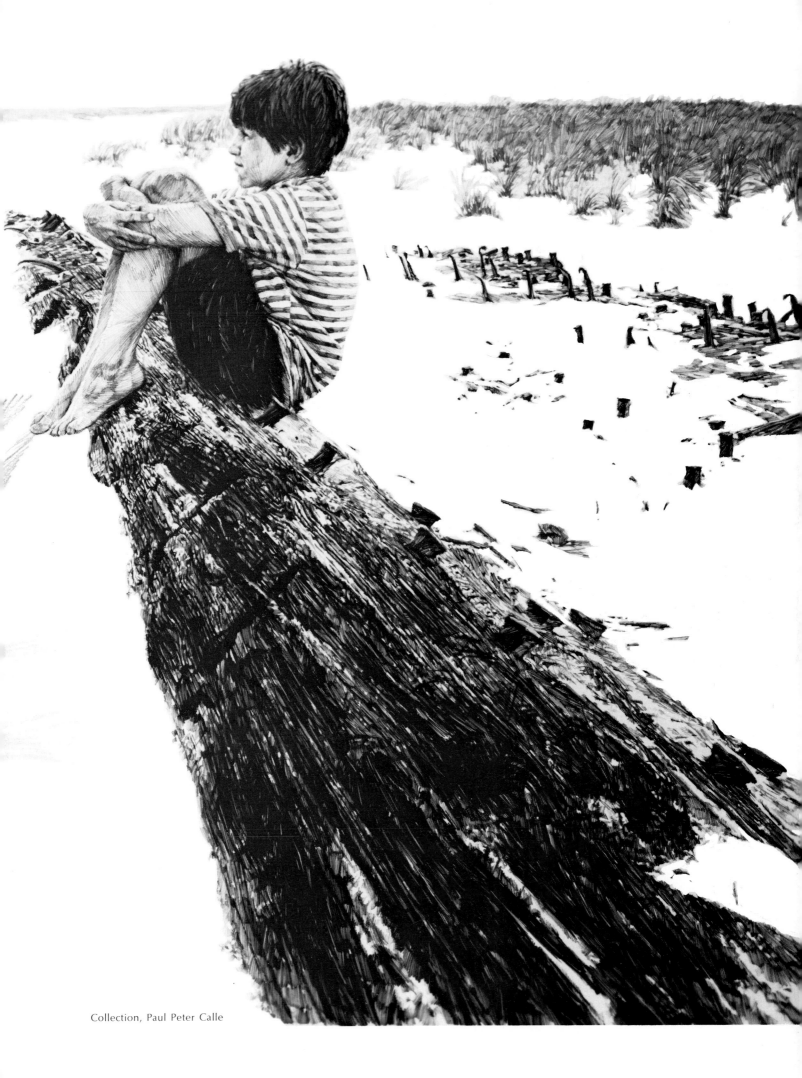

Collection, Paul Peter Calle

139

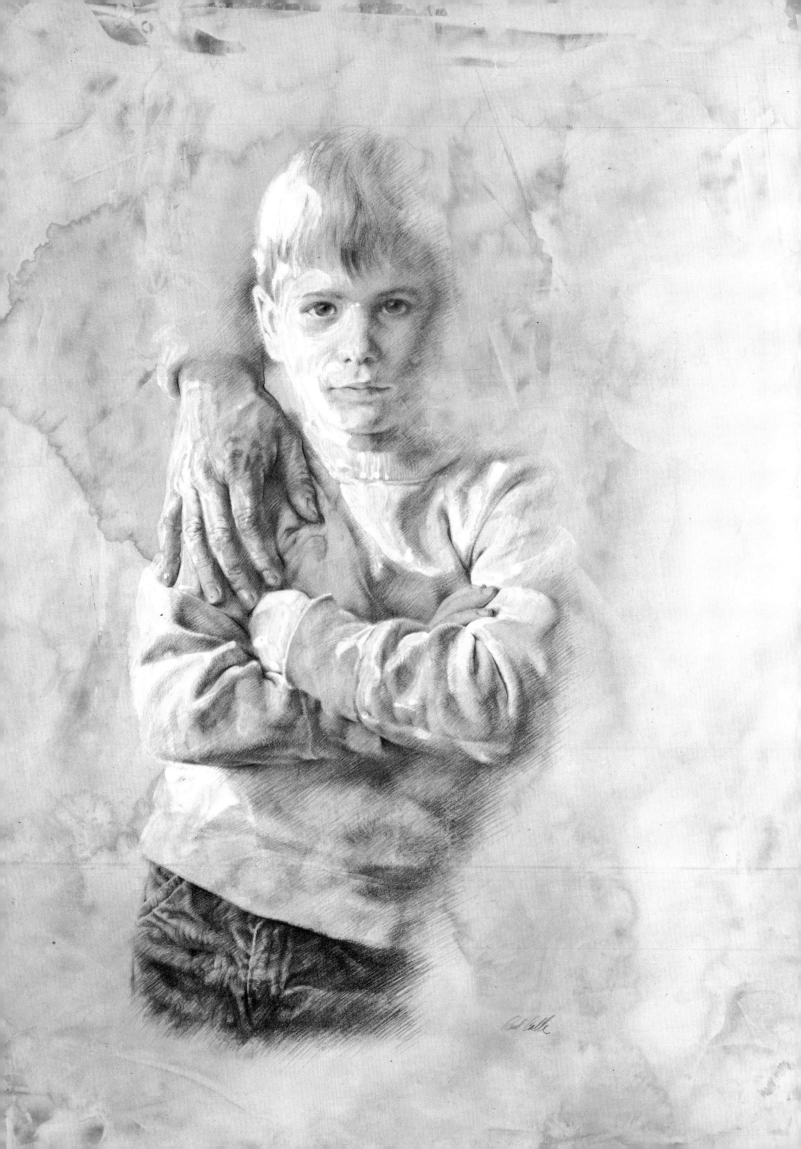

CHAPTER 7
CREATING A STYLE

Anyone who looks at pictures soon becomes aware of characteristic differences in the way one artist draws, applies paint, or uses color, which distinguishes his work from that of other artists.

Most of us come to admire the work of a particular artist, or perhaps a school of art, over all others. However, this admiration may lead to conscious or even unconscious imitation. It can be valuable training for a student to literally copy the work of outstanding artists (note the plural) as a means of learning how and why the original works were done. But, too closely following the styles of others can only retard the development of an artist's own originality.

This is particularly a problem for young commercial artists who may be encouraged by a client to work in the style of a popular artist who is in vogue. This saves the client the higher fee he would have to pay the original artist, and it is a temptation for the budding artist who is anxious to receive work on any terms.

Many artists spend so much time trying to imitate a current vogue, or to create the "new image" that by the time they do so, a new fad has come along and once again, the chase is on. How much better it is to try to express one's honest self!

Life is the subject material of an artist, and all the experiences encountered along the way become part of one's art. Creating a style is not something that one sets out to accomplish in a purposeful way. It is something that evolves and grows with the maturing person. It is not a deliberate process, rather, at its best it is evolutionary, having roots in one's life experiences. Obviously, one is influenced by other artists along the way. This becomes imput into our total being. When we find out who WE are, then this evolutionary process is well on the way to producing an individual rather than an imitator. Training is very important. However, in the final analysis, the most important ingredient is the desire and the relentless pursuit of drawing. For, through constant drawing, you develop yourself and your own style.

Collection, Christopher Calle

These diagrams should illustrate quite clearly the evolution of my style of drawing from an earlier, more traditional approach to the present etching-like style. The pattern flow of the strokes follow the form of the features going in and around to enhance the volume. In addition, as part of the line flow, I utilize a value scale to give it added dimension.

In the more traditional approach, the directional pattern of the lines run parallel to one another without regard for form.

Commissioned by Basic Incorporated

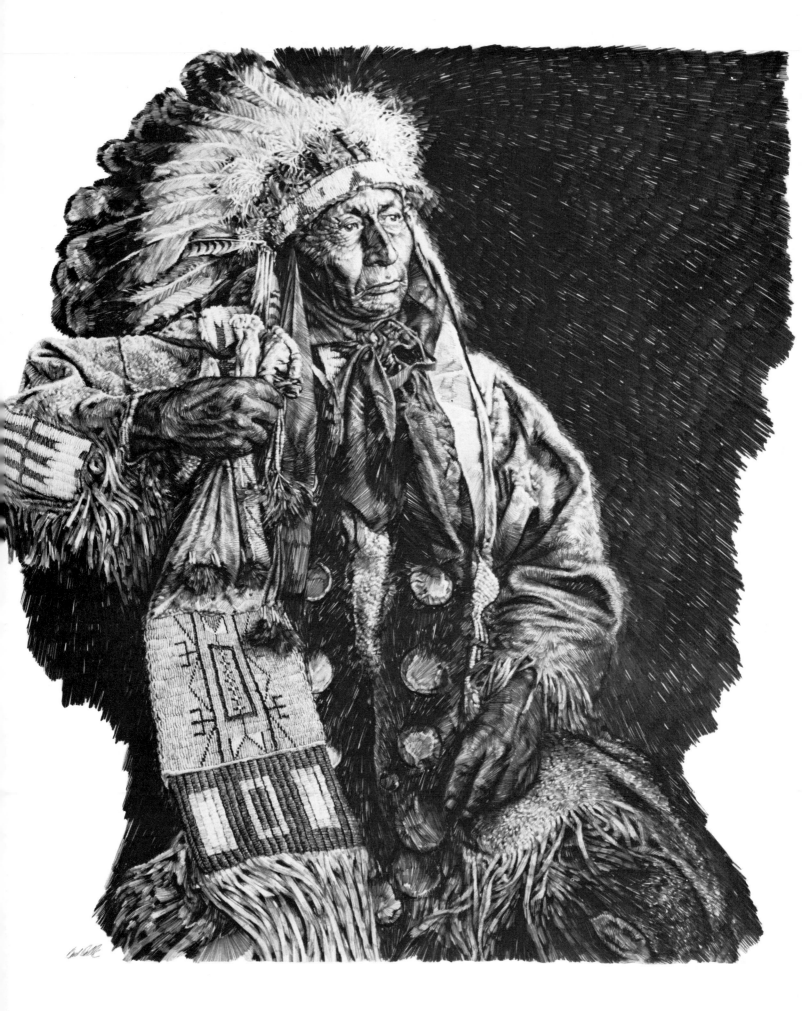

144

CHAPTER 8
PORTFOLIO OF
CURRENT WORK

My most recent work has taken a turn; perhaps a more appropriate description would be that it is more of a return, going back to the interests and visual stimulation experienced in several trips taken years ago to the Southwestern area of the United States.

For the past decade, I have been associated with the National Aeronautics and Space Administration's peaceful exploration of space for the benefit of mankind through its Fine Art Program. My drawings have been the result of visiting launch facilities at Cape Kennedy, serving as official NASA artist aboard a recovery carrier, visiting mission control centers in Houston and tracking stations from California to Ascension Island in the South Atlantic. Always, the eyes of my mind looked outward towards the planets and stars and the galaxies beyond. Now, like NASA after the successful landing of men on the Moon and their exploration of the planet, I have turned back toward the earth. NASA has its Skylab program whose primary mission is to probe the mysteries of our planet earth, gathering scientific data, charting weather patterns and searching for undiscovered natural resources.

And I have returned to the land, to the Southwest in particular, to draw and paint the constant, yet ever-changing landscape, to portray the wind-swept mesa, the knarled trees, the timeless Indian pueblos, the Mission churches, and the people. I am drawn to the eternal Indian, long patient, but with unhealed scars of the encroachment of an alien people on his society and way of life. I try to capture the features of the elderly whose deeply-etched, leathery skin eloquently and pridefully mirrors the hard life endured on the reservation. I try to go back in time to recapture the long departed but not forgotten Indian chiefs who fought to retain and preserve their historic lands.

CHIEF CHARLIE CORN
Collection, Helen and Fred Utter, Sr.

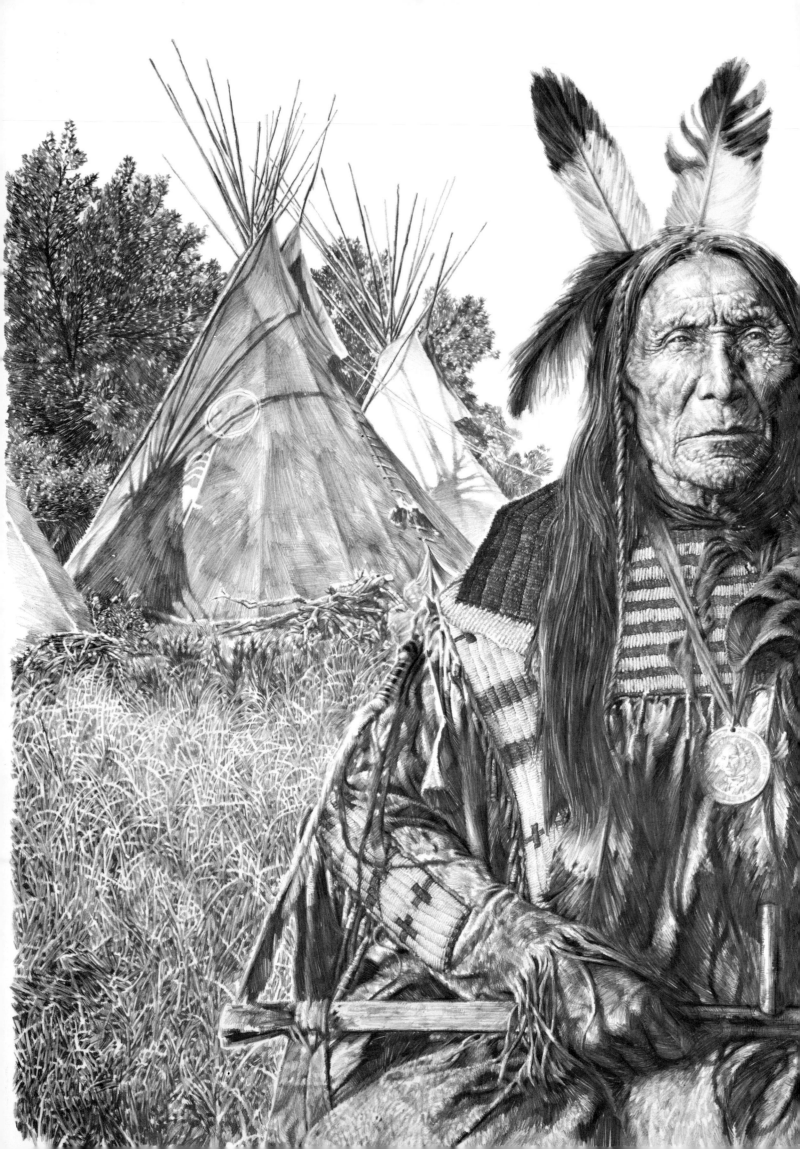

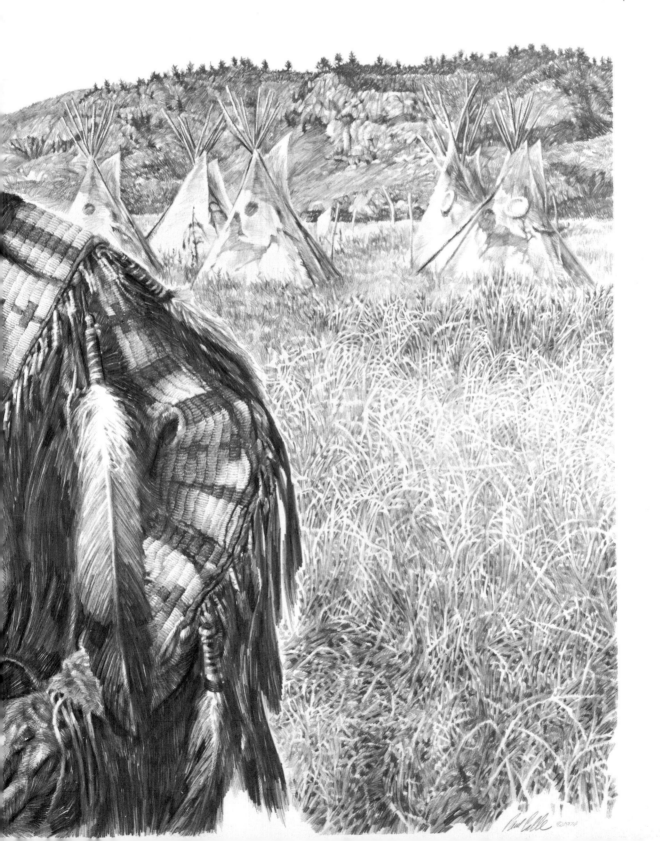

WARRIOR AT PEACE
Collection, Husberg Fine
Arts Gallery

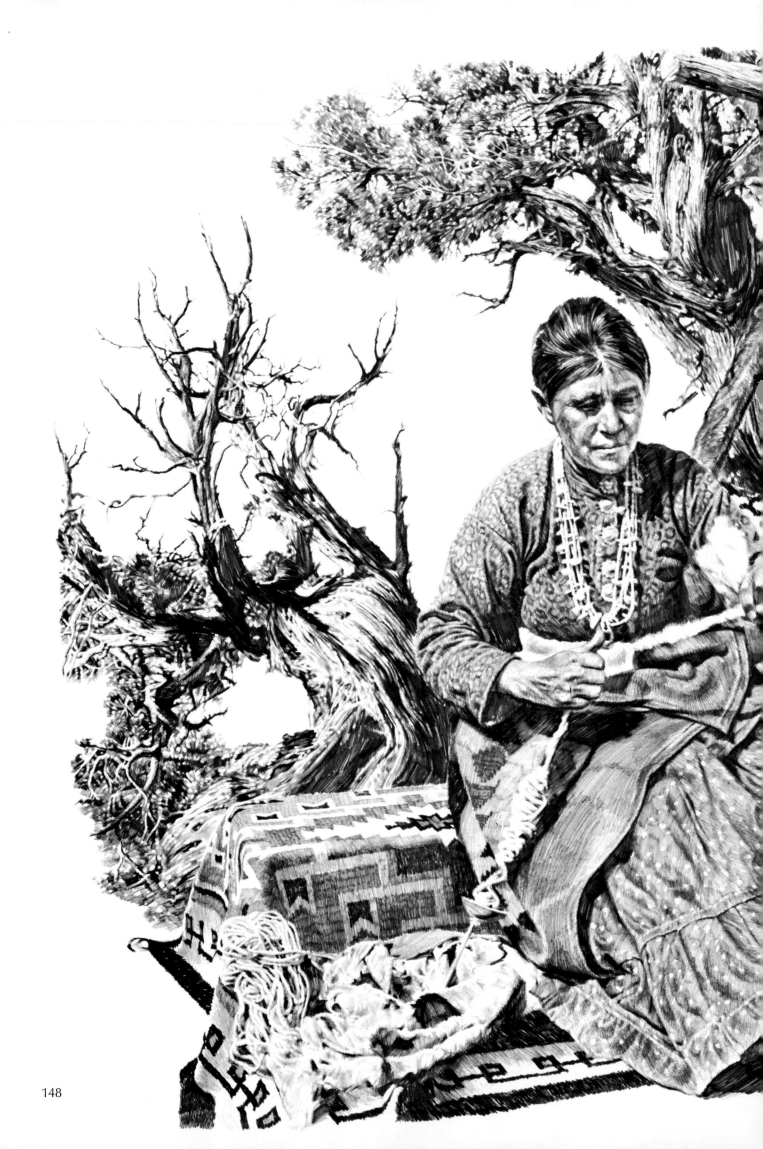

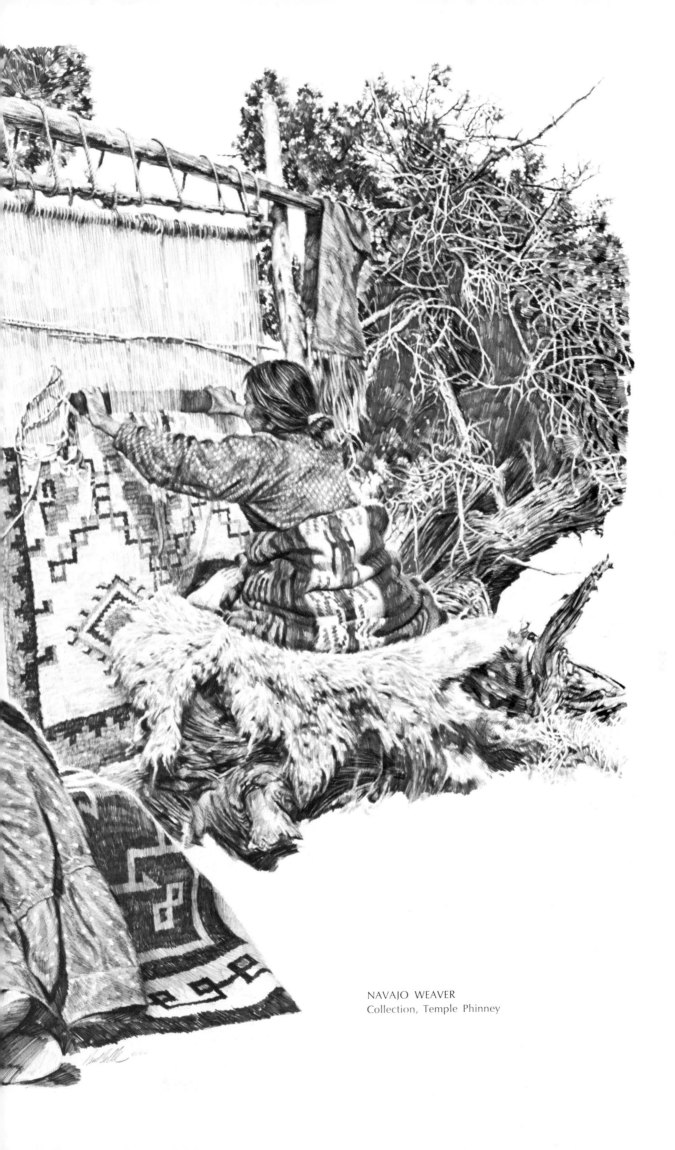

NAVAJO WEAVER
Collection, Temple Phinney

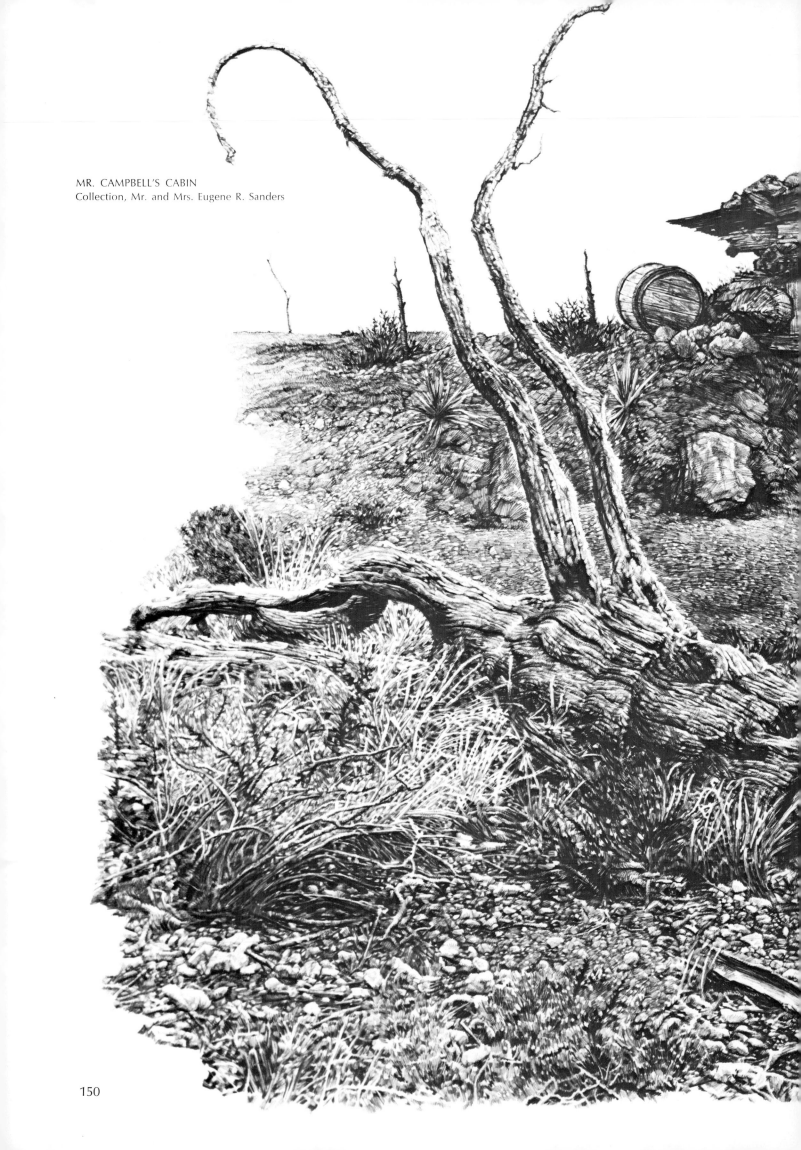

MR. CAMPBELL'S CABIN
Collection, Mr. and Mrs. Eugene R. Sanders

150

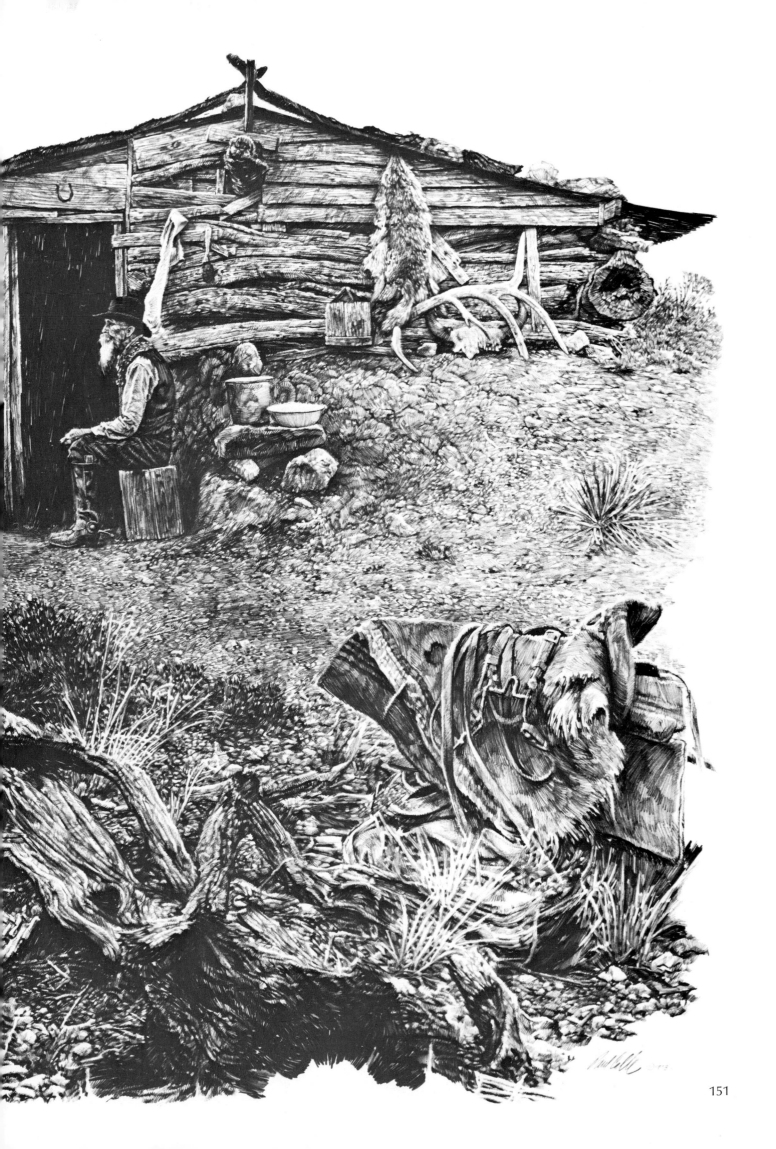

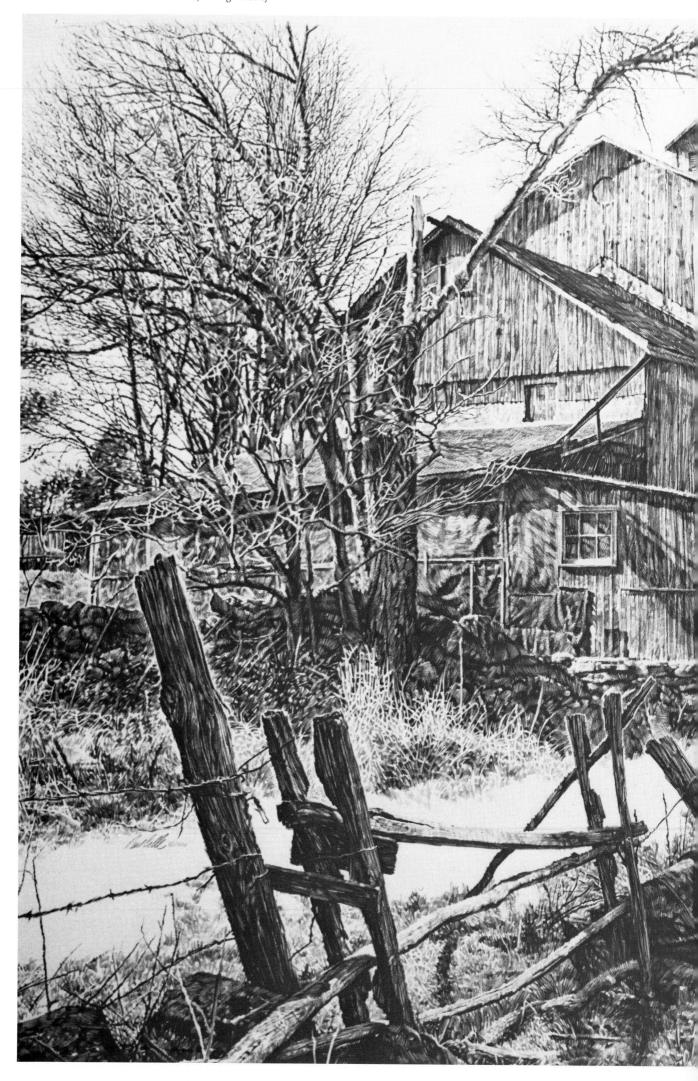

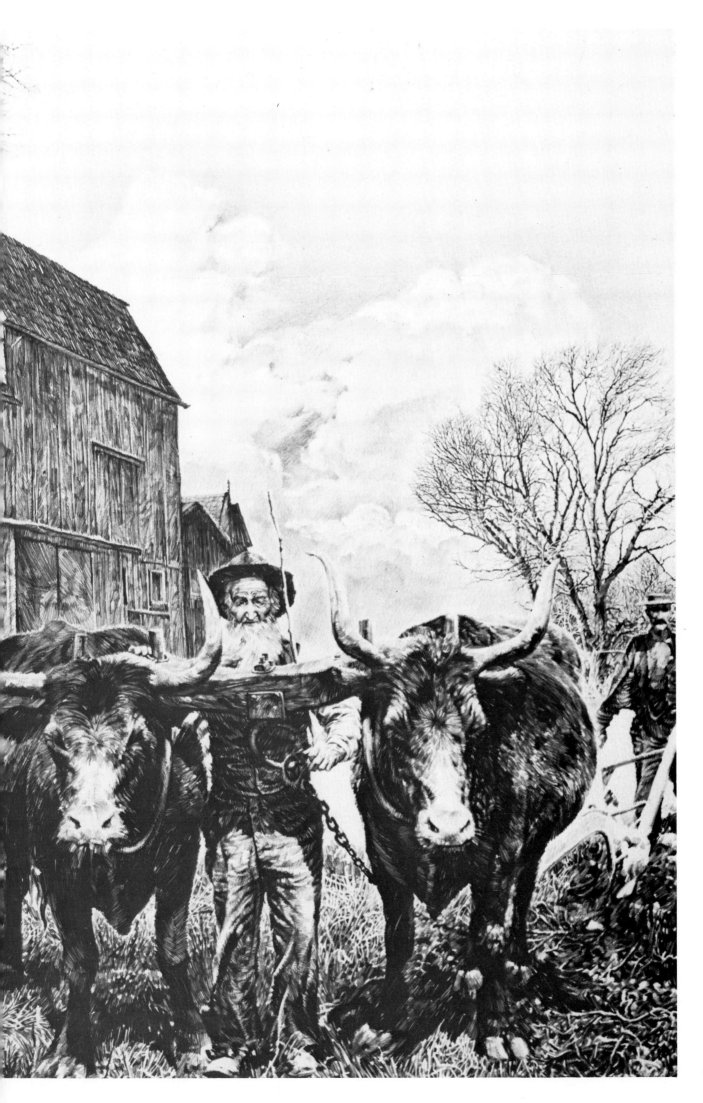

POWAMU KACHINAS
Collection, Helen and Fred Utter, Sr.

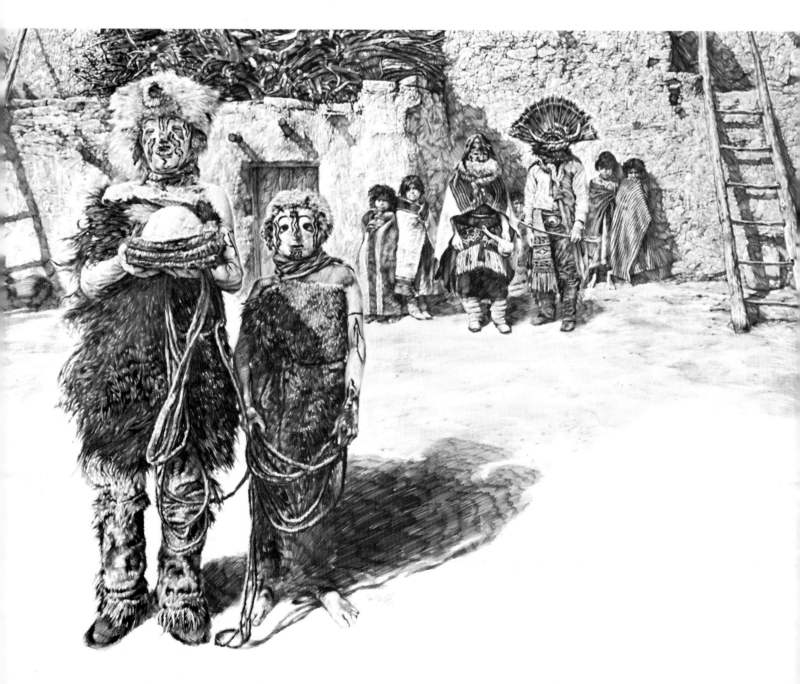

154

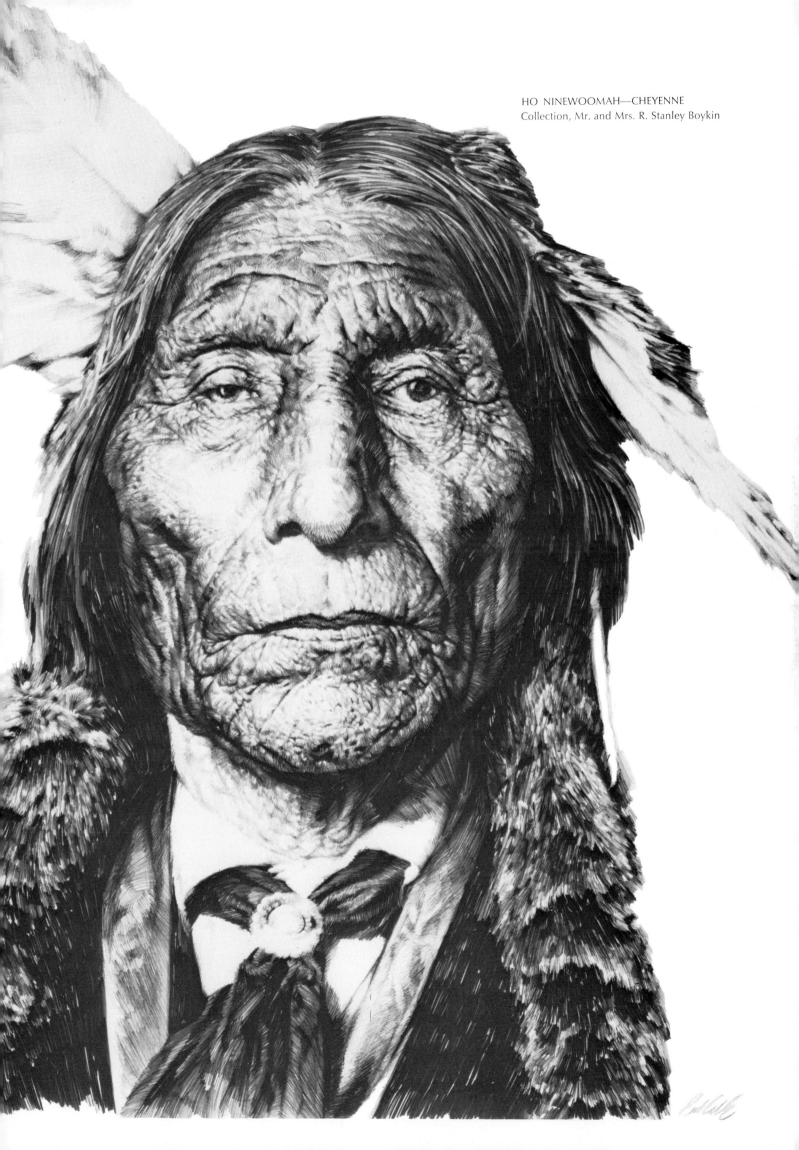

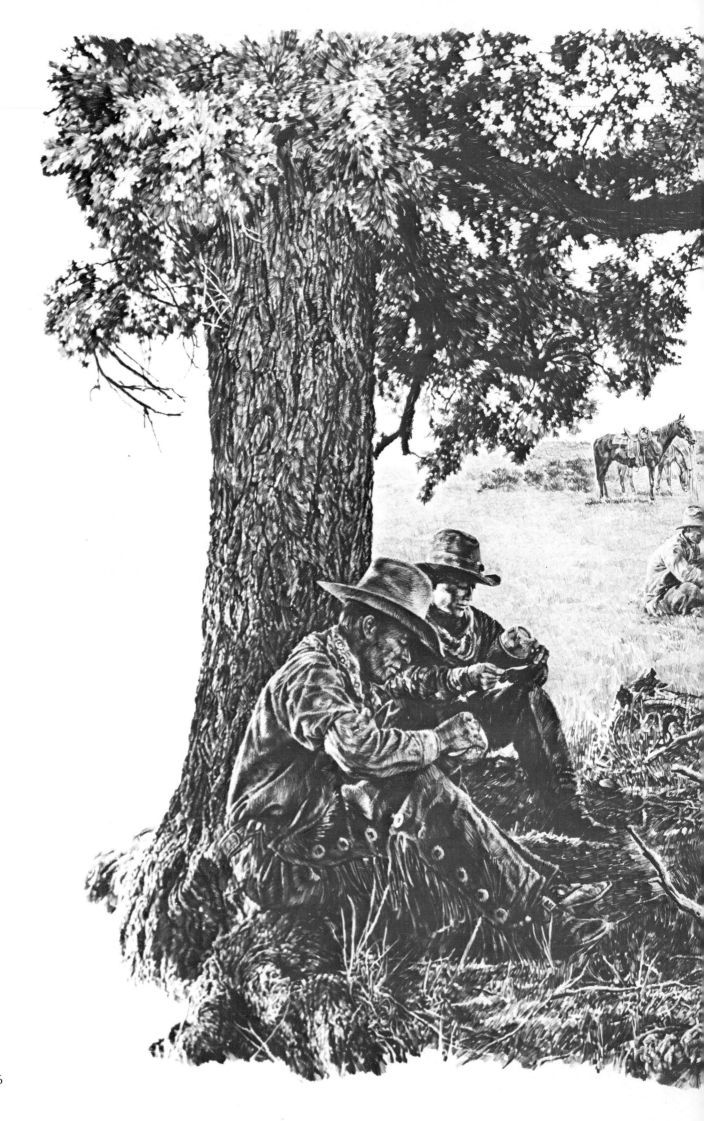

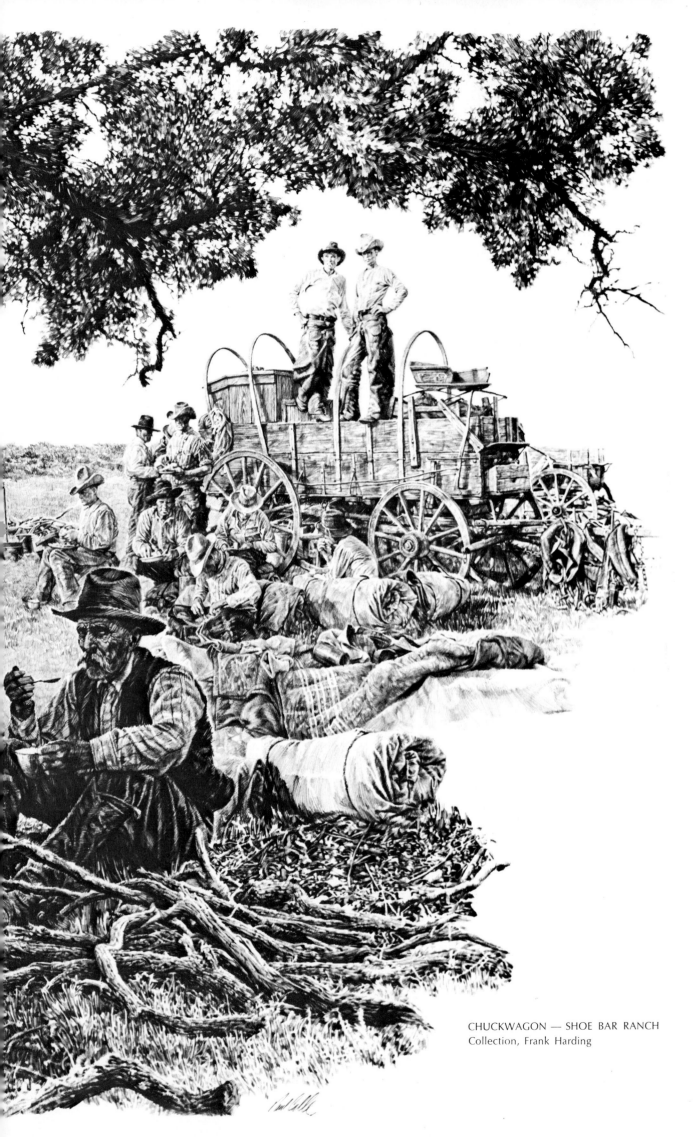

CHUCKWAGON — SHOE BAR RANCH
Collection, Frank Harding

157

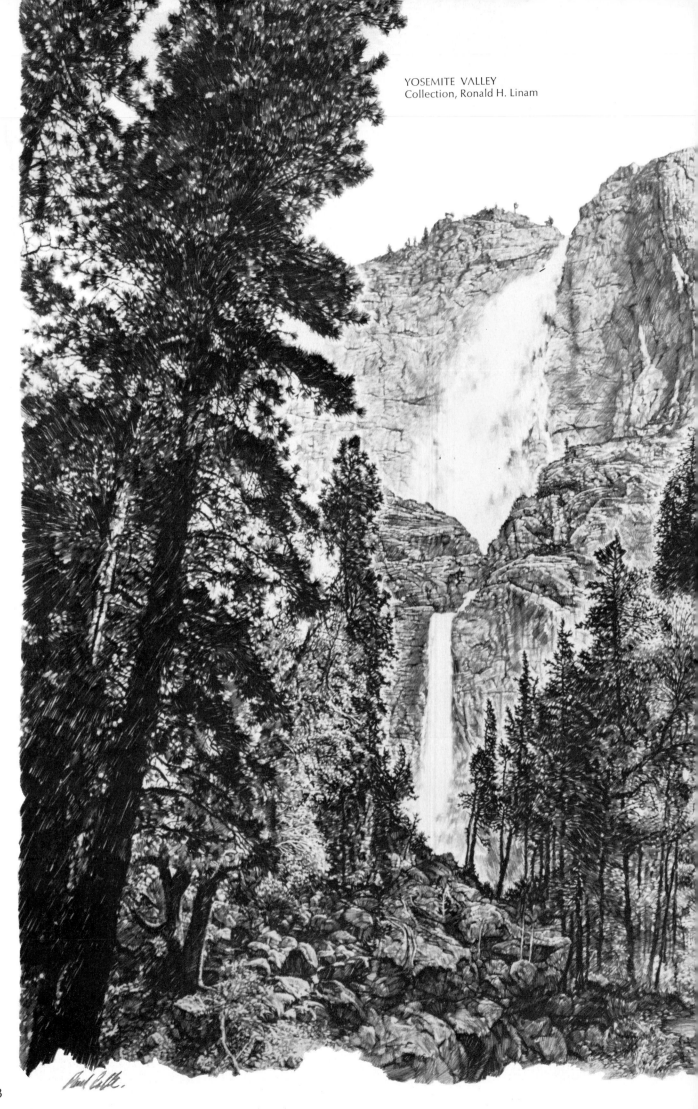

158

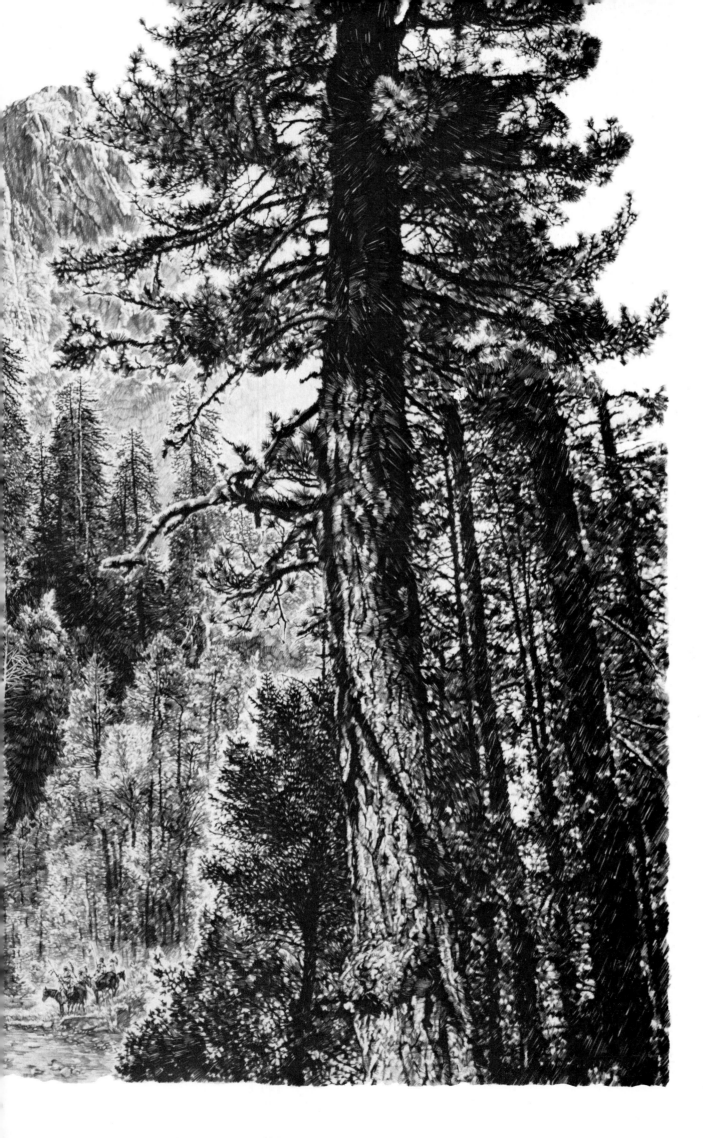

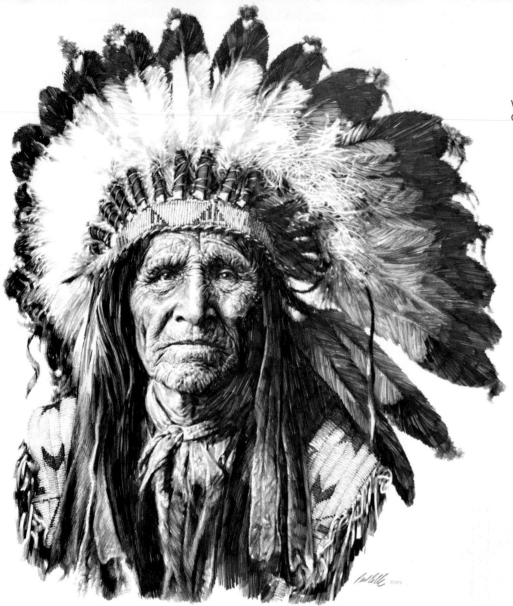

I read somewhere that Degas instructed his friend, Forain, that at his funeral he wanted no oration. "However, if it were necessary and if there had to be one, you, Forain, get up and say, 'He greatly loved to draw; so do I,' and then go home."

I think, for me, if I had to state a goal, a hope pertaining to my work, my aim would be to help keep alive that huge reservoir of our past, to draw strength and sustenance from it, to build upon it in ways that are new and different, but not reject it. I find my inspiration in all the life that surrounds and envelops me, from the evolution of man and his works, of the timelessness of the rocks, the trees, of man, his land, the sky and the sea.

I believe that in the end, art is esthetically good or bad, regardless of how the artist approaches his work or what methods he uses to produce it. To me, the philosophical discourse about, and analysis of, the work is meaningless if, in the end, a drawing fails to stand alone and evoke some response from the viewer. That's what it's all about; art is always a visual experience.

This is my world; I relish it with great affection!